SELF HELP GRAPHICS AT FIFTY

PUBLICATION OF THIS BOOK HAS BEEN AIDED BY A GRANT FROM
THE MILLARD MEISS PUBLICATION FUND OF CAA.

THE PUBLISHER AND THE UNIVERSITY OF CALIFORNIA PRESS
FOUNDATION GRATEFULLY ACKNOWLEDGE THE GENEROUS
SUPPORT OF THE LISA SEE ENDOWMENT FUND IN SOUTHERN
CALIFORNIA HISTORY AND CULTURE.

SELF HELP GRAPHICS AT FIFTY

A Cornerstone of Latinx Art and Collaborative Artmaking

EDITED BY

**Tatiana Reinoza and
Karen Mary Davalos**

UNIVERSITY OF CALIFORNIA PRESS

University of California Press

Oakland, California

© 2023 by The Regents of the University of California

Library of Congress Cataloging-in-Publication Data

Names: Reinoza, Tatiana, editor. | Davalos, Karen Mary, 1964– editor.
Title: Self Help Graphics at fifty : a cornerstone of Latinx art and collaborative
 artmaking/edited by Tatiana Reinoza and Karen Mary Davalos.
Description: Oakland, California : University of California Press, [2023] | Includes bibliographical
 references and index.
Identifiers: LCCN 2022019380 | ISBN 9780520390867 (cloth) | ISBN 9780520390874 (paperback) |
 ISBN 9780520390881 (pdf)
Subjects: LCSH: Self-Help Graphics and Art, Inc.—History. | Graphic arts—California—
 Los Angeles—20th century.
Classification: LCC NC998.5.C22 L678 2023 | DDC 744.09794/940904—dc23/eng/20220831
LC record available at https://lccn.loc.gov/2022019380

Manufactured in the United States of America

32 31 30 29 28 27 26 25 24 23
10 9 8 7 6 5 4 3 2 1

CONTENTS

KAREN MARY DAVALOS AND TATIANA REINOZA

INTRODUCTION

Intangible Registers: Self Help Graphics and the Creation
of Sustainable Art Ecologies

IN HER DAILY BUS RIDE from Westwood to East Los Angeles,
the artist Shizu Saldamando noticed a change in geography
that mirrored the familiar arts and culture scene of her native
Mission District in San Francisco. The undergraduate art program
at the University of California, Los Angeles (UCLA), had brought
her far from home, but she found a sense of community in the
vibrant studios of Self Help Graphics & Art (SHG), where she con-
nected with artists, musicians, activists, and academics. The Getty
Foundation's Multicultural Undergraduate Internship program
secured her place there, tending to the archives, slides, invento-
ries, certificates of authenticity—and eventually joining as full-
time staff. Upon graduating from UCLA, Saldamando was invited
to participate in the Professional Printmaking Program. Master
printer José "Joe" Alpuche and Amos Menjivar assisted her in the
production of a limited edition.[1] The residency—which, over the
years, had hosted some of the most renowned Chicana/o/x artists
and had produced the magnificent graphic archive she knew all
too well—bolstered her confidence in pursuing art.[2] Among her

many accolades, a mid-career retrospective of Saldamando's signature portraits opened in 2019 at the Scottsdale Museum of Contemporary Art in Arizona.[3] When asked about the significance of the organization in her trajectory, Saldamando noted that SHG had "paved the way to keep experimenting . . . instilled a sense of pride [in her multiethnic Chicana-Japanese heritage] . . . [and made visible] the many different art communities and art histories that make up LA."[4]

Saldamando's reflections on the multiple communities and art histories that intersect at this location are the axes that run through this collaborative anthology, which surveys five decades of contemporary art production at SHG and suggests a more complex account of American art. Building on the communal and ethical aspirations of founders such as Sister Karen Boccalero (Carmen Rose Boccalero, hereafter referred to by her familiar moniker "Sister Karen"), Carlos Bueno, Antonio Ibañez, Milton Jurado, and Frank Hernández, our diverse team of interdisciplinary scholars trace the aesthetic, cultural, pedagogical, economic, and political significance of the organization since its incorporation in 1973. For as long as fifty years, SHG has offered four signature programs: printmaking, exhibitions, art education, and the annual Día de los Muertos commemoration. Over time, SHG generated a historical and unprecedented visual archive and related documentation of these programs.[5] Previous scholarship has shed light on the history of the institution and its archives, exhibition-related research, and SHG's long-standing programming for Día de los Muertos.[6] However, this anthology is the first to provide a more thorough account of the formation of SHG's cofounders and, thus, the formative cultural politics of this arts organization. Furthermore, it is the first book to emphasize the organization's influence on the development of Chicana/o/x art as well as American art and *arte de las Américas.* As such, the anthology provides a more inclusive historical examination of SHG. Contributors employ intersectional, feminist, queer, transnational, decolonial, and innovative theoretical frameworks to understand these transnational and cross-racial collaborations and artistic practices at SHG. They examine art by well- and lesser-known artists, the earliest contributors and more recent generations of artists. The broadened analysis of SHG supports the new thinking about Chicana/o/x and Latinx art as part of US, international, and transnational flows of aesthetics.[7] In this way, SHG serves as a springboard for a critical analysis of Eurocentric art histories and proposes alternatives for historically marginalized artistic practices.

This intense focus on the art produced at SHG, from its early days in creative placemaking to its Professional Printmaking Program, provides new perspectives on its value as a cultural and aesthetic resource for the local community and beyond. The authors of this anthology document the resilience and boldness of SHG when economic resources were scarce and yet intellectual and creative knowledge flourished. Over five decades, this site of cultural production and collaboration, even with contestation, has raised the stakes on what it means to create art and community, what it means to educate artists and youth, while priviliging social values and ethical practices not authorized by the art market or museum world. Its success suggests that it is

possible for new modes of artistic expression to emerge from the so-called margins. SHG is an important incubator of modern and contemporary art, and on its own terms. Indeed, fifty years of creative output suggests that SHG has become its own center—a location with intangible power that consistently produces aesthetics, determines its own meanings for those creative products, and achieves a coalescence of creativity emerging from other locations.

Contributors tackle pressing questions about the multiple genealogies of art that intersect at this location, bearing witness to SHG's influential role in American, Chicanx, Latinx, queer, feminist, and global art histories. As such, the anthology provides an account of SHG that allows readers to place it alongside other significant historical moments like the civil rights movement, culture wars, and LA riots, as well as hemispheric cultural hubs like Black Mountain College, Los Grupos in Mexico City, and Tucumán Arde in Argentina. While conceptualized to mark the fiftieth anniversary of SHG, the anthology also tells a larger story about an arts organization at the crucial epicenter of American art and the possible futures of hemispheric art criticism.

Avoiding the celebratory tone of early Chicana/o/x art history, each contributor engages a rigorous social history of art that speaks to the ways in which art intersects with lived experience. Their research reveals a number of important themes that have been taken up by SHG artists in experimental and avant-garde ways such as cultural nationalism, *rasquachismo,* spirituality, feminisms, and queer of color critiques. It also documents the growing transnationalism of Indigenous and Central American immigrant communities, collaborations and exchanges with African American and Asian American artists, and the internationalization that would eventually position Los Angeles as a global art capital. SHG artists explored these sociopolitical themes in relation to the constantly changing "capitalist spatialization" of Los Angeles.[8]

The false dichotomies between art and commerce, or between art for the people versus art for art's sake, are likewise challenged in this volume. With close attention to the inner workings of the arts organization, authors document SHG's drive to create sustainable art ecologies and promote the work of underrepresented artists.[9] As a result of these magnanimous efforts, SHG earned its flagship status as one of the most cherished art institutions in the country for its capacity to support artistic innovation, career and market building, and a broad array of activist commitments.[10] This flexible and expansive ideological orientation rooted in the values of freedom of expression, solidarity, and self-determination has supported the growth of this arts organization and its remarkable trajectory over five decades. As Kency Cornejo suggests in her essay, SHG challenges the narrative of neoliberal multiculturalism by fostering "radical compassion, rather than declaring semblance," a generative framework for exploring collaboration at SHG.

SHG AND THE CHICANO MOVEMENT

SHG emerged from and contributed to the Chicano Movement, particularly the social justice struggles in East Los Angeles, the unincorporated neighborhood of Los Angeles

County that adjoins the Boyle Heights community.[11] For decades, the growing Mexican-heritage population of East LA experienced police brutality and criminalization of youth, substandard housing and education, environmental injustice, and the destruction of their neighborhood with the building of the freeway system.[12] As historian Ernesto Chávez observes, in the 1960s and '70s, East LA activists "embraced nationalist and Marxist-Leninist ideas that gained popularity as a result of social, economic, and political conditions in which ethnic Mexicans lived."[13] From the 1968 high school walkouts to the reformist agenda of the Mexican American Political Association, *el movimiento* produced a "complicated ideological terrain."[14] It was nonetheless coherent in its "serious challenge to all previous models of citizenship, assimilation and role of racialized minorities in the United States."[15] At SHG, the founding artists advanced this "multifaceted" approach to community empowerment by linking art to economic autonomy and political representation, embracing an international trend that foregrounded the role of the artist in collective insurgency.[16]

Artists navigated Chicano cultural nationalism to their advantage. Some artists, such as Wayne Alaniz Healy, Gilbert "Magu" Luján, Eduardo Oropeza, Dewey Tafoya, and John Valadez, turned to Mesoamerican and Mexican aesthetic traditions for symbolism and cultural memory—imagery becoming familiar to Chicana/o/x residents—while simultaneously engaging countercultural styles that challenged social norms. Peter Tovar's service during the Vietnam War oriented him toward solidarity among all who suffered the injuries of battle, yet when Sister Karen instructed him to study the local aesthetics, he found inspiration in the *rasquache* gardens and visual culture of East LA and Boyle Heights.[17] Similarly, Michael Amescua, Mari Castañeda, and Tovar acknowledge that Sister Karen generated a welcoming atmosphere by encouraging them to "bring photographs of their relatives" to enliven the space and recuperate their cultural heritage. For these artists, their family photographs complemented the "energy" of *Las Novias*, a series displayed and created by Carlos Bueno.[18] Other pioneering artists at SHG, including Linda Vallejo, Yreina D. Cervántez, and Margaret Garcia—all self-identified Chicana feminists—learned to maneuver against the heteropatriarchal bias of cultural nationalism yet remained rooted to indigeneity and the avant-garde. It is no surprise that Chicana feminist tenacity transformed the programming at SHG and created intergenerational leadership opportunities, as Claudia Zapata documents in their essay for this anthology. By the 1990s, Chicana and Latina feminist artists working at SHG had formed an intersectional critique of assimilation, white supremacy, and heteropatriarchy.[19]

TRANSNATIONAL SOLIDARITIES

As these cultural nationalist calls for a revolutionary art coalesced, their aims were transformed by a growing transnational *latinidad* and cross-racial solidarity among artists of color at SHG.[20] Following historian George Lipsitz, we suggest that SHG artists "draw their identity from their politics rather than drawing their politics from their identity."[21] The inclusive stance meant that artists such as Alex Donis, born in

Chicago of Guatemalan parents; the island-born Puerto Rican artist Poli Marichal; and Dalila Paola Mendez, a first-generation queer artist of Guatemalan and Salvadoran background—to name a few—not only identify with SHG as a space of belonging but actively shaped collective sensibilities. Their art linked cultural memory to transnational concerns, yoking Los Angeles to *las Américas* and the Pacific Rim, and resonating with recent migrants from southern Mexico, Central America, and the Caribbean. Therefore, this anthology describes SHG both as a Chicana/o/x arts institution and, simultaneously, as a US Latinx art space—and without contradiction, as this mode of synergy at SHG is intersectional, expansive, and aligned with what José Esteban Muñoz called the "brown commons," a structure of feeling connecting artists beyond their individualized subjectivities and toward a sense of shared commonality.[22]

Kency Cornejo documents the Central American presence within SHG, including the various isthmus-born artists who have held residencies and exhibitions, and the forms of solidarity extended toward the historical and contemporary refugee crisis. Recognizing this expansiveness and politics, the leadership of SHG cultivated cross-racial and cross-cultural coalitions. African American artists—such as Mark Steven Greenfield, Jacqueline Alexander, and the late Noni Olabisi—were invited to print at SHG, and they and others formed lasting connections with Latinx artists, as Mary Thomas points out in this anthology. Thomas, Cornejo, and other contributors document how SHG has consistently forged cross-racial and transnational solidarities, reinforcing Lipsitz's observation, for political positioning rather than cultural, ethnic, or racial solidarities. Furthermore, Olga U. Herrera's essay outlines the significance that SHG traveling exhibitions had in the internationalization of Chicanx art with shows that journeyed to Africa, Mexico, and Europe. This orientation supported SHG's impact beyond the local and regional spheres.

ART FOR THE PEOPLE/ART FOR A REVOLUTIONARY CULTURE

As part of a cultural landscape steeped in the rhetoric of social movements and the Catholic Left that advocated art for the people and art for a revolutionary culture, SHG embraced those goals in multiple ways.[23] From its inception in 1970 as Arts, Inc., in the garage of a home of the Sisters of St. Francis of Penance and Christian Charity, the founders set out to create an alternative arts center for the local community. Sister Karen Boccalero, an Italian American nun raised in Boyle Heights, returned to this neighborhood after completing her artistic studies abroad. Her aims in working with the impoverished East LA community—made up largely of Mexican immigrants and second-generation Mexican Americans—were aligned with the portentous changes of the Second Vatican Council, which called for a renewed theology connecting the Church with everyday people in a world that was increasingly secularized. For the sisters, this meant adapting to the local culture and adopting cultural traditions that promoted the dignity of the human person regardless of race, class, gender, or

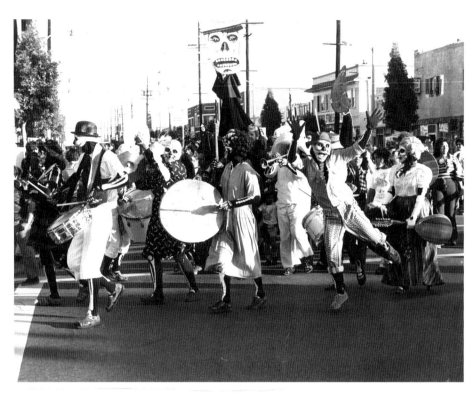

FIGURE O.1

Teatro Campesino performing for Día de los Muertos celebration produced by Self Help Graphics & Art, ca. 1980. Photograph by Guillermo Bejarano. Courtesy of Self Help Graphics & Art.

creed.[24] Her fortuitous meeting with Mexican artists Carlos Bueno and Antonio Ibañez set much of this vision in motion. In a racist society that devalued their community's worthiness, they would show a preferential option for the poor and vulnerable, and simultaneously promote pride in non-European ethnic heritage.

In general, the Eurocentric arts scene excluded artists of color, and SHG was one of many alternative centers that produced "work [that] was not only about local empowerment but about challenging Eurocentric constructions of identity, as well as of art and value itself."[25] As art historian Shifra M. Goldman reports, "mainstream museums (public and private) and commercial galleries . . . were implacably closed to Chicano [and Chicana/x] artists [in the 1960s and '70s]."[26] One of the most significant programs launched in the fall of 1972, prior to the organization's incorporation, was the annual celebration of Día de los Muertos (fig. 0.1). Recognized as one of the earliest and most elaborate celebrations to take place in the United States, Día de los Muertos includes a procession, musical and theatrical performances, altar making, an exhibition in the gallery, and culinary arts that draw thousands of participants to SHG each year (fig. 0.2). The organization is internationally recognized for expanding the cultural

FIGURE 0.2

Miyo Stevens-Gandara in the studio during the creation of *Evergreen,* her commemorative print for the forty-eighth annual Día de los Muertos, 2021. Courtesy of Self Help Graphics & Art.

form of Día de los Muertos. While it was previously practiced *within* families in Mexico, SHG inaugurated the celebration as a community-wide event taking place over a season, as Lara Medina and Gil Cadena have documented.[27] With its massive appeal and multiple locations, including Noche de Ofrendas (Night of Altars) at Grand Park, Día de los Muertos supports Indigenous heritage and spiritual beliefs, experimentation, and social critique, which engenders an alternative, postmodern aesthetic form.[28]

Another effective program to bolster art for the people was the retrofitted UPS delivery truck that gave rise to the Barrio Mobile Art Studio. The art-on-wheels education initiative brought art to the community's inner-city public schools, as discussed further in Adriana Katzew's contribution to this volume, which focuses on its social justice–oriented pedagogical philosophy. This public education program originally focused on K–12 students and employed dozens of local artists. It later became a signature mode of earned income for SHG, as it began to offer art workshops to local businesses, corporations, and universities for a modest fee. As an economically self-sustaining project, the Barrio Mobile Art Studio is an important innovation for non-profit organizations as it also supports general operations, the most difficult expense to fund among nonprofit arts institutions. SHG continues these art-for-the-people initiatives by supporting on-site, free studio arts classes for youth ages twelve to twenty-four, and by encouraging mentorship models. Soy Artista, one of their longest-running youth arts education programs, is an intensive five-week session taught by local artists on different media, from printmaking and photography to smartphone-based art and other new media. Students develop an art portfolio but also a sense of community. Generating a collective spirit of accountability, artists such as Yolanda González repeatedly return to teach, passing on the knowledge they learned from their peers and mentors, which in her case included Yreina Cervántez, Eloy Torrez, and Patssi Valdez. In the twenty-first century, SHG has also created long-term collaborations in after-school programs with the high school in Boyle Heights and with alumni and students from the California Institute of the Arts (CalArts), a private arts university in Southern California. These programs allowed SHG to serve as the training grounds for subsequent generations of SHG artists-teachers, including William Acedo, Daniel González, Yolanda González, Poli Marichal, and Dewey Tafoya.

Beyond making art accessible for all, SHG's commitment to people's art often took wide-ranging forms. For instance, it welcomed artist Willie Herrón's use of SHG as a rehearsal space for his punk band, Los Illegals, and, in 1980, with Sister Karen's blessing, as a music venue, The Vex. Although it was a short-lived venture, the Vex retains "legendary status as an incubator for Eastside punk," and its intersections with this alternative art venue inspired a number of artists to pursue this anti-establishment sensibility.[29] Patssi Valdez's photomontages and Diane Gamboa's drawings, photographs, and remarkable paper fashions drew on this energetic music scene. Transgressive performances by musicians such as Alice Bag and Teresa Covarrubias defied conventional gender norms for Mexican American women. As Pilar Tompkins noted,

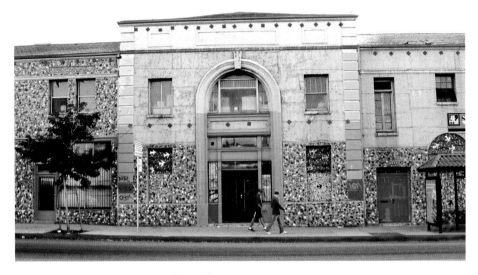

FIGURE 0.3

Between 1987 and 1990, Eduardo Oropeza (1947–2003) created the ceramic mosaic mural that adorned the Self Help Graphics & Art building at 3800 East Cesar Chavez Boulevard, ca. 1990. Photograph by Edgar Garcia. Courtesy of Edgar Garcia and the Los Angeles Conservancy.

"the female voices that emerged from East LA's punk scene hold a key position in elasticizing the invisible barriers of social positioning. . . . [T]heir modes of artistic production were forward thinking, as they embraced a totality of experience that situated music, art, and actions as open-ended discussions."[30] Creative spaces like SHG were at the center of these discussions, and even the façade of the building was a canvas for expression, as seen in the mosaic mural created by Eduardo Oropeza, expanding the role of art as an expressive and social platform (figs. 0.3 and 0.4).

BUILDING CAREERS, BUILDING A MARKET

Although these two cultural phenomena are rarely discussed in tandem, the emergence of social movements coincided with the rise of printmaking in Southern California. Another contribution of this anthology, therefore, is its mapping of SHG as an important incubator of modern and contemporary art, with Latinx artists, including women and queer creatives, at the center of the printmaking process. Figures such as Lynton Kistler, Jules Heller, Sister Corita Kent, and June Wayne were among the key players who transformed Los Angeles into a mecca for the boom in midcentury graphic arts. During this time, graphic arts divisions opened at universities and art schools in the region, dealers and gallerists created a market for prints, and spaces like the renowned Tamarind Lithography Workshop (founded by Wayne in 1960) began training a new

FIGURE 0.4

Detail of Oropeza's mosaic, ca. 1990. Photograph by Edgar Garcia. Courtesy of Edgar Garcia and the Los Angeles Conservancy.

generation of master printers and offering professional residencies to artists. The collaborative press movement increased the viability of the field, as a newly trained generation of printers dispersed about the country, opening more than three hundred workshops between 1960 and 1990, and dissolved the hierarchies between artist and printer.[31] Tamarind alumnus Ken Tyler founded Gemini Graphic Editions Limited (G.E.L.) in 1966, inviting East Coast artists such as Joseph Albers and Robert Rauschenberg; and fellow alum Jean Milant began Cirrus Editions in 1970, with a regional focus on Southern California white artists. The development of workshops such as Tamarind, Cirrus, and Gemini G.E.L. was essential for positioning Los Angeles on the cutting edge of experimentation in contemporary art.[32] However, the pressing social issues of the day were largely absent from the work being produced at mainstream workshops. Opening the field to new narratives in American graphic arts would require the development of creative spaces like the atelier at SHG, which this anthology names as a crucial epicenter of American and hemispheric art production.

In the racially segregated city of Los Angeles, artists of color were offered few opportunities to exhibit their work and were rarely, if ever, invited for residencies at these workshops. African American artists such as Betye Saar, David Hammons, and Timothy

Washington created innovative prints outside of the institutional context of these print workshops, which were "for the most part completely uninterested in their work."[33] Allan Edmunds, founder of the Brandywine Workshop in Philadelphia and a peer of Sister Karen, explained: "The 1960s was the heyday of printmaking in America but that's because the white printers were making prints with famous white painters, but the heyday really was the 1970s and 1980s in the minority communities when it really grew and got this diversity and also the print departments of universities expanded."[34]

Sister Karen's training at Immaculate Heart College under Corita Kent furthered her interest in collaborative printmaking as an aesthetic and social medium. Kent's pop-inspired prints tackled pressing social issues, including poverty, the war in Vietnam, and the Watts riots with faith-based messages of hope and resilience.[35] The transnational matrix and artistic innovation that emerges at SHG finds precedent in the relationship between Sister Karen and Kent, but also in Kent's connection to Mexican modernism. In 1951, Kent learned serigraphy from María Sodi de Ramos Martínez, the wife of Mexican modernist Alfredo Ramos Martínez (1871–1946), who "mastered the art of serigraphy in order to maintain the visibility of Alfredo's work" at a time when the printing process was relatively new as an artistic medium.[36] The art of silk-screen printing, the stencil technique whereby a mesh is used to transfer ink to a substrate, had been in use commercially since the early 1910s in the United States, but midcentury artists leveraged its multiplicity and accessibility to democratize artmaking.[37]

Sister Karen subsequently pursued an MFA at Temple University's Tyler School of Art. In the mid-1960s, Tyler professor Richard Callner started a program that brought American students to study painting, printmaking, and sculpture in Rome. The printmaking portion of the program in Rome was led by Romas Viesulas, a Lithuanian artist and World War II refugee. An abstract expressionist printmaker who had won two Guggenheim awards, Viesulas was the first artist-in-residence at Tamarind and would go on, by 1970, to represent the United States at the Venice Biennale.[38] As a displaced person who left war-torn Europe to pursue his artistic vision, Viesulas believed that art could communicate the experience of exile. In this milieu, Sister Karen learned the latest trends in graphic arts, as well as the value of supporting the work of migrant and displaced artists, which would shape her encounter with Bueno and Ibañez. In 1969, she held her first solo exhibition in Rome's Galleria La Sula, which showcased her latest screenprints, lithographs, etchings, and oils (fig. 0.5).[39] Her time in Rome also coincided with meeting fellow MFA student Edmunds. Both vowed to start collaborative workshops in their hometowns and to make printmaking accessible to underrepresented artists. Merging the Catholic Left's support for marginalized communities with an accessible artistic practice, Sister Karen cofounded SHG.

The mid-twentieth-century boom in printmaking coincided with the emergence of public art forms such as muralism in East Los Angeles. The Chicano mural movement, which transformed the built environment by embellishing and revitalizing under-resourced neighborhoods, eschewed institutional exclusions, and refused the terms of

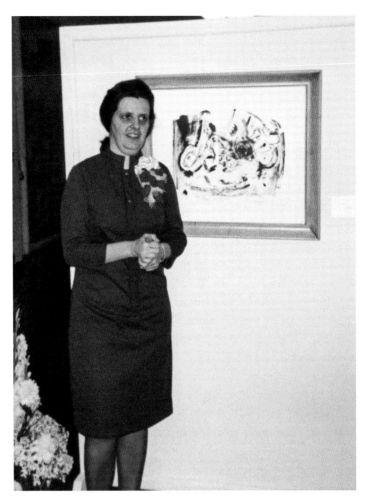

FIGURE 0.5
Sister Karen Boccalero standing
next to one of her prints, ca.
1969. Courtesy of Self Help
Graphics & Art.

commodification of the art world. These values were likewise mirrored in the development of the Chicana/o/x and Latinx printmaking field. Prints could function as a public art form in mass mobilization campaigns, and their cost-effectiveness could likewise democratize access for artists and audiences. "It's part of my philosophy," Sister Karen noted in regard to creating print editions that could be purchased by local community members. "I feel part of the Chicano art movement is to make art accessible. That's why there's all this public art, like the murals."[40] Printmaking and muralism were both regarded as art forms that could promote community engagement, collective action, and radical disruptions of the arts establishment.[41] The recuperative aim of printmaking and muralism, emblematic of art for the people and referencing the most widely known vanguard movements of Mexico, therefore was also interventionist, and SHG itself became a symbol of institutional critique and social interrogation. However, this did not preclude the organization's efforts to advance careers or build an alternative art market.

As the SHG community of artists grew, so did their needs for enhanced career development. The Experimental Screenprint Atelier program, launched in 1983, met that need by offering a professional residency, group critiques, exhibition opportunities, and a nascent market for the sale of the artists' work.[42] Sister Karen was among the second group of artists who participated in the fall of 1983 and created *In Our Remembrance/In Our Resurrection,* an abstract image of a bird emerging from flames (fig. 0.6). Centering the role of artists as leaders in aesthetic innovation, SHG appoints an artist-curator who selects the participants and theme for each atelier. The initiative responded to the neoliberal turn in which government agencies "closed off funds for public art but counseled artists to employ small business methods to advance their art."[43] The atelier was a method of creating economic autonomy for SHG artists in the truest "self-help" form. However, rather than promoting neoliberalism's obligatory individualism, the atelier generated funds for the artists and the arts organization. SHG reimagined the relationship between art and economic viability by sponsoring the publication, splitting the edition between the arts organization and the artist, and building a small circle of collectors to sustain and value the art. In an interview, Sister Karen described the significance: "The cornerstone of our programs is the Atelier program, where we invite twenty artists a year to develop their designs through a collaborative process in a series of meetings where various information is shared, and then we publish their designs. It's not a commercial process [such as a contract shop], but a collaborative one. We're there to create the structure for the individual artists."[44]

SHG as collaborative

Not only a structure, the atelier program was an *infrastructure* that advanced the careers of many artists who otherwise would not have had access to the medium, exhibitions, and a market. Some of the most well-known figures of Chicanx and Latinx art have published with SHG, including the Chicano photographer Don Gregorio Antón, seen here printing with Stephen Grace (fig. 0.7), and subsequent generations of artists such as Favianna Rodriguez, Vincent Valdez, and Melanie Cervantes have been welcomed at critical points in their emergence. Karen Mary Davalos's essay charts how this engine of production ushered avant-garde, feminist, and conceptual aesthetics in Chicanx art. Furthermore, some atelier resident artists would go on to found their own graphic workshops and collectives across the country, including the Coronado Studio in Austin, Texas; Dominican York Proyecto Gráfica in New York City; and Bay Area collectives such as Dignidad Rebelde and Taller Tupac Amaru. For these reasons, SHG became the flagship print shop that catalyzed much of the current Latinx graphic arts movement.[45]

Reflecting on their experiences in the atelier, the artists described the significance of the program in various ways. For John Valadez, working in this format allowed for a sense of fluidity and improvisation: "The flexibility in the run made it possible to start with tentative plans then complete the color process within a spontaneous inspired framework."[46] The artist Barbara Carrasco remarked on the collaborative aspect and the workshop's openness to her cultural heritage: "Before being invited by Atelier Printer Stephen Grace to participate in the program I was always interested in working

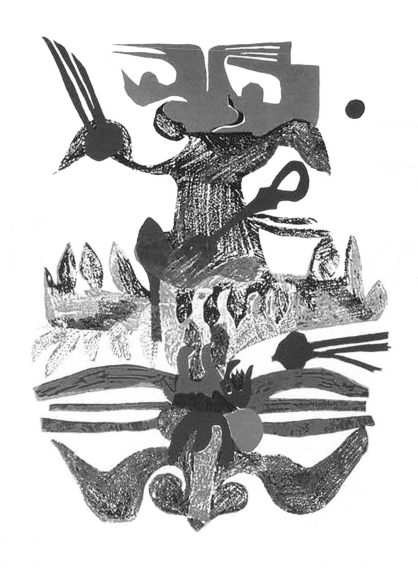

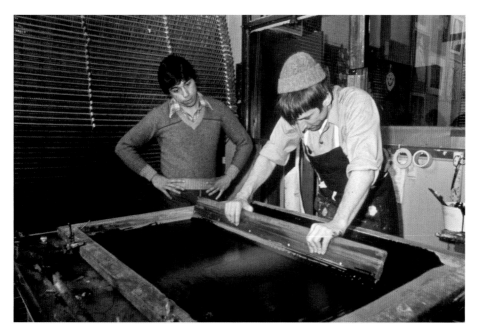

Don Gregorio Antón working alongside master printer Stephen Grace, Atelier 1 Workshop, 1983. Self Help Graphics & Art Archives, California Ethnic and Multicultural Archives 3, University of California, Santa Barbara Library. Courtesy of Self Help Graphics & Art.

in a collective. The fact that the workshop included Latinos/Chicanos made it even more appealing."[47] Similarly, the African American artist Alonzo Davis, cofounder of the Brockman Gallery and discussed in Mary Thomas's essay on Black and Brown solidarity art networks, "enjoyed the [collaborative] environment and the freedom to do work that dealt with a social issue."[48] For many of these artists, not only was this their first time working with a master printer and being introduced to the art of screenprinting, but the SHG atelier gave them the freedom to experiment with themes of identity, place, and politics. These facets of everyday life were often discouraged by other publishers, who were only concerned with the language of formalism.

While the residency program brought in artists from across the country, the Open Printmaking Studio (OPS) served local artists through an experimental environment with two midsize presses. Unlike the atelier, the OPS operates without a master printer and typically involves relief, intaglio, and monotype; for decades, it had no preconditions regarding the percentage of work created by hand. In 2017, SHG instituted a nominal studio fee or required five volunteer-hours as well as a donation of 20 percent of the artistic production for the arts organization's inventory. However, for most of the past fifty years, the OPS was largely unregulated, and artists were allowed to use the studio at any time of day or night, make use of the inks left over from the atelier program, and keep

the entire edition or set of prints created in the studio. This open environment fostered the unrelenting Victor Rosas, who worked almost daily in the studio for over a decade at the start of the twenty-first century; Miguel Angel Reyes, who generously made and sold monoprints at SHG events during the late 1990s; and the print collective Los de Abajo, a remarkably productive and flexible team that has included Poli Marichal, Marianne Sadowski, Kay Brown, Don Newton, and Nyugen Ly.

In addition to creating the professional residency program, the institution invested a great deal of energy in boosting artistic careers through its ambitious exhibition programming.[49] Since the earliest years, and formalized through Galería Otra Vez in 1976, SHG exhibitions have been a central component of the organization, showcasing the prints published in studio as well as the paintings, sculpture, photography, installation art, and textiles of invited artists.[50] Sister Karen adopted these principles from the local Chicanx community, noting that "Chicano culture deeply values the social fabric of life. So our system differs greatly from mainstream thinking about fine art. In that system, you struggle alone: at school, at college, you have to compete. The lucky few will get a gallery and there they have to compete again."[51] Offering culturally informed interpretations, historical and political contexts, and accessible knowledge about the art on display, SHG challenges the mainstream museum and art world and its conventional and narrow understanding of artists and their work, as Davalos argues elsewhere.[52]

As the gallery director and curator for twelve years (1994–2005), Christina Ochoa extended the self-help mission by nurturing emerging and mid-career artists and teaching them "the whole process"—from the studio visit to installation, creation of a press release, and design of the announcement.[53] Ochoa is credited with improving the presentation of the exhibitions, adding artist talks to the program, and increasing the quantity of exhibitions to thirty shows per year, including those presented at other institutions and traveling exhibitions. The caliber and synergy of the exhibitions Ochoa created gained notice in the Los Angeles art scene, and the LA Weekly regularly listed her shows for the "Pick of the Week."[54] She is also credited with bringing new artists to the arts institution, including Laura Aguilar, Raul Baltazar, Sandra de la Loza, and Rubén Esparza, and would take up and carry the torch during major crises, including the death of the founder and the sale of the building (both topics discussed below). Ochoa valued intergenerational exhibitions, the aesthetics of Chicana/o art rather than the cultural identity of the artist, and feminist practice, as evidenced by her consistent presentation of women artists.

While Ochoa served as gallery director, SHG opened a satellite location in 1997 on Olvera Street, a tourist attraction in Downtown Los Angeles. Named in honor of the founder, Galería Sister Karen Boccalero opened a few months after Boccalero's passing, at the invitation of the owner of Casa de Sousa. In the early 1980s, Ochoa had previously launched the satellite gallery for Goez Art Studio on Olvera Street, which provided her a familiarity with the audience and location, including its challenges. This rent-free gallery adjacent to the café at Casa de Sousa expanded the exhibition program and reached new audiences. The exposure from visiting locals and interna-

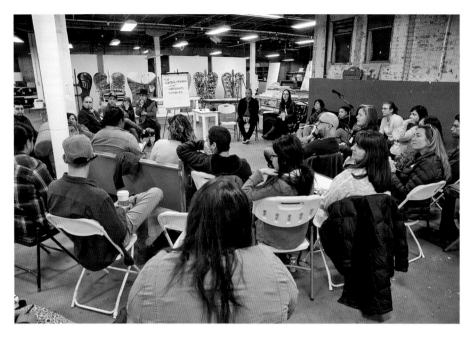

FIGURE 0.8
Artists and master printers attending the inauguration of the Biennial Printmaking Summit, 2017. Photograph by
Rafael Cardenas. Courtesy of Rafael Cardenas and Self Help Graphics & Art.

tional tourists proved fruitful for SHG when a vacationing Italian curator liked what
he saw and invited the show to Italy.[55] Although short lived (1997–99 or 2000), the
satellite gallery anticipated and inspired a major trend on Olvera Street and elsewhere.
It catered to middle- and working-class Chicana/o/x residents who craved merchan-
dise that spoke to their lived realities in Los Angeles rather than the products selling
romantic Mexican stereotypes for tourists.

In the twenty-first century, SHG added a new aspect to the printmaking program:
the Biennial Printmaking Summit, a weeklong forum for artists, master printers, and
novices to harness the collective knowledge and skills of Latinx print houses (fig. 0.8).
The Printmaking Summit emerged from the successive deaths of notable graphic art-
ists: Sam Coronado, founder of Coronado Studio in Austin, who passed away in 2013;
LA natives Sam Baray, in 2013, and Richard Duardo, in 2014; and the Nuyorican artist
Fernando Salicrup in 2015. The arts organization recognized the need for a formal pro-
gram to support the training of new master printers and to continue promoting the
socially conscious medium. The Printmaking Summit marshaled the collaborative spirit
and creative energy of Latinx printers; forty-five participants attended the premiere
event in 2017, sixty-five attended the second summit in 2019, and the virtual summit in
2021 had over three hundred participants. In the inaugural summit, participants chal-
lenged the gender bias in the male-dominated field of printmaking and called for new

criteria for defining a master printer.[56] Artist-printers such as Melanie Cervantes and Sandra Fernández were invited to conduct workshops in the second summit as SHG strived to recommit to honor the many women artists whose highly skilled printing shows mastery of the medium.

CONTESTATION AND SURVIVAL

The contributors to this anthology suggest that contestation further strengthened SHG, cementing its growth and survival for five decades. As such, we follow the insights of Anna Indych-López in her analysis of muralist Judith F. Baca and aim to "depart from much of the rhetoric surrounding community art by acknowledging the fallacy of collaboration and community unification."[57] Indych-López's concept of community and Baca's engagement with it, therefore, avoid the romanticism of earlier Chicana/o/x art histories by addressing the limitations and possibilities that emerge from conflict and critique. Contributors offer a more nuanced understanding of community that exposes the necessity of intersectional analysis. Along with collectivity, SHG also fostered internal critique and witnessed dissent, which frequently generated new collaborations or aesthetic innovations.

At times the multiple and intersecting ideological orientations supported healthy artistic production at SHG and expanded its reach to new audiences and artists. For instance, Sister Karen's pedagogical style required artists to question their compositional choices. Sometimes her intense artist critiques resulted in newfound vitality and creativity, as with Tovar, who deepened his commitment to cultural symbols and abstraction. Multiple artists report their attraction to the vibrant energy they experienced at SHG, in part because of the lively debates.[58] Others found these debates or artist critiques wounding.[59] Chaz Bojórquez reports that Sister Karen initially disliked his graffiti-based art, but after seven years she understood the power of this style and invited him to print *New World Order* in 1994.[60] Margaret Garcia recalls that her experimental approach was originally refused by master printer Stephen Grace and Sister Karen due to concerns about resources, but Garcia was eventually encouraged by master printer Oscar Duardo. In 1986, Duardo supported her application of ink directly on the screen. Eventually, this innovative monoprint technique became an important formal strategy for SHG printmakers.[61]

Even signature programs and the role of foundational figures were the subject of debate at SHG. Davalos wonders why the arts organization did not publicly acknowledge its queer cofounders, Bueno and Ibañez, during the 2008 atelier, which honored gay Latino/x artists.[62] No one will speak publicly about the reasons for their departure in 1977. As JV Decemvirale's essay indicates, it is unknown whether Sister Karen's expansive sense of community knowingly welcomed Ibañez and Bueno, as queer artists, or simply provided "self-help" to two Mexican migrants with few resources. However, subsequent gay artists, such as Teddy Sandoval, Joey Terrill, Alex Donis, and Miguel Angel Reyes, negotiated queer identities and aesthetics in the 1990s and into

FIGURE 0.9

Harry Gamboa Jr., *Locked Out*, 2005. Digital photograph. © 2005 Harry Gamboa Jr. Courtesy of the artist.

the twenty-first century. Robb Hernández's essay pays homage to their collaborative portfolio, titled *Homombre LA* (2008), and how it tells of the pride but also the "death worlds" these artists inhabit as a result of the AIDS epidemic.

For nonprofit management, "founder's syndrome" can be a major risk—that is, obstacles are anticipated when a charismatic leader departs from an institution. Although the unexpected death of Sister Karen in 1997 was traumatic for the SHG community, the fidelity of the artists and the leadership sustained the arts organization.[63] While the organization never returned to the comprehensive leadership that Sister Karen could provide as both an artist and an administrator, SHG artists and leaders ensured its survival, even through contestation. Tomas Benitez led SHG as an executive director (1997–2005) and relied on Christina Ochoa to develop exhibition programming and master printer Oscar Duardo to support artistic production.[64] After Sister Karen's passing, the once inactive and largely nominal board of directors became increasingly involved in operations. In 2005, the SHG board decided it could not operate without liability insurance, which had lapsed from nonpayment, and they closed the facilities. Harry Gamboa Jr.'s photograph of the padlocked structure became a symbol of the tragedy (fig. 0.9). Community outrage and pressure from artists led to the formation of an emergency board of directors with Armando Durón, collector and arts advocate, at the helm.[65]

FIGURE 0.10

Self Help Graphics & Art's building at 1300 East First Street, Los Angeles, ca. 2016. Courtesy of Self Help Graphics & Art.

Mary Thomas argues that SHG emerged as a locus of creative exchange between Chicana/o, African American, and Asian American communities. Looking at the Watts riots, the multiethnic history of Boyle Heights, and the 1992 LA uprising, she reflects on the social conditions and injustices that forged artistic and political coalitions during and after the civil rights movement. Her essay examines prints created at SHG by African American artists such as Alonzo Davis, Noni Olabisi, and Mark Steven Greenfield and the cross-institutional project "Finding Family Stories." She also considers the visual political solidarity during the pandemic that began in 2020. By revisiting these

moments of collaboration, exchange, and political empowerment, Thomas stresses how they informed SHG's mission toward inclusivity and cross-racial solidarity.

The second section of the book looks to historicize the Professional Printmaking Program. As mentioned, SHG's atelier became the cornerstone of a burgeoning Latinx graphic arts movement. But scholars have yet to fully analyze the impact of this residency program. Our contributors focus on how the atelier led a quest for experimentation, advanced Chicana/Latina feminist art, reckoned with the AIDS crisis, and served as an engine of avant-garde aesthetic trends in Chicana/o/x art.

Claudia Zapata analyzes the impact of the Maestras Atelier, which began in 1999 to remedy the gender imbalance in a printmaking field dominated by male artists. Their research reveals how the initiative increased the representation of women of color in printmaking. Perhaps more importantly, it forged intergenerational mentor networks that produced novel feminist frameworks for these artists. By examining their prints, Zapata explores the artists' quest for a radical female lineage, appeals to women of color iconicity, and self love in reclaiming the erotic female muse. They argue that the artworks born of this exchange subvert the paradigms of white feminist art history, challenge the patriarchal limitations of early Chicano art, and show the formal innovations that women artists contribute to the field.

Robb Hernández examines the first gay-male-themed atelier at SHG, *Homombre LA* (2008). Curated by Miguel Angel Reyes, this atelier brought together a group of artists whose work speaks to the vibrancy of queer Latinx Los Angeles as well as the lasting impact of the AIDS crisis. Through a close reading of prints by Alex Donis, Jef Huereque, and Rigo Maldonado, Hernández considers how forms of state-sanctioned violence, from police harassment to the antiretroviral therapies administered by the FDA, regulate the life, health, and survival of queer men. He reveals the "death worlds" these men inhabit and pushes against the normative understanding of early Chicano art history's heterosexist paradigm by demonstrating how homoerotic sensibilities were central to the organization's founding.

Karen Mary Davalos considers SHG's broad impact on the advancement of Chicana/o/x aesthetics. While this artistic field has often been read through the lens of political art, at the expense of its sophisticated lexicon, Davalos identifies vangardist tendencies that have emerged from the experimental atelier production. In particular, she foregrounds how this artmaking engendered novel forms of West Coast conceptualism, queer art, *rasquachismo*, abstraction, minimalism, *domesticana*, *punkero*, and psychedelic art. Davalos stresses how these experiments in print blended multiple styles that are attentive to the cultural hybridity of the artists' social context. Centering these aesthetic maneuvers, Davalos refutes essentialist readings of Chicana/o/x art by demonstrating the versatility of this field and how its ongoing evolution has been shaped by SHG.

The final section of the book looks to historicize the national, transnational, and international impact of SHG. Contributors ask broad questions: How does the art produced at SHG seek to establish forms of solidarity and shared political consciousness with other sites across the globe? How does it contribute to new diasporic formations in Los Angeles? How have SHG touring exhibitions internationalized Chicanx and Latinx aesthetics once thought to only serve local and regional audiences? The section concludes with a discussion of how the art produced at SHG creates an alternative art market intent on reciprocity, sustainability, and community empowerment.

Kency Cornejo reframes the first two decades of SHG as coinciding with an increase in US interventions in Central America. As part of its Cold War efforts to prevent the

spread of communism and left-leaning governments, the United States launched counter-insurgency campaigns, sending US military advisors and training Central American soldiers in scorched-earth strategies that sent Central Americans fleeing for safety. In a long-overdue discussion of the Central American history of SHG, Cornejo examines how Los Angeles became a primary site of refuge and how this new demography altered the politics of *latinidad* as well as the art being produced at SHG. Tracing the connections of SHG exhibitions and the national campaign *Artists Call Against US Intervention in Central America*, the solidarity tourism that encouraged SHG artists to travel to Nicaragua, and the mentorship that recently arrived Central American artists received at SHG, Cornejo sheds light on one of the most unexplored aspects of SHG history.

Olga U. Herrera likewise expands on the international dimensions of SHG exhibitions and artistic exchanges at the height of globalization in the 1990s. In tracing the impact of SHG in the global circuits of art, Herrera is attentive to how Sister Karen's training abroad exposed her to international art trends and the need for artists to exhibit and travel outside of the United States. She revisits the SHG curatorial project *Chicano Expressions: Serigraphs from the Collection of Self Help Graphics* (1993), which brought Chicana/o/x art to audiences in postcolonial Africa in the wake of decolonization movements, and to European audiences reckoning with the five hundredth anniversary of contact with the Americas. Herrera makes the case for positioning SHG at the forefront of internationalizing the Chicana/o/x avant-garde.

As mentioned above, a conversation with cultural anthropologist and Latinx studies scholar Arlene Dávila concludes this volume, in which she underscores how creative spaces like SHG create infrastructures of value for Latinx artists. The conversation addresses the tension between art and commerce that is often felt by organizations that originated in social movements of the 1960s and '70s, how a shifting landscape in public art funding led organizations to create revenue streams, and how this structural change empowered artists to seek forms of economic autonomy. Dávila outlines some of the key interventions that SHG established in order to create and increase value, particularly in the field of printmaking, but she likewise hints at the future work that lies ahead for the organization and for the larger arts ecosystem to foster sustainability and a more equitable art world.

We end this introduction with an important clarification. This anthology does not make a case for inclusion in the mainstream art system, which would imply that SHG and its artists contribute art identical to that already included in the dominant art world. Such a perspective or goal does little to dismantle the inherent racial privileging of the status quo and the hegemony of the contemporary art world. Rather than accept terms of inclusion that reinscribe white supremacy, heteropatriarchy, and transphobia, the authors spotlight SHG as an arts organization that might help us reimagine a more just and equitable art world. SHG's history forges solidarities across racial and ethnic communities, genders, sexualities, geographies, and aesthetic styles.

As John A. Powell theorizes about social transformation, SHG produces more than "voices for their communities or their worlds. [SHG] . . . participate[s] in the making of the whole society and the selves that inhabit it."[70] As a critical node of the living Chicanx and Latinx ecosystem of artmaking, SHG collaborations are aesthetic, relational, and intergenerational. This book documents those intangible registers and future-forward potential to alter what is currently an inequitable and unsustainable art world. After fifty years, SHG has its own metrics for determining artistic value, while upholding dignity and justice, and as these pages suggest, its celebration is well deserved in the present and future.

NOTES

This anthology presents the outcome of a five-year collaborative research project designed, in true SHG fashion, to stress the sharing of resources, constructive criticism, and rigorous attention to the social context that informs aesthetic innovation at SHG. We would like to thank each of our contributors for their steadfast commitment and insightful essays. We also wish to thank the many interlocutors, across the field of Latinx art history, who helped refine the aims of the book, including the two anonymous peer reviewers and Theresa Avila, Julia Fernandez, and Bernardo Ramirez Rios. Initial drafts of these essays benefited from the generous feedback of colleagues at the sixth biennial Latino Art Now! conference in Houston in April 2019. The group also convened in October 2019 at the University of Notre Dame with the support of the Institute for Latino Studies and the Institute for Scholarship in the Liberal Arts. We would like to express our sincere gratitude to our home institutions in the Midwest, the University of Notre Dame and the University of Minnesota, Twin Cities, for their unwavering support in advancing scholarship on Latinx art.

1. A *master printer* is a skilled printer who has completed an apprenticeship or other formal training and who directs the technical portion of a printmaking studio. Some master printers collaborate with artists who may have little or no prior knowledge of printmaking techniques, helping them develop their ideas and imagery into original prints. For example, Tamarind Master Printers must complete a two-year program of advanced technical printing, research, editioning, and collaboration. SHG has had four master printers since it established a professional printmaking program: Stephen Grace, Oscar Duardo, José "Joe" Alpuche, and Dewey Tafoya. As Anthony Griffiths points out, "the printer is the unsung hero of all the printing processes," and the master printers of SHG have introduced a great number of artists to the fine art tradition of silk-screen printing. See Anthony Griffiths, *Prints and Printmaking: An Introduction to the History and Techniques* (Berkeley: University of California Press, 1996), 34; Marjorie Devon, *Tamarind: 40 Years* (Albuquerque: University of New Mexico Press, 2000), 180.

2. The terms to identify the Mexican-heritage population living in the United States are contested. We honor this anthology's contributors' selected terms. In our introduction, we aim to acknowledge the limitations of heteropatriarchy and transphobia by our use of inclusive terms such as *Chicana/o/x*, clearly intended for print and open for debate. Among many SHG artists, *Chicano* and *Chicana* are terms that signal Indigenous heritage and contemporary populations in

the Americas. We take the side of inclusion and refuse "genderblind sexism" over complicated or unclear pronunciation. See Nicole Trujillo-Pagán, "Crossed Out by LatinX: Gender Neutrality and Genderblind Sexism," *Latino Studies* 16, no. 3 (2018): 396–406.

3. The exhibition, titled *southwestNet: Shizu Saldamando*, ran from May 18 to October 13, 2019. For an overview of the artist's practice, see Carolina A. Miranda, "Painter Shizu Saldamando Puts a Face to L.A.'s Latinx Art and Punk Scenes," *Los Angeles Times*, February 18, 2020; Shizu Saldamando, "On Art and Connection," *Asian Diasporic Visual Cultures and the Americas* 4 (2018): 321–27; Karen Rapp, ed., *When You Sleep: A Survey of Shizu Saldamando*, with essay by Raquel Gutiérrez (Monterey Park, CA: Vincent Price Art Museum, 2013).

4. Shizu Saldamando, email communication with Tatiana Reinoza, August 28, 2020.

5. The official archive of SHG is housed at the University of California, Santa Barbara Library, Department of Special Research Collections, California Ethnic and Multicultural Archives (CEMA). It includes art produced at SHG, administrative records, and documentary photographs of programs and events of SHG. We acknowledge the foresight of former CEMA director Salvador Güereña for this stewardship.

6. Previous scholarship includes the following: Shifra M. Goldman, "A Public Voice: Fifteen Years of Chicano Posters," *Art Journal* 44, no. 1 (Spring 1984): 50–57; Kristen Guzmán, "Art in the Heart of East L.A.: A History of Self Help Graphics and Art, Inc., 1972–2004" (PhD dissertation, University of California, Los Angeles, 2005); Kristen Guzmán, "Art in the Heart of East Los Angeles," in *Self Help Graphics & Art: Art in the Heart of East Los Angeles*, 2nd ed., edited by Colin Gunckel (Los Angeles: UCLA Chicano Studies Research Center Press, 2014), 1–30; Colin Gunckel, "Art and Community in East L.A.: Self Help Graphics & Art from the Archive Room," *Aztlán: A Journal of Chicano Studies* 36, no. 2 (Fall 2011): 157–70; Reina A. Prado Saldivar, "Self Help Graphics: A Case Study of a Working Space for Arts and Community," *Aztlán: A Journal of Chicano Studies* 25, no. 1 (2000): 167–81; Lara Medina and G.R. Cadena, "Días de los Muertos: Public Ritual, Community Renewal, and Popular Religion in Los Angeles," in *Horizons of the Sacred*, edited by T.M. Matovina and G. Riebe-Estrella (Ithaca, NY: Cornell University Press, 2002), 69–94; Sybil Venegas, "The Day of the Dead in Aztlán: Chicano Variations on the Theme of Life, Death and Self-Preservation," in *Chicanos en Mictlán: Día de los Muertos in California*, curated by Tere [Terezita] Romo (San Francisco: The Mexican Museum, 2000), 42–54; Chon A. Noriega, ed., *Just Another Poster? Chicano Graphic Arts in California* (Santa Barbara: University Art Museum, University of California, 2001); Regina M. Marchi, *Day of the Dead in the USA: The Migration and Transformation of a Cultural Phenomenon*, 2nd ed. (Newark, NJ: Rutgers University Press, 2022); Michelle L. López and Victor Hugo Viesca, eds., *Entre Tinta y Lucha: 45 Years of Self Help Graphics & Art* (Los Angeles: Fine Arts Gallery of California State University, 2018). Private collectors have also written about SHG and the value of its prints. See Gilberto Cárdenas, "Art and Migration: A Collector's View," in *Caras Vemos, Corazones No Sabemos = Faces Seen, Hearts Unknown: The Human Landscape of Mexican Migration*, edited by Amelia Malagamba-Ansótegui (Notre Dame, IN: Snite Museum of Art, University of Notre Dame, 2006), 103–14; Harriett and Ricardo Romo, "Four Decades of Collecting," in *Estampas de la Raza: Contemporary Prints from the Romo Collection*, edited by Lyle W. Williams (San Antonio, TX: McNay Art Museum, 2012), 13–22.

7. C. Ondine Chavoya and David Evans Frantz, eds., *Axis Mundo: Queer Networks in Chicano L.A.* (Los Angeles: ONE National Gay & Lesbian Archives at the USC Libraries; Munich, Germany: DelMonico Books/Prestel, 2017); Cary Cordova, *The Heart of the Mission: Latino Art and Politics in San Francisco* (Philadelphia: University of Pennsylvania Press, 2017); Karen Mary Davalos, *Chicana/o Remix: Art and Errata since the Sixties* (New York: NYU Press, 2017); Arlene Dávila, *Latinx Art: Artists, Markets, and Politics* (Durham, NC: Duke University Press, 2020); Ella Maria Diaz, *Flying Under the Radar with the Royal Chicano Air Force: Mapping a Chicano/a Art History* (Austin: University of Texas Press, 2017); Laura E. Pérez, *Eros Ideologies: Writings on Art, Spirituality, and the Decolonial* (Durham, NC: Duke University Press, 2019); Jennifer Ponce de León, *Another Aesthetics Is Possible: Arts of Rebellion in the Fourth World War* (Durham, NC: Duke University Press, 2021); Terezita Romo, *Malaquias Montoya* (Los Angeles: UCLA Chicano Studies Research Center Press, 2011).

8. Edward W. Soja, *Postmodern Geographies: The Reassertion of Space in Critical Social Theory* (New York: Verso, 1989), 191.

9. Shifra M. Goldman, for example, challenged the commercial strategy of arts organizations, implying that marketing peddled to the elite and art market, contradicting the ethos of the Chicano Movement (Goldman, "Public Voice," 56–57). Yet, as artists have demonstrated over the past five decades, creative expression can engage many styles and remain deeply informed by and critical of power dynamics. See Karen Mary Davalos, "Looking at the Archive," in *Chicana/o Remix*, 63–96.

10. In his comparative analysis of art and social movements in Mexico and the United States (primarily California), Edward McCaughan notes that SHG, along with three other cultural centers in California, survived due to the "mass-based, multifaceted movement" over two decades and "progressive politics in California [which] gave rise to a wider variety of public and private funding sources." Edward J. McCaughan, *Art and Social Movements: Cultural Politics in Mexico and Aztlán* (Durham, NC: Duke University Press, 2012), 146.

11. Shifra M. Goldman and Tomás Ybarra-Frausto, "The Political and Social Contexts of Chicano Art," in *Chicano Art: Resistance and Affirmation* (Los Angeles: UCLA Wight Art Gallery, 1991), 83–95; Margaret Nieto, "Across the Street: Self-Help Graphics and Chicano Art in Los Angeles," in *Across the Street: Self-Help Graphics and Chicano Art in Los Angeles,* edited by Bolton Colburn (Laguna Beach, CA: Laguna Art Museum, 1995), 21–37; Shifra M. Goldman, *Tradition and Transformation: Chicana/o Art from the 1970s through the 1990s,* edited by Charlene Villaseñor Black (Los Angeles: UCLA Chicano Studies Research Center Press, 2015), 44; McCaughan, *Art and Social Movements,* 146.

12. Dionne Espinoza, "'Revolutionary Sisters': Women's Solidarity and Collective Identification among Chicana Brown Berets in East Los Angeles, 1967–1970," *Aztlán: A Journal of Chicano Studies* 26, no. 1 (2001): 17–58; Eric R. Avila, "The Folklore of the Freeway: Space, Culture, and Identity in Postwar Los Angeles," *Aztlán: A Journal of Chicano Studies* 23, no. 1 (1998): 15–31.

13. Ernesto Chávez, *"¡Mi Raza Primero!" (My People First): Nationalism, Identity, and Insurgency in the Chicano Movement in Los Angeles, 1966–1978* (Berkeley: University of California Press, 2002), 4. Artists of SHG's first decade, such as Richard Duardo and John Valadez, read Mao Zedong's *Little Red Book. Richard Duardo,* interviewed by Karen Mary Davalos, November 5, 8, and 12, 2007,

Los Angeles, CSRC Oral Histories Series, no. 9 (Los Angeles: UCLA Chicano Studies Research Center Press, 2013); *John Valadez,* interviewed by Karen Mary Davalos, November 19 and 21, December 3, 7, and 12, 2007, Los Angeles, CSRC Oral Histories Series, no. 10 (Los Angeles: UCLA Chicano Studies Research Center Press, 2013).

14. George Mariscal, *Brown-Eyed Children of the Sun: Lessons from the Chicano Movement, 1965–1975* (Albuquerque: University of New Mexico Press, 2005), 7.

15. Ibid., 7.

16. Letter to the Campaign for Human Development from Sister Karen Boccalero, August 6, 1974, Self Help Graphics & Art Archives (hereafter SHGA), box 4, folder 6, California Ethnic and Multicultural Archives 3, University of California, Santa Barbara Library (hereafter CEMA, UCSB).

17. "The Early Years, 1970–1985," Michael Amescua, Mari Cárdenas Yáñez, Yreina Cervántez, Leo Limón, Peter Tovar, and Linda Vallejo interviewed by Karen Mary Davalos and Colin Gunckel, in *Self Help Graphics & Art: Art in the Heart of East Los Angeles,* 2nd ed., edited by Colin Gunckel (Los Angeles: UCLA Chicano Studies Research Center Press, 2014), 57.

18. Ibid., 53–54.

19. Laura E. Pérez, *Chicana Art: The Politics of Spiritual and Aesthetic Altarities* (Durham, NC: Duke University Press, 2007), 40–51.

20. George Lipsitz, "Not Just Another Social Movement: Poster Art and the *Movimiento Chicano,*" in *Just Another Poster? Chicano Graphic Arts in California,* edited by Chon A. Noriega (Santa Barbara: University Art Museum, University of California, 2001), 79.

21. Ibid.

22. José Esteban Muñoz, *The Sense of Brown,* edited by Joshua Chambers-Letson and Tavia Nyongo (Durham, NC: Duke University Press, 2020), 2.

23. Davalos, *Chicana/o Remix,* 68–73.

24. Vatican II inspired lay and religious Catholics, including Mexican American and Latina religious leaders, to promote social justice. See Lara Medina, *Las Hermanas: Chicana/Latina Religious-Political Activism in the U.S. Catholic Church* (Philadelphia: Temple University Press, 2004). See Olga U. Herrera's essay in chapter 8 of this volume for the influence of Vatican II on Sister Karen Boccalero.

25. Arlene Dávila, *Culture Works: Space, Value, and Mobility across the Neoliberal Americas* (New York: NYU Press, 2012), 134. See also Yasmin Ramírez, "Nuyorican Visionary: Jorge Soto and the Evolution of an Afro-Taíno Aesthetic at Taller Boricua," *Centro Journal* 17, no. 2 (2005): 22–41.

26. Goldman, "Chicano Art and the Neo-Mexicanist Generation of Mexico," in *Tradition and Transformation,* 45.

27. Medina and Cadena, "Días de los Muertos."

28. Karen Mary Davalos, "Innovation through Tradition: The Aesthetics of Día de los Muertos," in *Día de los Muertos: A Cultural Legacy, Past, Present & Future,* edited by Mary Thomas (Los Angeles: Self Help Graphics & Art, 2017), 21–29.

29. Colin Gunckel, "Vex Marks the Spot: The Intersection of Art and Punk in East Los Angeles," in *Vexing: Female Voices of East LA Punk,* edited by Pilar Tompkins (Claremont, CA: Claremont Museum of Art, 2008), 15.

30. Tompkins, "Ways of Living and Models of Action," in *Vexing: Female Voices of East LA Punk,* 11.

31. For a broad overview of the emergence of printmaking workshops across the United States, see Joann Moser, "Collaboration in American Printmaking before 1960," and Trudy Hansen, "Multiple Visions: Printers, Artists, Promoters, and Patrons," in *Printmaking in America: Collaborative Prints and Presses, 1960–1990,* edited by Elaine Stainton (New York: Harry N. Abrams in association with Mary and Leigh Block Gallery, Northwestern University, 1995).

32. For an extensive discussion of the development of printmaking in Southern California, see Leah Lehmbeck, ed., *Proof: The Rise of Printmaking in Southern California* (Los Angeles: Getty Publications, in association with the Norton Simon Museum, 2011), 10–51.

33. Damon Willick, "Handfuls of Creative People: Printmaking and the Foundations of Los Angeles Art in the 1960s," in Lehmbeck, *Proof: The Rise of Printmaking in Southern California,* 201.

34. Allan Edmunds, interview with Tatiana Reinoza, January 7, 2013, Philadelphia.

35. For more on the artist, see the exhibition catalog *Corita Kent and the Language of Pop,* edited by Susan Dackerman (Cambridge, MA: Harvard Art Museums, 2015).

36. Rachel Heidenry, "Uncovering the Legacy of María Sodi de Ramos Martínez," *East of Borneo,* March 11, 2020, https://eastofborneo.org/articles/uncovering-the-legacy-of-maria-sodi-de-ramos-martinez/.

37. In this volume, the terms *silk-screen, screenprint,* and *serigraphy* are used interchangeably to refer to the same printmaking technique. However, *serigraphy* is often reserved for fine art prints. For more on the medium, see two articles by Reba and Dave Williams: "The Early History of the Screenprint," *Print Quarterly* 3, no. 4 (1986): 287–321; and "The Later History of the Screenprint," *Print Quarterly* 4, no. 4 (1987): 379–403. The curator Carl Zigrosser popularized the term *serigraphy* for fine art prints; see Carl Zigrosser, "The Serigraph, a New Medium," *Print Collector's Quarterly* 28, no. 4 (December 1941): 442–77.

38. For more on Viesulas, see Regina Urbonienė, "Romas Viesulas: De Profundis," in *Romas Viesulas (1918–1986): Grafika/Graphic Art* (Vilnius, Lithuania: Lietuvos dailės muziejus, 2018), 10–78; Marjorie Devon, *Tamarind Touchstones: Fabulous at Fifty* (Albuquerque: University of New Mexico Press, 2010), 176.

39. Boccalero, exhibition pamphlet, La Sula, Galleria d'Arte, Rome, September 1969, https://en.expertissim.com/sister-karen-boccalero-not-tomorrow-lithograph-12212014 (accessed October 1, 2020).

40. Kathleen Hendrix, "Visual Aid: East L.A. Center Helps Bring Artists and Neighbors Together," *Los Angeles Times,* July 27, 1992, E1.

41. Guisela Latorre, *Walls of Empowerment: Chicana/o Indigenist Murals of California* (Austin: University of Texas Press, 2008).

42. SHG has variously described this program as *Experimental Screenprint Atelier, Experimental Silkscreen Atelier, Professional Printmaking Program,* and the truncated *Atelier Program.* This anthology uses the terms interchangeably.

43. Goldman, "Chicano Art and the Neo-Mexicanist Generation of Mexico," 45.

44. Boccalero as quoted in Greg Schneider, "A Conversation with Sister Karen Boccalero, Founder of Self-Help Graphics," *Artweek* 23, no. 21 (August 1992): 16.

45. Tatiana Reinoza discusses the 1996 SHG residency of Pepe Coronado, founder of the Dominican York Proyecto Gráfica, in "The Island within the Island: Remapping Dominican York," *Archives of American Art Journal* 57, no. 2 (Fall 2018): 4–27; and the residencies of Sam Coronado at SHG that inspired his workshop Coronado Studio in Austin, Texas, and residency program Serie Project, in "Printed Proof: The Cultural Politics of Ricardo and Harriett Romo's Print Collection," in *A Library for the Americas: The Nettie Lee Benson Latin American Collection,* edited by Julianne Gilland and José Montelongo (Austin: University of Texas Press, 2018), 150. E. Carmen Ramos also considers how SHG inspired the development of Coronado Studio and the Dominican York Proyecto Gráfica, in "Manifestaciones: Expressions of Dominicanidad in Nueva York," in *Manifestaciones: Dominican York Proyecto GRAFICA* (New York: CUNY Dominican Studies Institute Gallery, 2010). Lyle Williams also traces the connections between Coronado Studio and SHG in "Without Borders," in *Estampas de la Raza: Contemporary Prints from the Romo Collection* (San Antonio, TX: McNay Art Museum, 2012), 25–44. Although Richard Duardo was not an atelier resident artist until 1984, he was certainly present during the early years and founded several print studios in Los Angeles, including Hecho en Aztlan, Aztlan Multiples, and Modern Multiples.

46. John Valadez, Experimental Silkscreen Atelier Evaluation Form-85, SHGA, box 6, folder 4, CEMA, UCSB.

47. Barbara Carrasco, Experimental Silkscreen Atelier Evaluation Form-85, SHGA, box 6, folder 4, CEMA, UCSB.

48. Alonzo Davis, Experimental Silkscreen Atelier Evaluation Form-85, SHGA, box 6, folder 4, CEMA, UCSB. Signed by the artist March 22, 1985.

49. The exhibition history of SHG is an alternative history of Chicana/o/x art, deserving of its own monograph.

50. Rudy Aversa, "Otra Vez Art Gallery to Open Doors Sunday," *Los Angeles Herald Examiner,* April 23, 1976.

51. Cynthia Rose, "A Hope in Hell," *The Guardian,* June 16, 1992.

52. Davalos, *Chicana/o Remix,* 63–96.

53. Christina Ochoa, interview with Karen Mary Davalos, October 14, 2003, in Los Angeles.

54. Constance Monaghan, "Art Event Pick of the Week: Self-Help Graphics, Big Deal Fund-Raiser," *LA Weekly,* June 26–July 2, 1998, 157; Peter Frank, "Gallery Picks of the Week: Chaz Bojorquez, Ellen Brooks," *LA Weekly,* May 5–11, 2000, 16. Unless otherwise noted, quotations in this paragraph are from Christina Ochoa, personal communication with Karen Mary Davalos, July 31, 2020.

55. Christina Ochoa, personal communication, July 31, 2020.

56. See definition of *master printer* in note 1 above.

57. Anna Indych-López, *Judith F. Baca* (Los Angeles: UCLA Chicano Studies Research Center Press, 2018), 33.

58. *Barbara Carrasco,* interviewed by Karen Mary Davalos, August 30, September 11 and 21, October 10, 2007, Los Angeles, CSRC Oral Histories Series, no. 3 (Los Angeles: UCLA Chicano

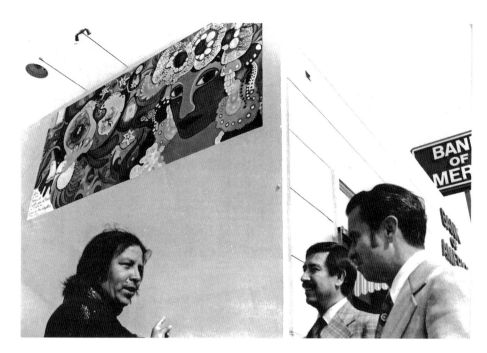

FIGURE 1.1

Carlos Bueno and Bank of America managers in front of *Maria de Los Angeles Novia de Pueblo* on the west wall of
the Bank of America building at 3051 Wabash Avenue, Los Angeles, ca. 1974. Courtesy of Milton Antonio
Jurado–MAJA Collection.

painted on the western wall of the Bank of America building on 3051 Wabash Avenue
in the Chicano neighborhood of City Terrace. Proudly signed "Ibañez y Bueno," a
shorthand for their artistic partnership in Los Angeles, it was most likely the first pub-
lic mural painted by gay, undocumented immigrant artists in Los Angeles County.[3]

The two artists arrived from Mexico City in January 1972 with nearly no English
language facility and little money.[4] In their five years in Los Angeles, from 1972 to 1977,
in collaboration with Sister Karen Boccalero, they initiated SHG's communal art stu-
dio and gallery, the yearly Día de los Muertos multimedia procession, and a full sched-
ule of on-site tours for schoolchildren; and implemented the Barrio Mobile Art Studio,
a modified mobile art van that brought Mexican and Chicano art lessons to public and
institutional sites across Los Angeles.

Moving to City Terrace, the artist couple joined their Chicano colleagues and
friends, like the legendary muralists Willie Herrón and Carlos Almaraz, who painted
some of the first Chicano murals in East Los Angeles in the early 1970s. From the bot-
tom left corner *Maria de Los Angeles* spoke directly to Chicanos, declaring: "*Alma de mis
'Novias de Pueblo' para el Barrio su nombre es Maria de los Angeles*" [Soul of my "Novias
de Pueblo" for the barrio her name is Maria of the Angels], a testament to the artists'
commitment to a Chicano countercultural sphere rooted in Mexican history.

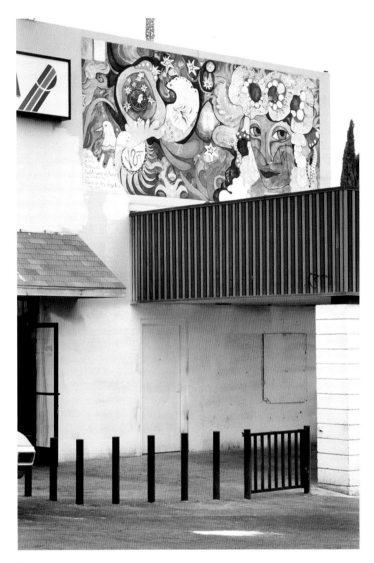

Bueno recalled decades later with great pride that "you heard *la raza* comment: 'Did
you know Carlos Almaraz is painting a mural on Soto? Yes, Willie Herrón is painting
another on so-and-so street and Carlos Bueno on the Bank of America.'"[5]

Ibañez y Bueno's mural offered a vision of Los Angeles as a mixed-race female icon
with profound spiritual and historical roots (fig. 1.5). Playing with the multiple refer-
ences in the city's Spanish name, El Pueblo de Nuestra Señora la Reina de los Ángeles
(The Town of Our Lady Queen of the Angels), *Maria de Los Angeles* envisioned the city
as a place where oppressed histories swirled up and cultural currents collided. In its
imaginative capacity as a mural, it disrupted a seemingly stable and siloed Los Angeles

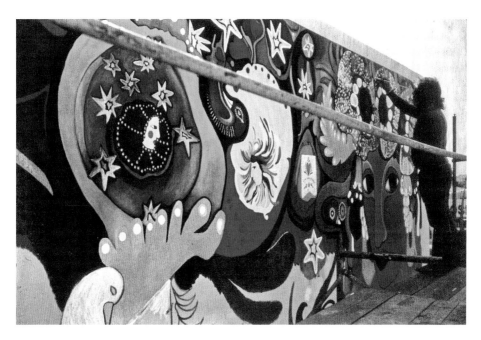

FIGURE 1.3

Carlos Bueno painting *Maria de Los Angeles Novia de Pueblo*, 1974. Courtesy of Milton Antonio Jurado–MAJA Collection.

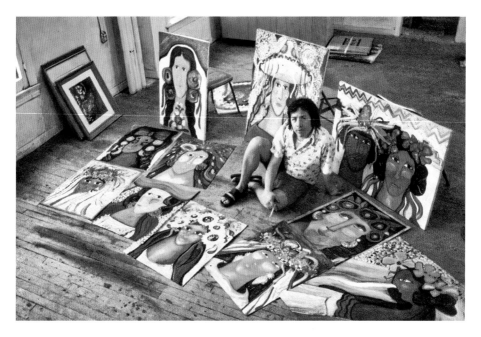

FIGURE 1.4

Carlos Bueno in his studio with the *Novias de Pueblo* series, ca. 1975. Courtesy of Milton Antonio Jurado–MAJA Collection.

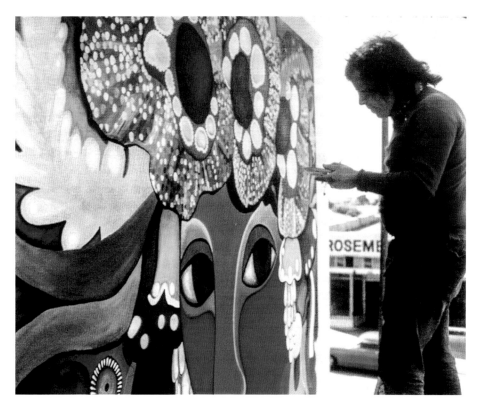

FIGURE 1.5

Carlos Bueno painting *Maria de Los Angeles Novia de Pueblo*, 1974. Courtesy of Milton Antonio Jurado–MAJA Collection.

> Simply disrupting the norm through its presence

by simultaneously articulating Indigenous, Mexican, and Spanish times and spaces for a specifically Chicano audience. They were histories that were barely acknowledged or memorialized in the city's civic imagination or urban landscape as it had been reconfigured by Anglo American settlers. ——> erasure through colonization

While the major trends among their Chicano contemporaries focused on memorializing Chicano life and depicting a revolutionary Chicano body politic in motion, Bueno worked in a branch of the Mexican muralist tradition that focused on rural and folkloric visual vocabularies. Bueno's informal studies in Cuernavaca and Guerrero likely exposed him to Indigenous patterns and symbols of the Mexican countryside. Art historian Shifra Goldman described the impressive range of Mexican *artesanía* in Bueno's work, in which "one finds the complexity of Hispanic-Moorish *retablos*; whimsical bark paintings from Guerrero; flowered lacquer work from Michoacán; *petatillo* earthenware from Tonalá; or the Talavera ware of Puebla."[6] In its highly stylized and tempestuous landscape, the mural calls forth the ancient and living symbols of Mexican Indigenous textiles, pottery, and customs: *alebrijes* (mythical mixed-body animals), birds, flowers, moons, suns, and arabesque vegetation. This symbology is markedly different from the

different set of cultural-geographic points reorients the mapping of socially engaged artmaking in the United States so as to give equal consideration to the parallel Mexican art traditions.

IBAÑEZ Y BUENO AND THE AVANT-GARDES OF MEXICO CITY AND LOS ANGELES, 1950s–1970s

Born in 1941 in Cuernavaca, Mexico, Carlos Bueno Poblett spent his childhood between his grandparents' ranch and Mexico City, enjoying the pleasures and customs of both city and country life. He moved to Mexico City in 1958 to pursue studies as an actor but was ultimately persuaded by his family to take up another profession, enrolling at the Escuela Nacional de Artes Plásticas in 1960. Attending one of Mexico's most well-known art academies, Academia San Carlos, where generations of muralists like David Alfaro Siqueiros had trained, he took classes in painting, muralism, live model drawing, engraving, and perspective for two years, but never completed his degree.

In video recordings and unpublished interview transcriptions, Bueno does not detail much about his Mexico City years or training, beyond mentioning some of the jobs he held and that this was where he met his artistic and romantic partner, Antonio Ibañez González.[15] Little is known about Ibañez's life. While Bueno is poorly represented within the SHG archive, Ibañez is almost absent. Based on the few archival materials and interviews with Bueno, it is known that Ibañez was a photographer, sat in on some classes with Bueno, and was a *chilango*, a native of Mexico City. Lifelong partners, they were not open about their homosexual relationship, and close friends describe Bueno as repeatedly denying any sexual involvement with Ibañez.[16]

From 1958 to 1972, they lived through two distinct moments in Mexican art history: the generation of artists in the 1950s and '60s that rejected the Mexican muralists' government-affiliated model, and the avant-garde practices that emerged in the repressive political climate of the late 1960s and '70s. Artist and provocateur José Luis Cuevas's 1959 landmark text "The Cactus Curtain" describes the art world of which Bueno and Ibañez were a part and is generally considered to capture the frustrations of a generation of Mexican artists in the 1950s and '60s. According to Cuevas, artists felt conflicted and stunted behind the "cactus curtain," his term for the self-assured and jingoistic conformity that sanctified the artistic formulas and political agendas of the Mexican muralist school as beyond reproach. Believing that the revolutionary politics and government frameworks for mural commissions had become far too restrictive, artists like Cuevas chose alternative exhibition spaces and spectacular publicity tactics, turning more and more toward international avant-garde styles like abstract expressionism and pop art.

The Tlatelolco student massacre of 1968 would shock and shift the tenor of artistic practice as the Mexican government initiated a dirty war on dissidents, students, organizers, and intellectuals who protested or criticized the Gustavo Díaz Ordaz regime. While still professing the revolutionary ideals of the Mexican Revolution, the

Mexican government began disappearing and torturing leftist critics, protest leaders, students, and countercultural dissidents. The drastic shift in Mexican cultural politics from 1968 to 1972 would have made Ibañez and Bueno targets for police harassment and arrest. Bueno described himself as a *jipi* (hippie) artist who sported long hair and dressed like Marlon Brando's rebellious and leather-clad character in László Benedek's *The Wild One*. Despite the experimentation and international influences in the art scene, Mexico City became increasingly dangerous for those exhibiting any rebellious fashions, lifestyles, attitudes, or artworks.

The avant-garde practices of the 1960s were short lived. The political events of the post-1968 years set the stage for a generational shift among Mexican artists, who began working collectively and collaboratively on interventionist, conceptual, and community art projects in the 1970s. Both intimidated by and highly critical of the government's disappearing of dissidents, some two hundred artists banded together in independent groups to form a loosely organized assembly that would come to be known as Los Grupos. Working in a nearly uncategorizable range of styles, there was a common joy in mixing political activism, institutional critique, installation, guerrilla street performances, and public art projects to fit particular contexts within Mexico City's politically charged cultural landscape. This politically motivated break from the traditional, government-structured mural model gives context to Ibañez and Bueno's Mexican aesthetic lineage, and might equally account for their banding together as *Ibañez y Bueno,* a philosophy of collaboration that was essential to an artist's survival in Mexico City and that would later prove crucial in the comparable "war zone" of East Los Angeles.

The historical lineages that art historians have proposed for Los Grupos are as varied as the public art strategies the groups developed. It is generally agreed, however, that Los Grupos explored the alternative venues and circuits for artworks, with many staging "projects outdoors in the midst of urban chaos," as Rubén Gallo has characterized it.[17] Felipe Ehrenberg, a member of Grupo Processo Pentágano, one of the first *grupos* to form (in 1973), described the public art ambitions as "an unusual sense of urgency to make direct connections with the man on the street and confront the conflicts imposed on him by our societies."[18] Ehrenberg would himself make a series of prints at SHG in the 1980s and spoke of Sister Karen's work with great admiration.[19] With the government-funding model of the Mexican muralist school no longer an option for Los Grupos, they brought their practices out into the open theaters of the streets of Mexico City in ways that ultimately advanced the muralist vision of a public art.

It was a practice in keeping with a more performative reading of the muralist tradition, as advocated by scholars like Bruce Campbell and Victor Sorell. Both argue that murals are best understood, in the words of Sorell, as a "processual undertaking involving many individuals in their conception."[20] Instead of an art historical paradigm privileging the objecthood of murals, Campbell suggests a more expansive and performative definition: a "method of muraling."[21]

Muraling encapsulates the performance of making and consuming a mural in the public sphere, along with the elements that activate and support the work, like using the mural as a memorial, as a starting point for protests, or for public education. Seeing a mural's socially engaged performativity reactivates the putatively contained mural object into an expanded ecology. Moving beyond the limits of its objecthood, it becomes what Sorell defines as a ritual site, in keeping with the expanded muralist practice of Los Tres Grandes in the United States in the 1930s, when the muralists made enormous advances in their public art initiative and left an indelible mark on socially engaged art history in the United States.

Los Grupos members like Tepito Arte Acá (founded in 1974), a group of painters from the Mexico City barrio of Tepito, continued this public art mandate when they used muraling as an opportunity to teach and collaborate on mural making with the residents of the impoverished neighborhood of Tepito. As Campbell identifies, Tepito Arte Acá, like many members of Los Grupos, were devoted to using art to serve, teach, and foster connections with communities "marginal to the art world" by developing the mural tradition's inherent performativity, which blurred divisions between artist, audience, and artwork and expanded the range of locations in which murals were created.[22]

Ibañez and Bueno left for Los Angeles one year before the first *grupo* formed in 1973. Imagining the artist couple as generating their own *grupo* in the form of SHG gives their artistic collaboration an art historical place and political agency that could not be seen from the American archives where their piecemeal memories have survived. The imagined connection also works to bring SHG into conversation with Los Grupos. From Mexico City to East LA, the family resemblance between the two sets of community art practices is notable. Both intended to break away from singular authorship, work with marginalized communities, address real political issues in everyday spaces, and redefine standardized artist-community models.

Sharing the same formative social, political, and artistic experiences with their Mexican colleagues, Ibañez and Bueno drew from a common set of Mexican cultural reservoirs and traditions to form their artistic responses to the crises they saw in their new neighborhood. On arriving in East LA, they saw that a younger generation of Chicano artists were also rebelling against and advancing muralism. Moving from Mexico City to East LA was to reenter a similar set of debates on the other side of the border, and the artist couple brought their own knowledge of those traditions and debates to the Chicano Art Movement.

THE EXPANDED SPATIALITY OF CHICANO MURALISM

Mexican muralism opened up a new set of socio-spatio-aesthetic problems for many Black and Chicano artists in the United States throughout the twentieth century. Artists based in the United States did not necessarily see the work of the Mexican mural-

ist school as institutionalized or compromised by government support as their Mexican counterparts did. Many Black and Chicano artists viewed the Mexican muralists as heroes who developed a new model of politically engaged artistry for life's sake.

According to art historians Anna Indych-López and Laurance Hurlburt, when Los Tres Grandes temporarily left Mexico due to a pause in government funding, they further democratized muralism by painting some of their most publicly accessible murals in the United States.[23] David Alfaro Siqueiros, for example, painted his first street mural in Los Angeles; he also opened his Experimental Workshop in New York City, a studio where, among other mural-based experiments, he and his students collaboratively designed artworks, banners, and floats intended for parades, memorials, and protests against economic injustice.[24] The Mexican muralist school's revolutionary rhetoric often outpaced the reality of its practices, and Mexican artists were particularly critical of that; from a Black and Chicano perspective, though, the muralists' practices were revered.

The Mexican mural tradition was the quintessential democratic art form for many Chicano artists of the 1970s. It offered deep connections to postrevolutionary Mexican politics and art history, as well as a Mexican cultural and historical imaginary from which artists drew and whose political positions they emulated. Subsequent generations, however, identified certain patterns within the muralist tradition as hackneyed or too reliant on a formulaic political identity and artistic vocabulary. Both Chicano and Mexican artists of the 1960s and '70s responded critically to that tradition, but not all critiques were a simple renunciation in toto. Instead, some explored the expanded spatiality of muraling to enact rituals, programs, and collaborative projects.

The best-known examples of this tension were the Chicano art collective Asco's early performances. Criticizing what, to them, appeared to be a traditional and conservative artistic tradition, echoing some of their colleagues in Mexico City, they processed down Whittier Boulevard in full costume as the Virgin of Guadalupe, a Mestizo, and a Christmas Tree in their *Walking Mural* (1972) performance. That same year, in their characteristic irreverence, the group experimented with the mural's objecthood in their *Instant Mural* (1972), lightly taping two members of their group to a wall as a tongue-in-cheek mural performance.[25] They were the first artist group in Los Angeles to extend the spatial and performative possibilities of muraling beyond the wall, whether as a renunciation of muralism or as a playfully antagonistic gesture.

It was not just those who were rebelling against the tradition who began to mobilize murals. Judy Baca, firmly aligned with the Mexican muralists, in particular with Siqueiros, was also experimenting with muraling. Baca's collaborative muralist practice unfixed the seeming immobility of the mural into what Indych-López characterizes as a "transient practice" that was part of a broader Chicano network's creation of a "new form of public art."[26] As Indych-López points out, Baca began to reenvision

her collaborative muralist practice as one producing social space, an approach that is arguably in line with the public art experiments of Mexico's generation of post-muralist artists.[27]

Chicana artist Sandra de la Loza, speaking of this very same moment, identifies the important work Chicano murals did "at the edge of architectural space."[28] Carving out a new spatiality and social relations through the process of muraling, artists were performing spatial and artistic activism in parts of the city where both small and large-scale gatherings of Chicanos could draw police harassment or arrest. De la Loza in her contemporary practice has experimented with this spatial framework to conduct decolonial projects throughout the city, resurrecting and making public the buried and overlooked histories of Los Angeles. The artist explains: "Within this new space a social architecture emerges that allows for cultural recognition and regeneration, the resurfacing of suppressed imagery and knowledge, and the imagining of new subjectivities. Space is transformed into place."[29] The power of aesthetic frameworks to change perception and to support cultural conviviality, as de la Loza does, requires an expanding of the liminal space where the material merges with the social.[30]

De la Loza's expanded muralism aligns with Sorell's idea of a "ritualistic muralism," which he sees as epitomized in the *Wall of Respect* (1968), a mural and performance created by Black artists in Chicago celebrating Black historical and cultural achievements.[31] As de la Loza proposes, the liminal spaces of Chicano muralism were fecund reservoirs that initiated experimental cultural practices that would become central to the Chicano Art Movement. But while Asco aggressively pushed the characters or mural "material" into the real spaces of Chicano life, it was the community art centers that built the scaffolding for public theaters where staged rituals, performances, and a broad range of Chicanidad would be enacted.

Whereas performance artists like Asco began chipping away at the materiality of muralism, and Los Grupos attempted to bring art "to the man on the street," the community art centers in East Los Angeles began diligently expanding the spaces and histories of muraling into permanent places where, as de la Loza describes, new subjectivities, imagery, and knowledge could be enacted and spatialized. Central to expanding this social architecture were art centers like Mechicano Art Center, Goez Art Studios & Gallery, and SHG, all of which facilitated public art works like murals, exhibitions, and social practice projects. Muralist and Goez cofounder Joe Gonzalez described his own "for-profit nonprofit" and large-scale collaborative mural projects as "picking up" where the Mexican muralists left off.[32]

This community art space initiative took the form of different projects across the Chicano Art Movement, and although we know the large-scale mural projects best, the projects extended beyond muralism. Just as *Maria de Los Angeles* was envisioned as part of a larger project of reenvisioning Los Angeles, so did SHG's Día de los Muertos and Barrio Mobile Art Studio continue the work of carving out public spaces and developing ritual practices to convert urban spaces into Chicano-affirming places.

THE ARTS OF *ACOMPAÑAMIENTO:* DÍA DE LOS MUERTOS AND BARRIO MOBILE ART STUDIO

From its very beginning, SHG developed a method of cultural work based in a radical ethics of care and camaraderie, as Kency Cornejo also argues in this volume. Its approach to cultural work differed distinctly from the Euro-American avant-garde's preference for antagonism and deconstruction, which arguably laid the foundation for the problematic relational models at the heart of contemporary social practice. Models such as the "drop-in" artist, commissioned to "collaborate" with a community to produce a product, more often than not left those communities (and later scholars) questioning the power dynamics of their participation. What undergirded this thinking were several assumptions about readymade groups of people, as well as the larger question as to whether or not such interventions were even needed.

SHG's approach was based in what Sister Maria Elena Martinez, a lifelong friend of Sister Karen and fellow Sister of St. Francis, described as *acompañamiento.* An unorthodox mixture of religious and artistic life, it was a socially engaged form of cultural work based in accompanying the cultural practices of a selected community. Sister Karen's example was so remarkable that Sister Maria Elena credits it as the model for her own religious work with Indigenous women in Chiapas, Mexico.[33] Instead of devoting her life to converting the communities she served, Sister Maria Elena saw it as her religious duty to listen, learn from, and walk with the women in Chiapas, to accompany them on their specific fights against anti-indigeneity, and to support their struggle to keep their ways of being and knowing alive.

This model of nonproprietary support for all manner of cultural-political projects was an uncommon model within a cultural sector that values distinction and gatekeeping. For Sister Karen, it was part of her cultural political project to make art (and its institution) pro-human. Trained in a progressive Catholic art tradition that worked to democratize art and questioned both the legitimacy and usefulness of its orderings and classifications, Sister Karen was the inheritor of a rebellious aesthetic tradition initiated by her mentor, Sister Corita Kent, at the Immaculate Heart College (IHC) Art Department in Hollywood, California. The department's philosophy was summarized in the IHC Art Department motto: "We have no art, we do everything as well as we can." The now legendary IHC Art Department was the source for the collaborative studio model SHG adopted, and provided some of its core tenets: that everyone is an artist and participant, that the rules sanctioning and separating certain creative practices from life should be dismantled, and that art is a creative framework for relating, knowing, and changing the world.

Beginning in her hometown of Boyle Heights, Sister Karen, in true Franciscan fashion, extended the life-affirming potentials of such a model directly to the socially and economically marginalized neighborhoods of East Los Angeles. Attempting to replicate the freedom and utopian camaraderie that she felt in the IHC Art Department, she would test this philosophy beyond the safety of the convent and campus. Pushing

art out of its traditional spaces to serve the poor required new skills and meant forfeiting models dependent on those traditional art spaces. Stepping away from the idea that cultural infrastructure was not part of an artist's work, Sister Karen began her lifelong practice of accompaniment.

Accompaniment has a longer history in liberation theology, a radical theology based in Latin America Catholicism and best known through the figures of Salvadoran Archbishop Óscar Romero and Peruvian theologian Gustavo Gutiérrez. Liberation theology posits that it is every Christian's responsibility to liberate the poor from their oppression and economic dependencies. Because Sister Karen's personal archive was never preserved, we can only rely on interviews with colleagues and her own work to describe what was either a full-on liberation theologist approach or a parallel theology she developed in practice as a Franciscan. While much can be attributed to her role as a nun, it was in aligning her own artistic capacities with her religious values that she began to envision putting art, and her role as artist, to different uses.

SHG's first few years testify to this shift. Sister Karen invited Ibañez and Bueno to live with her in the Sisters of St. Francis of Penance and Christian Charity's modern-day convent in City Terrace. Equally telling, the first exhibition the trio arranged in 1972 excluded Sister Karen and focused on Ibañez y Bueno's work.[34] By the time the organization moved into its first building, Sister Karen had morphed her creative capacities toward facilitating the infrastructures of support that would become hallmark characteristics of SHG's approach. As this new creative form of placemaking grew, the traditional, studio-based-artist model in which she had been trained slowly disappeared.

Accompaniment was not just for the religious life. It was Sister Karen's example that informed Ibañez y Bueno's own creative practice to serve the poor. Borrowing from the life of Archbishop Romero, scholars Barbara Tomlinson and George Lipsitz have likened accompaniment to "participating with and augmenting a community of travelers on a road."[35] Accompaniment is a multipart method of forming new methods of relating. As Tomlinson and Lipsitz explain, "accompaniment organized around the preferential option for the poor . . . can produce seemingly unlikely alliances, associations, affiliations, conversations and coalitions with aggrieved and excluded individuals and groups."[36] In the hands of Sister Karen, Ibañez, and Bueno, it would indeed form an unlikely alliance, as well as generate an aesthetic—rules for being an artist in the world—that resulted in two of the greatest Chicano public art projects: Día de los Muertos and the Barrio Mobile Art Studio.

DRAWING THE WAY TOGETHER

Día de los Muertos is a Mexican Indigenous and Catholic Mexican ritual celebrating the lives of the deceased. During the first few days of November, families visit, clean, and adorn the tombs of their ancestors at night, often building altars at the cemetery or in their homes. The altar making is common to Chicano and Mexican households,

but there was no equivalent holiday-like ritual in Los Angeles. Ibañez and Bueno were important transmitters of the Mexican tradition, but Sister Karen was also familiar with the event, having seen Charles Eames's film *Day of the Dead* (1957) at IHC.[37]

In 1973, SHG, along with the Chicano art collectives Asco and Los Four, initiated the Chicano Día de los Muertos. The procession of mostly elementary and college students began with a Catholic mass in Evergreen Cemetery and ended at SHG's location on Brooklyn Avenue, where participants laid marigolds on an altar commemorating the dead. Subsequent iterations (fig. 1.6) expanded on this structure, eventually including elaborate floats, handmade costumes, painted faces, theater performances, live music, food, and exhibitions of artworks made in the Barrio Mobile program (fig. 1.7).

Día de los Muertos began as a procession down a road. Proudly walking from the land of the dead, down the highly policed and contested Brooklyn Avenue, and arriving at a spiritual sanctuary where food, conviviality, and sustenance were waiting, the event was the physical enactment of the idea of accompaniment. It was an artist-facilitated, participatory performance that expanded over many years, but remained true to its cultural commitments: it was free and completely open to the public, everyone had a role, all contributions were welcome, and the important part was to participate.

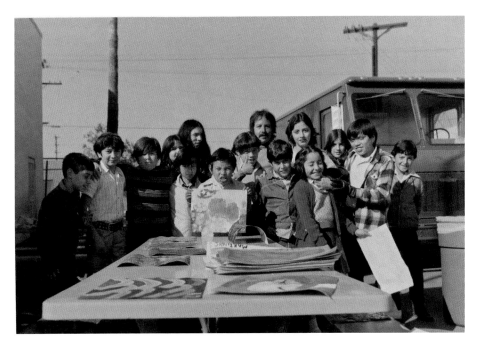

Carlos Bueno and schoolchildren in front of the Barrio Mobile Art Studio, ca. 1976. Self Help Graphics & Art Archives, California Ethnic and Multicultural Archives 3, University of California, Santa Barbara Library. Courtesy of Self Help Graphics & Art.

In subsequent years, participants drew from the art and art history lessons they received from SHG staff on, for example, the Mesoamerican roots of Día de los Muertos or the prints of Mexican artist José Guadalupe Posada. Participants made paper flower crowns and papier-mâché skulls, wore flowers in their hair, painted their own faces, and dressed in a wide variety of "cholo" and "zoot suit" fashions, freely mixing Mexican and Chicano culture together. Turning contested public space into a large-scale participatory stage, the event reframed the barrio as a place worth celebrating. After decades of processions that drew national and international attention, the once humble procession would develop into a large-scale event that amplified Chicano culture to the world, and fortified Chicano Los Angeles as one of the country's great creative centers.

Asco had embodied the traditional figures of Mexican muralism and brought them off the wall, but Día de los Muertos extended the mural's ritualistic potential and facilitated the public stage-work that called artists, neighbors, children, and senior citizens forth to manifest Chicano community. Essential to this work was the public artwork created by Ibañez y Bueno: the Barrio Mobile Art Studio. In true "making do" fashion, the artists converted a retired UPS step van into a mobile darkroom with water and electrical hookups, as well as shelving and fold-out tables for art activities and films.

Replicating the logic of the lowrider, an adapted car that was meant to move low and slow, the Barrio Mobile no longer delivered packages but, like a Trojan horse, carried artists to public and institutional spaces (campuses, parking lots), which they turned into classrooms grounded in a Chicano worldview—often in the very spaces where Chicano bodies and tongues were disciplined and silenced.[38]

Under the shadow directorship of Ibañez and Bueno, the Barrio Mobile traveled to schools, community colleges, juvenile halls, and probation camps, as well as government-funded public service sites like senior citizen centers, teen youth centers, and housing projects. Setting up in parking lots or on city blocks, paid and trained artists led art-and-culture lessons and activities, serving tens of thousands of schoolchildren and residents across all of Los Angeles County during the project's nearly ten-year run. Like the expanded space of muraling that could turn a corner into a classroom or a parking lot into a political arena, the Barrio Mobile continued the work of using art as a framework to transform urban and institutional spaces into sites of learning, teaching, and protest. The Chicano aesthetic meant much more than nationalist and revolutionary images of resistance. It was also a way of occupying space and making a new social reality in a part of town that most city planners had plainly abandoned. Whether art could indeed make change in Chicano lives was not a question of how to better integrate the institution of art into those lives, but rather how to magnify and support the cultural values and creative practices of everyday Chicano life.

CONCLUSION

Thanks to the work of the Mural Conservancy of Los Angeles, whose website contains hundreds of digitized slide photographs and saved screen captures of the Google Maps "street view" of many murals, Ibañez y Bueno's *Maria de Los Angeles* resurfaced in 2009.[39] Once an important economic hub in City Terrace, the Bank of America on Wabash Avenue where the mural was painted is now a laundromat with no visible trace of the mural. Not destroyed, but haunting the location, the mural's distinctive green eye peeks out from a square of exposed building paint in a 2009 screen capture on the Mural Conservancy's website. The reappearance of the mural is remarkable, as it required the Google Maps camera to capture it during the brief window of its exposure, along with the fortuitous timing of the Mural Conservancy saving a screenshot of the address. Google Maps updates regularly, and the 2020 Google Maps street view of the very same location shows a blank, pink and white wall.[40]

The mural reappears at a crucial moment, adding to the initiative to identify and dislodge the disciplinary bias that has classified SHG and its fellow Chicano social practice artists as somehow inferior in comparison to Euro-American standards. As Pérez observes, Chicano creative practices have a ghettoized place in art history where they are "always other, always marginal, and, at best, a flavor of the month."[41] These characterizations have done great damage to Chicano community art traditions for many decades, as mainstream funders and institutions have been unwilling or unable

to see these projects as working within a decolonial program invested in an entirely different set of objectives and skills.

As Colin Gunckel has shown, Chicano community art practices are obligingly referenced in the literature on social practice, but they never break into the main discourse.[42] The social practice projects that scholars like Claire Bishop, Suzanne Lacy, and Miwon Kwon analyze as examples in their now landmark texts overlook the community art practices developed in the 1960s and '70s. As I maintain throughout this chapter, Chicano social practice is not just an additional history that can be easily added to the mainstream. Rather, Chicano social practice troubles that narrative, both by pointing to the blind spots in the developing social practice history and by offering a decolonial model that is less invested in the European avant-garde model of bringing art into life, and more focused on excavating, nurturing, and accompanying extant cultural-political and historical projects of pressing importance.

Without the Chicano public art tradition, however, social practice art history is restricted to a limited range of historical examples that make it almost impossible to see what it inherited from the Euro-American avant-garde and the public art museum. In the book *One Place after Another*, Kwon admonishes the lack of criticality in both the practice and discourse of social practice, which can, as she describes, "exacerbate uneven power relations, remarginalize (even colonize) already disenfranchised groups, depoliticize and remythify the artistic process and finally further the separation of art and life (despite claims to the contrary)."[43] Chicano social practice puts the avant-garde mandate into stark contrast, revealing this colonial dimension as it confronts the Euro-American status quo with a different model. The successes and differences of the Chicano model seem to suggest that the avant-garde logic was more a rephrasing of the civilizing and proselytizing mission at the heart of Euro-American colonialism.

As of yet, there is no real way for art historical analysis, as it currently exists, to grasp and evaluate the experiential and boundary-crossing dimensions of an expanded public art. Performance art historian Shannon Jackson, observing the dilemmas that social practice poses to art history, directs attention away from evaluative models "that measure artistic radicality by its degree of anti-institutionality" and points toward projects that encourage and facilitate communication and dialogue through art.[44] Asking that we analyze such projects for their ability to "help us to imagine sustainable social institutions," Jackson's call is similar to cultural theorist George Lipsitz's reformulation of the community-based art tradition, suggesting that "it is more productive to view it as a form of art-based community making."[45]

The Chicano and Mexican public art projects of the 1970s developed an alternative model for socially committed artists in the wake of a muralist tradition that had opened up a new set of socio-spatio-aesthetic problems. Judging those problems in terms of the success of their community building is a component of their larger project to redefine art and the artist's role in society for the benefit of all people. This required new skills and models, which are evident in how the tradition on both sides of the

border intended to articulate distinctly Chicano or Latin American artistic identities, definitions, and traditions composed from Chicano and Mexican people's experiences and ways of knowing and being.

Working at the roots of Chicano culture to address the lived realities of its constituency, SHG created a new cultural infrastructure that abandoned the dominant culture's preformulated model based on imposition and intervention. SHG's style of committed, on-the-ground work built alliances around creative practices that were not just *for* Chicano people, but *from* a wide range of Chicano creative practices and traditions. SHG had a clear understanding of what social justice work it intended for its experimentation to serve, and it built an artistic practice in service to a particular place and people. The model SHG developed in its early years was not universal or superior to the dominant culture's models, but—maybe more importantly—it was an approach that made SHG one of the most sacred sites in the Chicano cultural imaginary.

NOTES

A special thanks to Milton Antonio Jurado for access to the photographs of Carlos Bueno and to Dr. David Chambers for his masterful digitization of these aged photographs and Xeroxes.

1. For a historical overview of mural destruction in modern Los Angeles, see Erin M. Curtis, Jessica Hough, Oscar Castillo, Guisela Latorre, and Gustavo Arellano, *¡Murales Rebeldes!: L.A. Chicana/Chicano Murals Under Siege* (Los Angeles: Angel City Press, 2017).

2. Quote from an unpublished and undated transcribed interview with Carlos Bueno by Aleyda Rojo (hereafter "Rojo interview"), Ricardo Muñoz Family Collection Archive, Los Angeles.

3. The dimensions and timeline of Ibañez and Bueno's working relationship are unclear. Soon after the artists' return to Mexico in 1977, Ibañez's interest in art waned and his health began to deteriorate. Sometime thereafter he abandoned his artistic career. Bueno continued to sign artworks as "Ibañez y Bueno," but the signature had clearly become a nostalgic gesture by the 1980s. In the undated (possibly ca. 1999) interview with Aleyda Rojo cited above, Bueno recalls: "Después empezaron a aparecer en mi trabajo las cholas y los cholos. . . . En aquel entonces yo firmaba como 'Ibáñez y Bueno,' en honor a mi carnal Antonio, pero cuando conocí a Raquel Tibol me regaño y me dijo que no hiciera eso que firmara con mi nombre completo y entonces empecé a firmar como 'Carlos Bueno P.'" ["Then cholas and cholos started to appear in my work. . . . In that time I signed 'Ibáñez y Bueno,' in honor of my dearest friend Antonio, but when I met Raquel Tibol she castigated me and told me not to do that, that I should sign with my complete name and then I began to sign 'Carlos Bueno P.'"] This quote from the Rojo interview is probably the source for Bueno's 2001 *Los Angeles Times* obituary, which echoed this point. Without an inventory of Ibañez's work or a written statement, I do not believe there is sufficient evidence to take Bueno's characterization as verdict, most particularly because it effectively nullifies Ibañez's artistic contributions. As an artist who is barely documented in the SHG archive, but whose name repeatedly appears in the form of this signature, it would stand to reason that the signature might have been generated in a period when the artists did work collaboratively, however briefly. Whether Ibañez was an artistic collaborator, muse, or technician, or possibly all three, requires

My research sheds new light on a significant aspect of the history of SHG that has generally received only cursory attention and has, at times, been erroneously documented.[1] This may be partly related to the fact that scholars have generally paid more attention to SHG as an art center within a Chicano community or to specific art programs that were organized with local artists.[2] To date, scholarship has largely ignored the innovative work of SHG in the field of art education through its outreach program, the BMAS. This chapter aims to correct and fill this lacuna and reposition the history of the BMAS, making it more central to the broader history of SHG.

THE CREATION OF THE BMAS IN CONTEXT

Since social justice was the guiding philosophy for the BMAS, it is important to contextualize this program by considering two definitions of *art education for social justice*. One focuses on art forms, visual artifacts, and educational activities "to encourage social equity and the opportunity for all people to achieve their vocational, professional, personal, social, and economic goals in the world."[3] The second definition asserts that art is the means through which the rights and privileges of democracy are available to all. According to this second definition, it is vital to guide students to know themselves and their worlds, as well as to make their interests, voices, and lives part of the curriculum.[4] It is equally important to consider the teachers who engage in social justice education, and their role as cultural workers and intellectuals whose work affects how people understand themselves and their worlds.[5] These cultural workers determine content that validates their students and, at the same time, expands their understandings and experiences.[6]

SHG came into existence in 1972, when two Mexican émigré artists, Carlos Bueno and Antonio Ibañez, came together with an Italian American nun, Sister Karen Boccalero, to establish an art center in East Los Angeles's predominantly Mexican American community. The formation of SHG was shaped by the historical, social, political, and cultural context of the Chicana/o Civil Rights Movement.[7] Just four years before the center's creation, in that same area of Los Angeles, the Chicana/o Movement erupted when more than fifteen thousand Mexican American students walked out of the local high schools to protest the endemic poor educational conditions that afflicted their schools and the lack of a culturally relevant curriculum.[8] This movement promoted the struggle of Mexican Americans for social justice and for a cultural consciousness that emphasized language, heritage, ethnic roots, and Chicana/o contributions. It also stressed the development of political activism and power through grassroots community organizations.[9] The Chicana/o Movement brought about a high sense of idealism, which led to an emphasis on community-oriented art forms, an insistence on political and ethnic themes, and the creation of several artistic collectives, sites of artistic production, and cultural centers. During this period (1968–75), art served as a means of capturing the history and culture of Mexican Americans as part of their struggle for self-determination.[10]

SHG was conceived predominantly as a center for printmaking. Like other art collectives and groups, it emerged in response to the lack of access to centers and studios for artists of color and women artists; it aimed to provide spaces for these artists to create representations of themselves.[11] From the outset, Sister Karen clearly articulated the purposes of SHG as a place that would provide training and studio space for local artists in East Los Angeles (including but not limited to Chicanas/os) who worked or were interested in printmaking; an art center for artists who had no access to other art venues; and an organization that would bring to the surrounding community, families, and children (most of whom were Chicanas/os and Mexican immigrants) art and cultural experiences that engendered a sense of cultural pride. The latter was especially important to Sister Karen since this population had practically no access to these kinds of experiences.

Sister Karen believed that Chicanas/os and Mexican immigrants came from a culturally rich environment but that schools had effaced their cultural values. She thought that reclaiming these values through art would instill a sense of cultural pride and bring about positive self-esteem, which would then be transferred to the home, the community, and the schools.[12] In short, she envisioned SHG as a major political force to precipitate social change through art.[13]

To be sure, Sister Karen's desire to create an outreach program as part of SHG was motivated by her religious background as a member of a Franciscan order and by the substandard educational conditions of Chicana/o and Mexican immigrant children in East Los Angeles. Sister Karen grew up in East Los Angeles, where she was in contact with Mexican Americans to such an extent that that she even came to think of herself as Chicana and was often perceived as such by others.[14] She was a staunch believer in the potential of each person to make significant contributions to society; she asserted that Chicanas/os were not inferior or culturally deprived—the prevalent view at the time—but a gift to society thanks to their tremendous cultural richness. Overall, she adhered to the idea that culturally diverse groups had the potential to enrich society and that people of scarce means deserved to have resources that would allow them to express their own reality. Art was one such tool of self-empowerment.

The deplorable educational status of Chicana/o and Mexican immigrant children in East Los Angeles was a major driving force behind Sister Karen's program. The process of Americanization and the ideology of the "melting pot"—the idea that immigrants should shed their own heritage and assimilate to the mainstream or dominant culture—made them feel inferior.[15] Furthermore, there was very little art education in schools because of the focus on math and reading, and bilingual or bicultural art programs were essentially nonexistent. Because children in the neighborhood did not go to art centers, Sister Karen set out to bring art to them.

In April 1972, not long after SHG opened, Sister Karen created its first educational outreach program. This program served the community in East Los Angeles, with a focus on children. From February 1973 through the end of 1974, thirty-five hundred

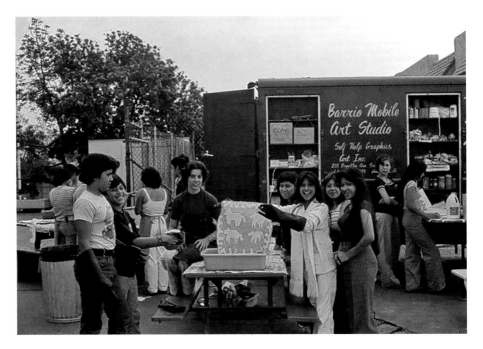

FIGURE 2.1

Barrio Mobile Art Studio hosting a batik workshop at a local school in Los Angeles, ca. 1975. Courtesy of Self Help Graphics & Art.

children participated.[16] But it was SHG's next iteration of an educational outreach program—the BMAS—that became the most known, respected, and influential. Since its inception, the BMAS program was rigorously planned, from the development of its curricula to the implementation of methods for assessing its effectiveness through various evaluation and documentary processes.

THE BMAS: GOALS THAT REFLECT SOCIAL JUSTICE

The BMAS was established in September 1975 (fig. 2.1). In conceiving the program, Sister Karen followed the "Curriculum Model of Aesthetic Education," based on an in-service workshop of the Aesthetic Eye Project sponsored by the Office of the Los Angeles County Superintendent of Schools.[17] This model took into account the setting (the community, schools, agency), the learners (the characteristics of the student population), and the content (aesthetic education). These areas informed the objectives of the BMAS, its teaching strategies, and its instructional materials.[18] As noted in a funding proposal of SHG, "The nature of the program . . . stemm[ed] from an analysis of the characteristics of East Los Angeles' needs."[19]

In the earlier years of the program, the overarching goals of the BMAS were to bring art and culture to Chicanas/os and recent Mexican immigrants who had little access to art; to increase children's awareness of the interrelation of art and one's quality of life;

to build a positive self-concept in children; and to develop potential artists. In addition, the BMAS had two specific aims in working with artists in the community: to develop a staff of artists who gain skills as teachers while advancing their artistic development, and to provide a means by which artists could "become an effective force in the community."[20]

In addition, the BMAS outlined specific pedagogical goals: for individuals to develop aesthetic appreciation, to make art as an alternate mode of self-expression, and to appreciate their Mexican and Chicana/o culture.[21] To accomplish these goals, the artists-teachers were encouraged to incorporate three elements into every art activity: culture (usually Chicana/o or Mexican), aesthetic development (the feelings aroused by art through formal expressive properties and aesthetic judgment), and technique (tools and materials). They were also asked to use visual materials and resources to inspire the participants.[22] According to Sister Karen and the BMAS curriculum coordinator, Juan Geyer, "This holistic approach to art education is highly successful because it links thinking and doing, thereby bridging the gap between abstract principles and real experience."[23]

TRAINING THE ARTISTS-TEACHERS

In addition to the pedagogical goals of the art activities, the BMAS formulated others for the artists-teachers, especially because most of them had little, if any, teaching experience. Sister Karen's background and training as a high school teacher, a university instructor, and an artist enabled her to scaffold their learning and mentor them as they gained teaching experience.

Unlike other programs that send artists with limited understanding of teaching or the community to schools and communities, the BMAS artists-teachers underwent rigorous preparation. It started with a "forty-hour intensive training and orientation workshop," developed with the needs of the East Los Angeles community in mind, which artists-teachers were required to attend before going out into the community.[24] For instance, in its first year (1975), the BMAS orientation included an "Introduction to Curriculum Building" workshop, which was designed around the theme of Día de los Muertos. Artists worked in pairs to prepare and lead an activity based on this holiday, which was then evaluated at length. The entire staff was required to participate in every activity. As part of this workshop, the artists and staff studied films, books, and actual products from previous Day of the Dead celebrations.[25] The BMAS artists were also required to attend weekly meetings to discuss curriculum, to receive training from other educators on teaching methods, to see the work of other artists, to go to museums and community field trips, and to read pertinent literature.[26] These activities introduced them to ideas relevant to education, art, and culture and prepared them to integrate content and culture into each artmaking activity they taught. In one of their weekly training workshops, for example, Sister Karen taught a seminar on the relationship between artist and community (problems, needs, culture); meanwhile, Geyer, the

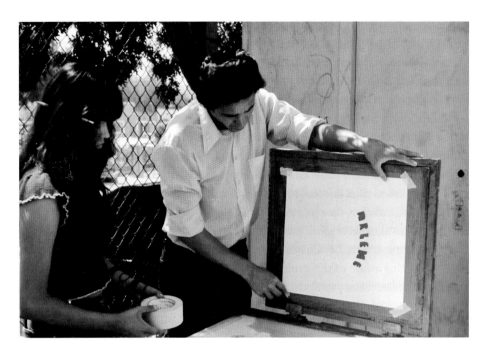

Barrio Mobile Art Studio teaching a silk-screen workshop at Griffith Junior High School in East Los Angeles, 1976. Courtesy of Self Help Graphics & Art.

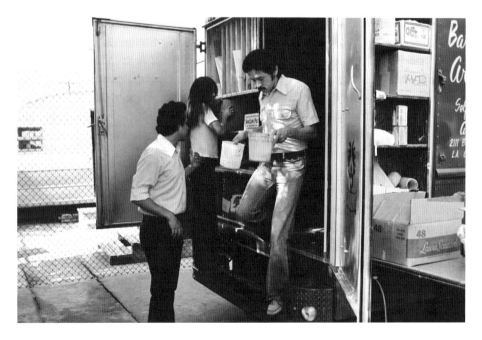

Barrio Mobile Art Studio teachers setting up for a workshop at Griffith Junior High School in East Los Angeles, 1976. Courtesy of Self Help Graphics & Art.

usually ranging from one to four visits (though sometimes there were as many as seven visits for silk-screening workshops). Generally, the BMAS preferred to work with the same classroom several times during the school year so that the children could participate on longer-term projects and be exposed to a wider variety of art activities. By visiting multiple schools, sometimes multiple times, the BMAS artists-teachers could push the artmaking beyond simple "arts and crafts." They could also bring art projects into the schools that the teachers were unable to implement because of their limited resources and expertise; such projects included silk-screening, photography, and animation.

Another unique aspect of the BMAS was that several of its artists-teachers were bicultural and/or bilingual, which greatly aided them in reaching and connecting with Chicana/o children and with children who had recently immigrated from Mexico and thus often spoke little English. As discussed below, these bicultural and bilingual connections enabled the BMAS artists and students to establish positive relationships. Ongoing and thorough self-evaluations became important tools for learning about, and improving upon, the effectiveness of the BMAS's work. To this end, the BMAS staff responded to a set of questions and wrote monthly summaries tracking each month's progress and setting up goals for the next. The questions inquired about specific problems, their effect on the program, and how they were dealt with. It also asked which activities had generated the most enthusiasm among the children.[43] In keeping with the desire to monitor progress and the need for change or adjustments to the program, the BMAS often updated some of the questions. In its second year (1977), for example, it asked specifically about the program's effect on the East Los Angeles community and ways to improve it.[44]

THE IMPACT OF THE BMAS

Measuring the impact of the BMAS is not an easy task, more than four decades since its creation, but there are a few avenues to assess its effect on the people who participated in the program. The BMAS's most obvious innovation was its pedagogical approach, which was articulated by its organizers: "As the emphasis in the schools is on primarily math and reading skills, there is very little emphasis placed on culture and the arts. Consequently our services are very much needed and appreciated by the schools."[45] By offering in-service training and workshops for teachers and other individuals in the community, the BMAS had a broader impact. An example was the "Art in the Barrio" workshop, conducted in 1977, which taught participants "how to integrate culture and art into meaningful, educational arts activities for children and adults."[46] A few years later, the BMAS developed "cultural educational material," workshops and lessons for children, teachers, and other interested adults in East Los Angeles and beyond that no longer focused primarily on the Chicana/o and Mexican cultures but expanded into a "multi-cultural arts program" (fig. 2.4).[47]

The BMAS's impact can also be measured by looking at the large number of people who participated in the program.[48] By the end of May 1976—its first year of operation

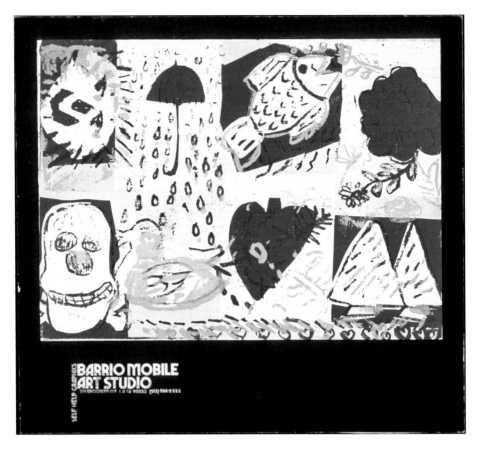

FIGURE 2.4

Barrio Mobile Art Studio poster, undated. Galería de la Raza Archives, California Ethnic and Multicultural Archives 4, University of California, Santa Barbara Library. Courtesy of Self Help Graphics & Art.

and funding[49]—3,108 children in sixteen schools (mostly elementary) had participated in school van visits, surpassing the BMAS's own targets; the encounters between the children and the BMAS artists totaled 10,345, because the BMAS visited some classrooms multiple times.[50] Additionally, the BMAS van traveled to other sites in the community, including libraries, housing projects, diversion programs, a probation camp, and different neighborhoods and parks. By July 1976, the BMAS had conducted 175 school-visit sessions and thirty-two neighborhood sessions,[51] with 7,482 children and adults participating, and a little over 16,000 encounters.[52] In its first year of operation, the BMAS held special events in the community, including an exhibition of the participating children's artwork and events celebrating the Day of the Dead and Cinco de Mayo "to present aspects of Mexican-American culture to the population at large."[53]

In its second year of operation (March–November 1977, owing to a funding gap), the program included 7,320 participants, even though the number of BMAS

artists-teachers had decreased from ten to four and the program was reduced to part-time because of ongoing funding difficulties.[54] In its third year (November 1977–July 1978), the BMAS had five artists, again working part-time. During that period, it served 3,853 participants at local schools and community groups. It also held a children's exhibition in May 1978, and two hundred people attended the opening.[55] All in all, thousands of people were served by the BMAS, with schoolchildren generally having contact with the BMAS artists on multiple occasions.[56]

Another way to gauge the BMAS's impact is through the comments of those directly involved—the classroom teachers and the children. Teachers attended the BMAS sessions with their students and were therefore able to witness and assess the program's effectiveness firsthand. The teacher evaluation forms reveal that most teachers had a positive experience with the program. Many teachers specified that the children were learning innovative and new art techniques, such as photography and silk-screening, which were seldom offered in schools and not in elementary schools. Teachers in East Los Angeles also remarked that the children were gaining knowledge of their Chicana/o and Mexican culture. As one elementary school teacher put it, "even the most Americanized, I believe, felt pride in being Chicano."[57] Others noted that having Spanish-speaking artists of Chicana/o or Mexican background was important, especially for Mexican immigrant children, and that this bilingual and bicultural shared experience was seen as positive. An evaluation of the BMAS conducted in 1976 by the Los Angeles County Department of Parks and Recreation, an external agency, also found that "most teachers felt that the self-esteem-building result of the program was invaluable." Furthermore, the evaluation continued, "after seeing the results of the children's exposure to sophisticated art techniques, teachers in several schools reevaluated their expectation of the skill levels of the children. They now realized that the children were capable of handling a higher level of creative work."[58] Some teachers noted that they planned to integrate what they had learned from the BMAS into their own classrooms,[59] while others incorporated relevant films and books to enhance their curriculum.[60]

The students' evaluations also provide an indication of the reach and effectiveness of the program, enabling us, even if in a small measure, to recover the voice of the children. They wrote hundreds of thank-you notes to the artists-teachers. Some of the letters are fairly formulaic, which suggests that the teachers provided clear guidelines on how to write them and what kind of information to stress (e.g., a favorite art activity or a specific aspect of the Mexican or Chicana/o culture). The more interesting letters, however, are those that are personalized and reflect the special bond that the children developed with the artists. In the letters, the children often refer to them as "good people" and as "nice," and they mention that the artists treated them well. Some letters indicate the deeper connection that some children felt toward a particular artist-teacher. One student, for example, addressed his letter directly to the artist and stated, "What I like most is working with you."[61] Another mentioned that "Pete [Peter Tovar, the BMAS artist] wouldn't get mad at me if I did something wrong."[62]

These comments inevitably raise questions as to how their other teachers treated and valued these children and how this education outreach program stood apart from their school education. For other children, the BMAS artists served as role models and as inspiration to learn more about art. A young girl told one of the artists that she wanted to become an "*experta en arte como tú, Michael* [an art expert like you, Michael],"[63] while a fifth-grader wrote, "I hope you can teach me to be an artist."[64] Another boy asked a BMAS artist to write back and tell him more about carving and to send him a book about art. Children also remarked on the positive messages that the artists gave them. One letter stated, "They want us to be a great artist. They encourage us to go to college to learn about art."[65]

The letters reveal that the art activities allowed students to "stretch and explore"— that is, to reach beyond their artmaking capacities and to explore materials.[66] One boy's description of his experience in a photography project illustrates this point: "I never done anything like it . . . [the photos] came out like magic and nice."[67] Similarly, a girl found cardboard sculpture exciting because, in her words, "it is something I never did before."[68] Another girl's letter highlights the encouragement the artists-teachers gave them to experiment with everyday materials and use them in their art-making. She writes, "I liked the way . . . we were fooling around and trying to think of what we could do with the wires."[69] No less significant are the letters that children wrote emphasizing how little art education they received at school. One girl's letter, written in May 1977—nearing the end of the school year—underscores this reality: "I had a really nice time because that was the first time in the school year we had art!"[70] All these comments demonstrate the children's emphasis on the positive pedagogical approach of the program and their enthusiasm for the curricula.

There is another powerful avenue to gauge the extent of the impact of the BMAS on the community: its funding challenges. For its first year of operation (August 1975–August 1976), the BMAS was funded by the Los Angeles County General Revenue Sharing Funds for Community Organizations. By June 1976, however, there were already concerns that the BMAS would not receive further funding; indeed, support was cut off that August. As soon as there were signs that its funding would not be renewed, an extraordinary level of support and mobilization emerged on behalf of the BMAS, from grassroots organizers to high-ranking politicians. The remarkable number of letters to the funding agency and local politicians testifies to this community support.[71] They came from teachers, principals, and students who had worked with the program; they came from other community organizations in East Los Angeles; and they even came from local political leaders and from Edward R. Roybal, a US congress-man from California who had grown up in East Los Angeles. The level of support was so overwhelming that, within six months, the BMAS's funding was reinstated, and it continued to receive support from the county's General Revenue Sharing Funds for a few more years.

An external evaluation of the BMAS, written in July 1976 for the Los Angeles County Department of Parks and Recreation, recommended renewal of its funding and attested to the importance of the BMAS to the community:

> The greatest strength of the program is its ability to combine a sensitivity to the special needs of the community it serves with a highly organized, efficient staff. The origins of the program from within the community, with organizers who understood the problems, resources, attitudes, interests, and values inherent in the area, gave a head start to acceptance of the program by that community. Unlike programs which are developed outside of a community, then imposed upon the existing structure, the BMAS was developed within the framework to achieve goals recognized by the East Los Angeles community. The major goal and the actual achievement of the program was to build self-esteem and community pride among the participants. This was greatly facilitated by training the staff of artists to see the community both as its members see it and as it could be with the help of their creative skills. Thus both the artists and the community grew in their awareness of each other. . . .
>
> The program engendered much support based on its high degree of organization and efficiency while some programs in that community are poorly implemented and fail when potential participants are afraid of disappointment. The BMAS gained the confidence of its community because it was recognized as a well-founded program.[72]

RELEVANCE OF THE BMAS TODAY

The history and ambitions of the BMAS—a program that came into existence in 1975 and was phased out in 1985 and then renewed in 2014—have contemporary importance.[73] First, by studying the BMAS, we can recover a small piece of Chicana/o history and give it its due. Although several articles, book chapters, and a doctoral dissertation have examined the work of SHG, their focus has been on the center as a site for production of Chicana/o art. The BMAS is often mentioned in scholarship, but it is given only cursory attention. The Chicano scholar Chon Noriega has underscored the need to recover and safeguard the history of Chicano and Latino participation in the arts. As he notes, "This history is fragile, ephemeral, and—in terms of the archive—largely neglected. Preserving and documenting this history is vital."[74] In this chapter, I have attempted to recover part of that history by focusing primarily on the pedagogical achievements of the BMAS. Aside from having particular relevance to the field of Chicano studies, this case study should be considered part of the broader history of art education in the United States; it expands our knowledge of the ways in which art education has intersected with marginalized populations. In other words, it makes an invisible history visible.[75]

47. Lesson Plans, Barrio Mobile Art Studio documentation, April 1979–July 1980, SHGA, series II, box 23, folder 4, CEMA, UCSB.

48. E. Bonewitz, "Final Evaluation: Barrio Mobile Art Studio," 1976, SHGA, series II, box 24, folder 11, CEMA, UCSB.

49. The BMAS's funding for its first year was from September 1975 to August 1976.

50. Barrio Mobile Art Studio, submitted to California Arts Council, "Alternatives in Education Program," 1976, SHGA, series II, box 24, folder 3, CEMA, UCSB.

51. E. Bonewitz, "Final Evaluation: Barrio Mobile Art Studio," 1976, SHGA, series II, box 24, folder 11, CEMA, UCSB.

52. Barrio Mobile Art Studio documentation, September 1975–August 1976, compiled February 22, 1977, SHGA, series II, box 21, folder 4, CEMA, UCSB.

53. E. Bonewitz, "Final Evaluation: Barrio Mobile Art Studio," 1976, SHGA, series II, box 24, folder 11, CEMA, UCSB. Cinco de Mayo is a celebration commemorating the victory of the Mexican army over the French forces in Mexico in 1862. In the United States, however, Cinco de Mayo has become more of a celebration of Mexican heritage and pride.

54. Barrio Mobile Art Studio II documentation, March–November 1977, SHGA, series II, box 22, folder 1, CEMA, UCSB.

55. Barrio Mobile Art Studio III documentation, November 1977–July 1978, SHGA, series II, box 23, folder 1, CEMA, UCSB.

56. At the time of this writing, documentation of the number of people served by the BMAS through its outreach program was not yet available through the archives.

57. M. Cuevas, teacher evaluations, Barrio Mobile Art Studio III, November 1977–July 1978, SHGA, series II, box 23, folder 2, CEMA, UCSB.

58. E. Bonewitz, "Final Evaluation: Barrio Mobile Art Studio," 1976, SHGA, series II, box 24, folder 11, CEMA, UCSB.

59. G. Schimke, letter to BMAS Artists-Teachers, May 22, 1980, SHGA, series II, box 20, folder 5, CEMA, UCSB.

60. E. Bonewitz, "Final Evaluation: Barrio Mobile Art Studio," 1976, SHGA, series II, box 24, folder 11, CEMA, UCSB. It is important to note, however, that several teachers also expressed that they would not be able to incorporate the activities introduced by the BMAS because of a lack of art supplies.

61. L. Yurriaga, letter to BMAS Artists-Teachers, 1978, SHGA, series II, box 20, folder 5, CEMA, UCSB.

62. LMCTK [a student], letter to BMAS Artists-Teachers, 1976, SHGA, series II, box 20, folder 4, CEMA, UCSB.

63. M. Cervantes, letter to BMAS Artists-Teachers, 1979, SHGA, series II, box 20, folder 5, CEMA, UCSB.

64. Tony [a student], letter to BMAS Artists-Teachers, 1976, SHGA, series II, box 20, folder 5, CEMA, UCSB.

65. Thank-you letters from students to BMAS Artists-Teachers, 1977, SHGA, series II, box 22, folder 2, CEMA, UCSB.

66. Lois Hetland, Ellen Winner, Shirley Veenema, and Kimberly M. Sheridan, *Studio Thinking: The Real Benefits of Visual Art Education* (New York: Teachers College Press, 2007).

67. Thank-you letters from sixth-grade students at Rowan Elementary School to BMAS Artists-Teachers, 1976, SHGA, series II, box 20, folder 5, CEMA, UCSB.

68. Thank-you letters from students at Robert F. Kennedy School to BMAS Artists-Teachers, 1978, SHGA, series II, box 20, folder 6, CEMA, UCSB.

69. Thank-you letters from sixth-grade students at Rowan Elementary School to BMAS Artists-Teachers, 1976, SHGA, series II, box 20, folder 5, CEMA, UCSB.

70. Thank-you letters from sixth-grade students at St. Mary's to BMAS Artists-Teachers, 1977, SHGA, series II, box 22, folder 2, CEMA, UCSB.

71. Letters of support for Barrio Mobile Art Studio, 1976–80, SHGA, series II, box 20, folders 1–7, CEMA, UCSB.

72. E. Bonewitz, "Final Evaluation: Barrio Mobile Art Studio," 1976, SHGA, series II, box 24, folder 11, CEMA, UCSB.

73. Salvador Güereña, "Guide to the Self Help Graphics Archives, 1960–2003," in *Self Help Graphics & Art: Art in the Heart of East Los Angeles,* edited by Colin Gunckel (Los Angeles: UCLA Chicano Studies Research Center Press, 2005), 37–133. The exact timing of when the BMAS was phased out is somewhat unclear, though the archival record seems to support 1985, as established by archivist Sal Güereña. Kristen Guzmán, however, writes that Sister Karen "decided to give up the Barrio Mobile Arts Studio" in 1990 (Guzmán, "Art in the Heart of East L.A.," 120). Regardless of the exact date, SHG continued to be involved in educational initiatives in the early 1980s, such as developing the *Arts-in-Education Approach,* a booklet for the Exemplary Arts Education Program in El Rancho School District, Pico Rivera, California. Sister Karen Boccalero and Self Help Graphics & Art, "Arts-in-Education Approach," 1981, SHGA, series IV, box 40, folder 1, CEMA, UCSB. By the 1990s, however, Sister Karen, as executive director of SHG, "chose artistic development over art education" in an effort to institutionalize and solidify its reputation as a center for fine arts (Guzmán, "Art in the Heart of East L.A.," 120).

74. Chon A. Noriega, "The CSRC Partnership with Self Help Graphics: A Model for University-Community Collaboration," in Gunckel, *Self Help Graphics & Art,* 32.

75. Paul E. Bolin, Doug Blandy, and Kristin G. Congdon, eds., *Remembering Others: Making Invisible Histories of Art Education Visible* (Reston, VA: National Art Education Association, 2000).

76. Ibid.; Freire, *Teachers as Cultural Workers.*

77. Howard S. Adelman and Linda Taylor, "Immigrant Children and Youth in the USA: Facilitating Equity of Opportunity at School," *Education Sciences* 5, no. 4 (2015): 323–44.

78. Abby Budiman, "Key Findings about U.S. Immigrants," *Pew Research Center,* www.pewresearch.org/?p=290738.

79. Carola Suárez-Orozco, Hirokazu Yoshikawa, Robert T. Teranishi, and Marcelo M. Suárez-Orozco, "Growing Up in the Shadows: The Developmental Implications of Unauthorized Status," *Harvard Educational Review* 81, no. 3 (2011), 438–72.

80. Garber, "Social Justice and Art Education," 4–22.

3

GENERATIVE NETWORKS AND LOCAL CIRCUITS

Self Help Graphics and the Visual Politics of Solidarity

ONCE A WORKING-CLASS COMMUNITY, home to people of Mexican, Japanese, and Jewish descent, Boyle Heights fostered solidarity across perceived difference at a time when redlining supported pervasive housing discrimination.[1] The internment of Japanese Americans during the 1940s and the construction of freeways through Boyle Heights during the 1950s dramatically reshaped this community. Residents able to do so moved to other neighborhoods or the suburbs, whereas others were forcibly removed from their homes.[2] Following these events, the population that remained was predominantly working-class Mexican Americans, whose quality of life was further diminished by pollution, policing, and the proposed construction of a prison.[3] Despite these conditions, the collective memory of Boyle Heights' history persisted, and by the time that Self Help Graphics & Art (SHG) first opened in 1970,[4] residents had established grassroots coalitions to protect the community from further disenfranchisement, while *el movimiento* catalyzed a new level of collective organizing among Chicanos in Boyle Heights and on a national scale.

as a tool for liberation as an important influence.[17] Although Boccalero's interactions with Edmunds were brief, Brandywine and SHG were founded within a short time of each other, and the organizations share values that prioritize community outreach, educational programs for local youth, and printmaking residencies to support the creation of aesthetically rigorous work.[18]

A moment of nascent intersection between SHG and African American artists in Los Angeles took place in the mid-1970s, when Brockman Productions received funding from the Comprehensive Employment and Training Act (CETA), a federal program that provided funds for training in public service, including allocations for public art and arts programming.[19] Between 1976 and 1978, Brockman Productions hired Richard Duardo with CETA funds to design and print posters, brochures, and promotional materials for their programming. He designed these materials at Centro de Arte Público in Highland Park, which he founded alongside Frank Romero and Carlos Almaraz.[20] With Linda Vallejo, Leo Limón, John Valadez, and Michael Amescua, Duardo was among a core group of artists during SHG's founding years.[21] Vallejo introduced Alonzo Davis and Boccalero, each of whom had navigated the complexities of maintaining an art practice while leading an arts organization dedicated to expanding opportunities for artists of color to show their work.

At this time, Duardo's physical movement throughout Los Angeles spanned Boyle Heights, Highland Park, Leimert Park, and the county's west side, where he worked at the Social and Public Art Resource Center (SPARC) in Venice and apprenticed under Jeff Wasserman of Gemini Graphic Editions Limited in Santa Monica.[22] Among a relatively small subset of institutions within LA's broader cultural landscape that are often led by artists, it is not unusual for artists, such as Duardo, to work at multiple organizations, fostering the formation of informal networks.[23] This movement across sites, coupled with future exchanges between Brockman Productions and SHG, points to Duardo as a figure who linked networks of artists that convened around these organizations. The promotional posters Duardo produced speak to the intersections among artists and organizations on the routes he traversed. A poster for SPARC's involvement in a multisite "California Dada" festival in 1980 suggests an expansive interpretation of the term *dada* through its inclusion of mail art and performance art, the participation of George Herms and Jerry Dreva, and a performance by Wanda Coleman.

A poster Duardo created for Brockman's Professional Musicians Program underscores the cultural exchanges across ethnoracial groups that these informal networks sustained. The Professional Musicians Program consisted of free public concerts, and the poster features a Japanese man wearing a yukata and playing a saxophone (fig. 3.1). The text below the image lists the names of participating musicians, whose affiliations also speak to the intersecting cultural geographies of the city, extending beyond Black and Chicanx artists. The list includes Dan Kuramoto, June Kuramoto, and Danny Yamamoto—members of the band Hiroshima, notable for its incorporation of traditional Japanese instruments, such as the *koto*, a stringed instrument, into

FIGURE 3.1
Richard Duardo, *Professional Musicians Program: Brockman Gallery Productions*, 1978. Screenprint, image: 34¾ × 14½ in., sheet: 35¼ × 15¼ in. Richard Duardo collection of silk-screen prints, California Ethnic and Multicultural Archives 65, University of California, Santa Barbara Library. Courtesy of the Estate of Richard Duardo.

contemporary jazz and R&B motifs. Although Dan Kuramoto is from East Los Angeles, Danny Yamamoto and June Kuramoto grew up in the Crenshaw district, a predominantly Black neighborhood.[24]

SHG established a setting where artists could develop their work in a context where they were free from the obligation to tailor or explain their work to a predominantly white staff and audience. Spaces such as the Brockman Gallery shared this value, thus facilitating a connection between SHG and the Brockman that extended beyond participation in a larger network of nonprofit arts organizations in Los Angeles. In both settings, this orientation away from an assumed white viewer offered artists the flexibility to contend with challenging imagery. This flexibility is evident in prints produced within SHG's Atelier Program, such as those by Alonzo Davis between 1985 and 1989. The prints that he created addressed the history of voter suppression and the use of stereotyped imagery against African Americans. *Act on It* (1985) is a text-based piece featuring the word *VOTE* in white capital letters, enclosed within a mottled red square that is set against a violet and lavender background.[25] The "O" in *VOTE* is rendered in bright pink, and its center includes a photograph of two Black men. At the bottom of the "O" is a semicircle that forms the shape of a slice of watermelon. The work was part of a larger series that sought to encourage voter participation, and Davis recalled his aunt's experience of being subjected to attempts at voter suppression in Birmingham, Alabama, such as literacy tests and poll taxes.[26]

Two years later, Davis created *King Melon* (fig. 3.2). Whereas *Act on It* presented viewers with a direct call to political action, *King Melon* addresses and untangles the visual politics of stereotyped imagery depicting African Americans. By centering an image of a watermelon, Davis engages the watermelon's conflicted history as a cultural symbol.[27] During enslavement, watermelons became a symbol of struggles for autonomy and power. For example, some enslaved people were able to cultivate watermelons within their personal gardens, which could be sold to generate an income. Slave owners often used the watermelon as the centerpiece in performative acts of generosity toward the people they enslaved.[28] Because it could be cultivated with little effort and space, and could help enslaved people purchase freedom for themselves and their loved ones through its sale, the watermelon came to symbolize African Americans' freedom and self-reliance. After emancipation, however, white Americans deployed the watermelon as a racist trope, inverting the ease by which it could be grown and its association with pleasure and leisure to imply that freed African Americans were unfit to be recognized as citizens.[29]

King Melon recognizes and intervenes in this cultural and political symbol's enduring power. Although the work does not directly address the watermelon's shifting historical significance, Davis's use of a crown and the title's reference to royalty speak to a sense of autonomy and power that are intertwined with the image of the watermelon. The print's semi-abstract composition features an array of bold lines forming facial features topped by the crown. A semicircular slice of watermelon hovers beneath the figure's lips, a small bite removed from its edge. The watermelon conceals the

Alonzo Davis, *King Melon*, 1987. Screenprint, image: 36 × 23¾ in., sheet: 36 × 23¾ in., edition of forty-five, printed by Oscar Duardo, Atelier 9. Self Help Graphics & Art Archives, California Ethnic and Multicultural Archives 3, University of California, Santa Barbara Library. Courtesy of the artist.

figure's neckline, and the rest of the figure's torso is obscured by layered patches of light blue, pink, and white interspersed with swooping arcs in yellow and black. This layering of color recurs throughout the work, the white and pink patches taking on a diffuse texture reminiscent of aerosol spray paint. The watermelon and a superimposed, geometrically patterned, yellow-and-black square containing an arrow represent the largest opaque fields of color within the composition, perhaps suggesting an ambivalence in the figure's ability to define himself against the entrenched racist narratives attached to the fruit.

CONTESTING THE POLITICS OF "COLOR BLINDNESS" IN THE ARTS

SHG's consistent decentering of a presumed white viewer offers a generative lens for considering the display of artworks that engage racist and otherwise controversial imagery, resulting in demystification of the perception that cultural spaces are inherently "neutral."[30] In October 1992, Sister Karen Boccalero and Tomas Benitez removed an artwork by Filipino artist Manuel Ocampo from *Monster? Monster!,*" a group exhibition that commemorated the quincentennial of Columbus's arrival in the Americas. The work was removed from the exhibition on the grounds that it featured a caricatured depiction of a Black man that upheld racist stereotypes. The decision generated an accusation that SHG had censored Ocampo, but Boccalero's and Benitez's comments regarding the removal of the work spoke to a deep understanding of how the potential harm the artwork could cause was heightened by the social and political context surrounding the exhibition.[31] In particular, the exhibition came on the heels of five days of unrest throughout Los Angeles that followed the acquittal of the police officers who had been filmed beating Rodney King.

Additionally, the exhibition took place during the culture wars, when the National Endowment for the Arts was the target of politically conservative vitriol due to the funding of artworks that were considered "obscene." Benitez and Boccalero both noted that the imagery in Ocampo's piece would offend local community members and that the potential existed for the artwork to ignite resentment and anger in the aftermath of the uprising. Moreover, Ocampo's use of stereotyped imagery of African Americans in the context of an artwork raises questions regarding the ethics and implications of a non-Black artist engaging with this imagery linked to an extensive history of racialized violence and trauma.[32]

Noni Olabisi's participation in the 1999 Maestras Atelier, however, speaks to SHG's awareness of the need to support the practice of artists who had been the center of heated public discussion. Olabisi's mural *To Protect and Serve* was denied funding by the Department of Cultural Affairs following a successful proposal to SPARC as part of the Neighborhood Pride Mural Program. The mural referenced historical imagery exposing the violent conditions to which the Black Panther Party for Self-Defense responded, highlighting the Panthers' embrace of the Second Amendment as a form of self-

protection and their creation and operation of nationwide programs such as breakfast for schoolchildren and other free food programs. Although objections to the mural may have cited individual motifs, such as the inclusion of guns, they were rooted in a broader ideological opposition to the visual representation of Black self-determination.[33] Controversy over the work evolved and extended into the mid-1990s, meaning that when Olabisi participated in the atelier in 1999, the controversy was still fairly recent.[34]

Olabisi joined the Maestras Atelier at the invitation of Yreina Cervántez; both artists had created murals through SPARC's Citywide Mural Program.[35] During the atelier, Olabisi created *King James Version,* a print that depicts an enslaved person with bound hands whose back is bleeding (fig. 3.3). The background, rendered in crimson, features a Ghanaian fertility figure and the silhouette of a person who has been hanged. Beneath the enslaved person, the foreground features the Bible, open to a chapter in Leviticus, and a gun. Olabisi drew upon imagery from the film *Sankofa* (1993) when developing the print, and the piece shares a cinematic quality with her large-scale mural projects, due to her use of a montage-like composition. *King James Version* also maintains Olabisi's signature palette of red, black, and gray—with a singular gold accent placed between the eyes of the figure, recalling the location of the third eye and suggesting ancestral wisdom.[36] Her consistent use of this palette, and her use of crimson in particular, can be understood as an invocation of a Black Atlantic collectivity that fostered syncretic spiritual practices, made visible through the reference to the fertility goddess alongside the Bible.[37] This sense of duality carries throughout the work, as the Bible was used to justify the institution of slavery while also serving as the text by which some enslaved people were able to learn how to read, just as the gun can be read as a symbol either of suppression or of self-preservation.

The following year, Mark Steven Greenfield worked with stereotyped images of African Americans through his participation in Atelier XXXIV (fig. 3.4). The series of works he created drew upon his collection of photographs of white Americans performing in blackface.[38] The series examined the images as a "source of disturbance and fascination" for the artist.[39] Greenfield reproduced the photographs in a silk-screen format and superimposed text over the images. Throughout the series, Greenfield formats the text to resemble an eye chart featuring letters arranged in rows that decrease in size, forming a pyramid. Greenfield's recontextualization of racist imagery links his work to other Black artists, such as Betye Saar, Fred Wilson, and Kara Walker, who have worked with minstrel imagery and stereotyped representations of African Americans. Greenfield's reference to eye exams also coincides with a series by Kerry James Marshall from the early 2000s that used the circular and color-variant forms of the Ishihara colorblindness test.[40] The creation of these works within the context of SHG, however, offers a generative lens for understanding the significance of Greenfield's work.

Similar to work by other artists, Greenfield's prints intervene within the historical usage of blackface and minstrel performance as a tool to remediate Black bodies in a way that naturalized whiteness and reified a "national understanding of racial distinction."[41]

FIGURE 3.3

Noni Olabisi, *King James Version*, 1999. Screenprint, image: 26½ × 19¼ in., sheet: 30¼ × 22 in., edition of fifty-eight, printed by José Alpuche, Maestras 1/Atelier 33. Self Help Graphics & Art Archives, California Ethnic and Multicultural Archives 3, University of California, Santa Barbara Library. Courtesy of the artist.

FIGURE 3.4

Mark Steven Greenfield, *Untitled (Some Indignities Persist)*, 2000. Screenprint, image: 25 × 18 in., sheet: 30 × 22 in., edition of fifty, Special Project. Self Help Graphics & Art Archives, California Ethnic and Multicultural Archives 3, University of California, Santa Barbara Library. Photograph by Self Help Graphics & Art. Courtesy of the artist.

This understanding relied on the construction of a Black-white racial binary, which persists despite ongoing critique and refutation. Many works with which Greenfield's series are in conversation maintain the assumption of this binary through a racialized gaze that is implicit in the work. For example, when Walker's silhouettes are installed within mainstream gallery contexts, she can presume that the viewing audience will be predominantly white.[42] This creates a dynamic within which the artist, as a Black woman, stages a reckoning where the viewer will presumably interrogate their response to the often explicit imagery in her work that is itself drawn from white artists' graphic, exaggerated representations of Black people.

Through their creation at SHG, Greenfield's prints expand the presumed racial binary that viewing such work entails, instead positing "Blackness" and "whiteness" as constructed racial concepts to which viewers may understand themselves as in differing proximity, depending on a given context. Specifically, SHG's refusal to presume an ethnoracially homogeneous viewing audience complicates the tendency to uphold a racial binary in how Greenfield's artwork might be read. Additionally, embedded within SHG's mission centering Chicanx and Latinx communities is an awareness of the ways that these communities directly challenge and complicate the notion of a Black and white racial binary. As a result, this creates an additional interpretive layer to Greenfield's work: in this context, it is possible to understand the prints as inviting viewers to examine their own proximity to these experiences of racialization.

Compared to Marshall's invocation of color-blindness tests (and the implied pun on "race blindness"), Greenfield's use of eye charts cannot deliver a "positive" or "negative" test result for the viewer in the same way that the Ishihara test indicates what kind of color blindness a person experiences. Instead, Greenfield's works ask the viewer to question whether they pull the lever on the "trap door of racism" or fall through it, and whether they can make out the fuzzy edges of racial violence enacted at the level of the microaggression.[43] Greenfield's prints suggest that underlying the banal and mercurial ways that racism occurs is the specter of Blackness created to uphold white supremacy.[44]

COUNTERING NEOLIBERAL MULTICULTURALISM THROUGH COLLABORATIVE FRAMEWORKS

Beyond the Atelier Program, SHG has played a significant role in connecting artists from different Los Angeles communities through programming and participation in collaborative initiatives. SHG is part of a complex network of art institutions throughout the city that share missions to advocate for artists who have been historically underrepresented within cultural institutions and to preserve the histories of marginalized ethnoracial populations.[45]

SHG was a collaborating institution for "Finding Family Stories," an eight-year, cross-institutional initiative led by the Japanese American National Museum that sought to foster dialogue through partnerships between cultural institutions and art-

ists. "Finding Family Stories" emerged in response to the aftermath of the 1992 LA uprising, which coincided with the opening of the museum, prompting the institution's leaders to consider what role they could play within LA's diverse communities.[46] As a result, the project prioritized cultivating dialogue across communities.

The thematic frame of family stories offered a meaningful foundation from which to build a dialogue, and the three institutions that participated in the project in 1999 were uniquely poised to nuance this frame by drawing upon the complex and interconnected histories of Japanese Americans, Chicanxs, and African Americans in Los Angeles. This iteration brought together SHG, the California African American Museum, and the Chinese American Museum, institutions that share a commitment to foregrounding the historical and cultural contributions of communities that are often marginalized within mainstream museums. "Finding Family Stories" also expanded to include the selection of eight artists who would serve as partners for the project: Sandra de la Loza, Teresa Hagiya, Patrick Hebert, Betty Lee, Michael Massenburg, Dominique Moody, Jose B. Ramirez, and Steven Yao-Chee Wong.[47] This project, which took place over three years, involved the creation of original works for the multisited exhibition and the artists' development of the project alongside staff from the institutions.

The organization and duration of "Finding Family Stories" distinguish it from other collaborative initiatives within museums in several ways. First, the inclusion of artists as stakeholders, on a comprehensive level, in the project's development offered a structural reimagining of the artist's role within a cultural institution that challenged power dynamics within predominantly white, mainstream museums. Second, the project's multiyear duration supported substantive engagement between artists and institutional staff, and inverted conventional power dynamics that render artists' voices invisible within cultural institutions. Outside of having their work acquired for an institution's permanent collection, living artists are not represented within museums and lack a substantive voice to help shape the institutions that purport to represent them. Although participation in residencies theoretically offers a venue through which an artist can pose an intervention within a museum's space, the brief format of the residency all but guarantees that even interventions that bring to light sophisticated critiques of the institution will be limited in their impact, or co-opted as an indication of the institutions' receptivity to criticism. Finally, the hierarchical dynamic characteristic of predominantly white cultural institutions is not inherent to the community-centered institutions that participated in "Finding Family Stories." Both the Watts Towers Arts Center and SHG, for example, were founded by artists. Throughout both organizations' histories, artists have taken on key leadership roles. By contrast, although artists often work within predominantly white cultural institutions, their insights and experiences as artists are not often consulted or considered.

"Finding Family Stories" can be understood as shaped by the imperatives that informed institutional initiatives during the 1990s and early 2000s. For example, the civil rights movement's calls for self-determination and cultural reclamation resulted

in mainstream cultural institutions offering conciliatory measures of representation to historically underrepresented and disenfranchised communities while leaving exclusionary structures intact. These gestures, while resulting in demographic shifts within collections and institutional staff, ultimately suggest that mainstream institutions are capable of reform despite their entanglement with colonial ideologies, allowing the institutions and the inequities they reproduce to remain standing in the face of ongoing critique. By the early 2000s, this resulted in a false dichotomy in which work by artists of color that makes reference to their identity either is eclipsed by their identity, or is considered aesthetically or conceptually rigorous only if the artist eschews references to identity in their work.

"Finding Family Stories," however, offers a compelling example of how a cohort of institutions and artists found agency under circumstances defined by constraint for mainstream cultural institutions. For example, the institutional missions of SHG, the Japanese American National Museum, and the California African American Museum have historically been grounded in an understanding that the communities they represent are culturally rich, complex, and deserving of attention and preservation, whereas predominantly white institutions may have viewed multiculturalism as analogous to a wheel, on which other ethnoracial groups' experiences and histories were spokes, emerging from a center defined by whiteness. Efforts to make mainstream institutions more multicultural within a neoliberal context, though often lauded upon their launch, inevitably fail due to a lack of administrative or financial investment. They also typically prioritize the transformation of cultural institutions at the scale of the individual, making it possible to overlook structures that generate exclusion and hostility toward people of color.

"Finding Family Stories" contradicts these premises through its emphasis on a sustained practice of collaborative thinking across institutions where whiteness has been decentered. This ethos carried into the conversations between artists. Michael Massenburg, a muralist and public artist who participated in the project, spoke about how the artists in "Finding Family Stories" formed a cohort that endured beyond the project's duration.[48] The collaborative setting of "Finding Family Stories" offered a space for the artists to discuss their process and the development of their work that differed from the educational setting of a studio critique. One element that supported the formation of this cohort was the artists' memories of having to explain and contextualize their work for a predominantly white audience in past contexts.[49] Although the participating artists created artworks that spoke to a wide range of experiences and utilized an array of media, they were freed from the obligation to justify their work's existence that shaped their experiences in other settings.

Massenburg created a mixed-media work titled *In Time* for the exhibition. The work drew upon the artist's efforts to learn about his family's history from fragmented information that he was able to collect. In 2003, Massenburg created a print at SHG, titled *Grandpa James,* that speaks to his complex and serendipitous process of recovering this history (fig. 3.5). The work is based on the only photograph Massenburg

FIGURE 3.5

Michael Massenburg, *Grandpa James*, 2003. Screenprint monoprint, 16 × 22 in. Courtesy of the artist.

possessed of his paternal grandfather, who passed away in 1969.[50] The artist came into possession of the photograph not through encountering it in a photo album owned by his family, but while attending a gallery reception with his mentor, Cecil Fergerson, a renowned arts advocate and curator. At the reception, two other attendees, who were his grandfather's former neighbors, asked him if he knew James Massenburg, before handing him an envelope with family photos, including one of his grandfather.[51] These photos became a significant reference point throughout his participation in "Finding Family Stories" and the creation of two prints at SHG.

Grandpa James offers an evocative visual exploration of Massenburg's experience retracing his family's history. In developing the print, the artist created the composition freehand, using the photograph of his grandfather as reference.[52] The piece also draws upon Massenburg's assemblage-driven approach to artmaking, in which he salvages discarded objects and fragmented narratives in order to bring new histories to light. He has likened this process to improvisation in the sense that, as an artist, he has honed his ability to respond to the material he encounters.[53] In *Grandpa James,* this occurred through Massenburg's decision to create the print without an overarching sketch to guide the initial draft, providing the artist with spontaneous shifts in the work to which he could respond. The print has an ethereal, expressive quality reminiscent of a watercolor painting. The titular figure stands in the foreground in a pale suit, his gaze cast away from the viewer. A horizon line distinguishes a clouded, turbulent green and goldenrod sky from the ground. Behind the man's shoulder, a road rendered in shadowy blues and purples winds back toward a structure in the distance. A silhouetted child appears to be running toward the man.

Massenburg's emphasis on the expressive qualities of color in the print creates an impression that the viewer has entered a dreamscape or is witnessing a lost memory reanimated. In several places, it appears as if the white surface of the paper peeks through dense patches of color, suggesting the fibers of the screen, gesturing toward the malleable sense of the real and unreal that arises when retracing one's family history. To the right of the figure, the cloudy and shifting fields of color are reminiscent of the tonal distortions that indicate photographs damaged by age. The piece depicts a moment of departure and could be read as a break in generational ties. This fragmentation is a recurring element in Massenburg's family history that extends to his enslaved ancestors who faced the impossibility of maintaining a familial structure under those conditions.[54] Post-emancipation, the prospect of better opportunities beyond the US South led many African Americans to relocate farther North and West. This scale of movement, however, inherently poses a challenge to the extensive preservation of family memorabilia and maintenance of ties to extended family who remained in place.

The difficult inheritance of family histories that are lost or hidden as a result of racial trauma and violence is one that links Black Angelenos with Japanese Americans

FIGURE 3.6

Tomie Arai, *Double Happiness,* 2000. Screenprint, image: 25 × 31 in., sheet: 30 × 35 in., edition of forty-two, printed by José Alpuche, Special Project. Self Help Graphics & Art Archives, California Ethnic and Multicultural Archives 3, University of California, Santa Barbara Library. © 2000 Tomie Arai. Courtesy of the artist.

and Chicanxs. For example, the descendants of Japanese Americans who were detained in relocation centers have sought to recover histories and experiences their relatives did not share with them. Similarly, Mexican Americans whose elder generations were abused for speaking Spanish have sought to acquire the language skills their families were forced to conceal.

SOLIDARITY IN AN ERA OF POLITICAL DIVISION: SHG IN THE TWENTY-FIRST CENTURY

An awareness of the distinct experiences that connect communities in Los Angeles is apparent in *Double Happiness* (2000), a print created by New York–based artist Tomie Arai as part of the "Artists & Communities" residency initiative at SHG, presented by the National Endowment for the Arts and the Mid Atlantic Arts Foundation (fig. 3.6).[55] The work overlays family photographs with an image of a young girl eating with chopsticks.

Arai's residency at SHG took place over six months and coincided with the 2000 election, a time that particularly heightened the perceived differences and political divisions between communities, due to the controversy surrounding the election's outcome.[56] Throughout the composition, Arai arranges *hanafuda* and *Lotería* cards, emphasizing their shared use of simple yet striking imagery and bright colors, suggesting the delight of play and the capacity of the graphics to speak across cultural contexts. A street map of Los Angeles is faintly visible in gray against the piece's black background, suggesting the ways that culture moves beyond geographic borders throughout the city. During her residency, Arai stayed in a neighborhood that was adjacent to three distinct communities, Monterey Park (home to one of the largest suburban Chinatowns), Little Tokyo, and East Los Angeles, prompting her to learn about Boyle Heights' history as a multi-ethnoracial community.[57] The experience of driving from Monterey Park to East LA further invited Arai to contemplate how people have adapted to cultural shifts against the physical and administrative structures—such as forced relocation, freeways, and redlining—that have divided communities.[58]

In the years following Arai's residency, the significance of artists' engagement with histories of cross-ethnoracial solidarity and the necessity of cultivating them in the present moment took on a heightened urgency. The election and subsequent reelection of Barack Obama, the United States' first Black president, revealed the profound extent of racial resentment and hatred held by white Americans. Donald Trump, the subsequent occupant of the White House, stoked this sentiment using violent rhetoric, which accelerated and deepened existing crises related to immigration, police violence, white supremacist domestic terrorism, and poor health outcomes for Black and Brown Americans. SHG and the community of artists connected to it have met these crises by continuing an enactment of solidarity that has carried throughout SHG's history.

In September 2019, this cross-ethnoracial solidarity became the subject of an exhibition curated by Nery Gabriel Lemus and Jimmy O'Balles titled *Black, Brown, and Beige,* which underscored the shared experiences of racism and discrimination that Black and Latinx people encounter despite the expansive range of identities that the terms encompass.[59] The exhibition, which featured artworks in a wide range of media, included works created at SHG by Black artists, such as Willie Middlebrook, as well as a new body of work by Mark Steven Greenfield that had not previously been shown at SHG.

Amid the start of the COVID-19 pandemic in the spring of 2020, ongoing crises surrounding police violence against people of color took on heightened national visibility following the murders of people such as George Floyd and Breonna Taylor. Sustained public unrest called for justice to be enacted at the level of ensuring that officers were charged for the violence they committed, alongside broader demands for funding to be diverted away from police departments and invested in community-based alternatives.[60] During this time, large-scale cultural institutions had their statements expressing solidarity with and support for Black Lives Matter scrutinized and critiqued on the

FIGURE 3.7
Andi Xoch, *Black Lives Matter*, 2020. Screenprint, dimensions unknown. Courtesy of Ni Santas.

basis that their hiring practices, permanent collections, and exhibition histories suggested a long-standing indifference to internally addressing these inequities.

SHG's sustained attention to these issues, and to other issues that shape the lives of the communities to which it is connected, made it possible for the organization to use its resources and platform to support timely and community-centered responses to state-sanctioned violence. For example, Ni Santas, an autonomous, womxn of color–led collective, held live-printing events at SHG in June 2020, creating posters and graphics for protesters en route to demonstrations. One print by Andi Xoch featured the words *Black Lives Matter* in gothic script against a background with monstera leaves and the hashtag #DefendBlackLife at the bottom of the composition (fig. 3.7). Similarly, SHG and the artists affiliated with it have developed strategic responses to policies that threaten the lives of undocumented immigrants in Los Angeles, such as the creation of informational posters regarding the rights of immigrants under threat of an Immigration and Customs Enforcement raid. Artists have also created work responding to the conditions faced by families seeking asylum at the US-Mexico border, including separation of children from their parents and their detention.

In the 2020 Día de los Muertos exhibition, curated by Sandy Rodriguez, Devon Tsuno and Shizu Saldamando created *ofrendas* that linked these conditions to the

FIGURE 3.8

Devon Tsuno, *Kiyoko Shimabukuro* ~~(Shikata ga nai)~~, 2020. Mixed-media installation, archival inkjet prints, variable dimensions. Courtesy of the artist.

internment of Japanese Americans (figs. 3.8 and 3.9). Tsuno's piece, titled *Kiyoko Shimabukuro* ~~(Shikata ga nai)~~, was a tribute to the memory of his grandmother, who was incarcerated from 1946 to 1948. The piece incorporates elements of a traditional *ofrenda*, such as fresh flowers and fruit, with references to the experiences of internment, such as stories written by Japanese American teenagers during that time. There is a persistent sense of the way that traces of the past not only linger but shape the present: the background of the work features photographic wallpaper that shows the physical traces of the barracks that housed Tsuno's family.[61] Azaleas offer a poignant sense of the relationship between the past and the promise of an unknown future: in addition to fresh blooms, Tsuno includes an image of an azalea bush planted by his grandfather, a gardener, for a client in Beverly Hills in the early 1950s, suggesting the ability to flourish beyond and in spite of the experience of internment.

The ability to imagine a future amid a present in which entrenched, institutional, white supremacist violence has been given greater visibility through its unchecked expansion is a quality shared between Tsuno's work and Shizu Saldamando's piece, *When This Is All Over. . .*, which uses a segment of found chain-link fence as the structural support for a wreath of paper flowers made by the artist. The upper edges of the fence are broken, suggesting the possibility of opening or escape against the rigidity of the structure. The flowers, made from Washi paper, were inspired by a craft book that the artist found in the archives from the Manzanar prison camp. Interned Japanese

FIGURE 3.9

Shizu Saldamando, *When This Is All Over. . .*, 2020. Mixed media, washi paper flowers, wire, found chain-link fence, 4 × 3½ feet. Courtesy of the artist and Charlie James Gallery.

Americans created paper flowers to honor the deceased because they did not have access to fresh flowers.[62] Although the piece suggests a link between the internment of Japanese Americans and those imprisoned at the US-Mexico border, the artist takes a wider view, suggesting that new forms of solidarity emerge from a shared understanding that all forms of imprisonment are unjust.

FIGURE 4.1

Maestras Atelier 33, 1999. Left to right: Yolanda M. López, Barbara Carrasco, Delilah Montoya, Favianna Rodriguez, Diana Gamboa, Margaret Guzmán, Patricia Gómez, Yreina Cervántez, and Laura Pérez. Not pictured: Noni Olabisi, Rose Portillo, and Laura Alvarez. Courtesy of Self Help Graphics & Art.

staff, and participating artists, I outline the unique legacies and experience of the Maestras participants and administrators. Several of the prints produced during the debut Maestras Atelier have gone on to great acclaim, such as Carrasco's *Dolores* and Cervántez's *Mujer de Mucha Enagua, PA' TI XICANA*. I argue that many of the works' inspiration and iconicity are due to the Maestras residency cohort acting as a Xicana feminist site of artistic production. This essay highlights the images' contextual development within the SHG atelier space. I posit that this debut Maestras cohort fundamentally changed the SHG residency in several ways. The artists' contestation of the SHG institutional copyright agreement resulted in a new one protecting sole copyright to artists. Xicana feminist recovery practices in the residency's conceptual structure aided in the resurgence of historical women such as Mexican colonial scholar Sor Juana Inés de la Cruz (1651–95) and of contemporary Chicana activist Dolores Huerta. Also, the techniques employed by an emerging Maestras artist, Favianna Rodriguez, debuted the change in SHG's use of digital technology in the printing process.[5]

From the colonial era to the contemporary moment, cross-generational inspiration reflects the chronological interplay that defined the Maestras Atelier. SHG approached the Maestras program as a reparative effort for its historical underrepresentation of women printmakers. The Maestras's success relied on SHG resources such as equipment and printing expertise, but I argue that the participating artists benefited

most from the intergenerational mentorship within the cohort. By offering a professional, unified space for these select women printmakers, SHG transformed into a professional, feminist artistic exchange site.

SHG afforded the Maestras artists a gateway to becoming more skilled printmakers, but it was the cohort's unifying efforts—for example, around demanding greater rights regarding artistic copyright of their artwork—that truly redefined SHG's relationship with its artists. Therefore, SHG and the Maestras artists mutually educated one another regarding printmaking, artists' rights, and the role of women printmakers in graphic art history.

THE MAESTRAS ATELIER

SHG's community advocacy has been the cornerstone of the institution since its cofounding by Sister Karen Boccalero, Carlos Bueno, and Antonio Ibañez in 1973. After a decade of arts programming, in 1983, the print residency became the centerpiece of artistic programs. Dedicated to underserved artists often unfamiliar with the screenprinting process, the residency affords artists access to SHG's printmaking facility, a master printer, and half of their print edition.[6]

Previous artists and employees mention that during Sister Karen's administrative years, she prioritized the artistic process and exchange among the cohort of resident artists.[7] There was an institutional idealism centered on the notion that artists did not create artwork to sustain the institution financially. Instead, the partnerships and education between the master printer and artists was the incalculable metric that gave SHG its intrinsic value. After Sister Karen died in 1997, Tomas Benitez led the institution until 2005. As part of this shift in administration and with the exodus of the last institutional founder, Benitez declared a rebranding initiative effort in which "no less than a third of our activities are specifically directed toward women."[8] In conversation with SHG administrator Patricia Gómez and master printer José Alpuche, Benitez collaboratively decided that SHG would highlight women artists to remedy the gender disparity of the print residency's past.[9] Benitez invited Cervántez to curate this new initiative, known as the Maestras Atelier.[10]

This guest curator format would begin a recurring effort, spearheaded by Benitez. He aimed to select artist-curators who "have earned their accolades" and would grant them oversight on SHG's artistic direction.[11] This was also an administrative maneuver to move out of the shadow of Sister Karen's legacy. Benitez was eager to disrupt what he referred to as the "single vision, and one person" organization to a more "diversified leadership."[12] This format was also a financially viable strategy, given SHG's limited funds to hire additional staff specifically dedicated to the print residency.

As a result of Cervántez's participation in previous SHG ateliers, she supported Sister Karen's idea of collaborative artmaking, whereby artists were required to discuss outcomes together as an atelier cohort.[13] Cervántez's efforts were to continue this practice of collaborative sharing of knowledge as a form of a vital artistic mentorship.

Therefore, when asked to develop her artist list, she specifically invited emerging artists, cross-disciplinary creators, and professional artists who had participated in previous SHG residencies. There were younger, emerging artists such as Laura Alvarez and Favianna Rodriguez, who were beginning to define their artistic practice; non-printmakers, such as painters Margaret Guzmán and Noni Olabisi; veteran stage actress Rose Portillo, who was new to printmaking; major, professional Chicana artists well trained in printmaking; and SHG regulars such as Barbara Carrasco, Diane Gamboa, Yolanda López, Delilah Montoya, Patricia Gómez, and Cervántez herself. Cervántez was eager to direct a professional exchange among a broad spectrum of women who could benefit from one another in the studio. She also invited scholar Laura E. Pérez to write an essay about the Maestras Atelier.[14]

The acceptance letter sent to the participating artists outlined the Maestras Atelier's objectives of cross-professional pairing: "The Maestras Atelier has been organized to enhance greater participation of women in the printmaking activity at Self Help Graphics, as well as to provide a unique and timely mentoring opportunity between experienced printmakers and other women artists new to our studio."[15] Cervántez lays out the following conceptual prompts, asking the artists to "consider the ideas and images which [one] may distill from any of the themes": Sor Juana Inés de la Cruz; Goddesses, Icons, and Heroines; and Erotica.

The emphasis on Sor Juana Inés de la Cruz, a nun in seventeenth-century viceregal New Spain, was part of an interdisciplinary community effort. Benitez and Portillo suggested to Cervántez that the historical Sor Juana should act as a thematic foundation for the Maestras artists, to coincide with the 1999 About. . .Productions play *Properties of Silence*.[16] In this production, veteran actress and Maestras artist Portillo plays Sor Juana as part of an interdimensional exchange between the colonial figure and a repressed woman living in present-day Phoenix.[17] This cross-partnership brainstorm to honor Sor Juana was part of an ongoing "resurrection" by authors, playwrights, poets, and scholars who reclaimed the colonial nun as an icon of feminist empowerment, Chicana lesbians, and Mexican women's literature in the twentieth century.[18] After these initial conversations with Benitez and Portillo, Cervántez employed this lesser-known historical figure to ground the Maestras program in a pan-historical and conceptual feminist intellectualism.

The other two thematic groups provided an expansive thematic opportunity for the Maestras artists. A benefit of having a Chicana artist, such as Cervántez, as the curator for this cohort was her awareness of recurring themes in Xicana feminist art and the presence of such themes among her selected artists' work. Cervántez elaborates on her curatorial strategy and its connection to her own artistic practice:

> These other themes, erotica and Goddesses, heroines and icons I felt were important in terms of giving voice to a liberatory Xicana feminist perspective and imagination. These were also themes that allowed for very diverse interpretations based on the complexity of experiences from the different mujeres/artists. Also, these were themes I was very much

interested in expanding on in my own artwork as well; contemplating those intersections of gender, sensuality, sexuality, Native American spirituality and Xicana feminist politics, which I hoped would be inspiring for the group. I was extremely pleased with the powerful expressions and varied results and styles from all the women.[19]

Cervántez grounded her vision for the Maestras project on Xicana scholar Ana Castillo and her concept of Xicanisma. In her canonical publication *Massacre of the Dreamers*, Castillo coined the term *Xicanisma* to refer to Chicana feminism, as part of a philosophy that helps women "be self-confident and assertive regarding the pursuing of [their] needs and desires."[20] The use of the "X" in lieu of the "C" for Chicana also recalls Nahuatl, the Indigenous language predominant in central Mexico, to promote *indigenismo* as a central tenet in Xicana consciousness.[21]

Historically, SHG's inception, creation, and mission supported aspiring Chicana/o artists and provided community arts programming efforts for East Los Angeles since the 1970s. However, a concentrated effort to focus solely on women artists had not been a programmatic priority within the print residency. The decades-long underrepresentation of women artists in the print residency was an evident concern among the administration. As curator, Cervántez grounded the Maestras project in Xicana feminism. I argue that this curatorial ideology informed the selection of artists and ultimately resulted in a cohort that demanded unprecedented professional changes to the SHG institution and its relationship to artists.

There were four mandatory Maestras Atelier meetings during the residency season, and all artists were required to be present during the development of their print with SHG master printer José Alpuche.[22] These meetings were an orientation, mentorship exchange, artistic critique, and professional development (fig. 4.2). Beyond the residency requirement, the meeting space, as participating artist Laura Alvarez remembers, was a rare occasion for her to be part of an arts space consisting of all women of color.[23] Given the participatory nature of the cohort, SHG's space allowed the artists to have a greater sense of creativity and enabled their artistic voices to be heard among one another and, eventually, as a unified collective front.[24] As previous SHG employees and participants recall, the final artwork was not the sole objective of the artist's presence. Instead, the residency's success must also be recognized in the process of its production.

Cohort selection was vital in striking a balance and providing a fruitful and comparable relationship. The multigenerational makeup of the cohort included elder Chicanas who had overcome generations of historical neglect. In two articles included in the 1977 "La Mujer Special Issue" of the Chicano arts publication *ChismeArte*, Chicana scholar Sybil Venegas wrote some of the earliest reflections acknowledging Chicana art's need for recognition.[25] In "Conditions for Producing Chicana Art," Venegas maps out the dramatic changes for Chicanas, including challenging the patriarchy of marriage and the restraints of Catholicism, and demands that Chicana artists receive equitable treatment within Chicano art recognition.[26] In "The Artists and Their Work—The Role of the

FIGURE 4.2
José Alpuche and Patricia Gómez
at one of the four mandatory
Maestras Atelier meetings,
1999. Self Help Graphics & Art
Archives, California Ethnic and
Multicultural Archives 3,
University of California, Santa
Barbara Library. Courtesy of Self
Help Graphics & Art.

Chicana Artists," Venegas recognizes Chicana artists who were active across the nation, highlighting several muralists and the not-yet-iconic feminist works of Chicana print-makers: Ester Hernandez's *La Virgen de Guadalupe Defendiendo los Derechos de los Xicanos* and Maestras artist Barbara Carrasco's *Pregnant Woman in a Ball of Yarn.*[27] While individual Chicana artists and their prints would become the subject of dedicated scholarship, not until 2001—with the publication of Holly Barnet-Sánchez's essay "Where Are the Chicana Printmakers? Presence and Absence in the Work of Chicana Artists of the Movimiento" in the *Just Another Poster?* exhibition catalogue—was a scholarly analysis dedicated solely to Chicana contributions to printmaking.[28]

Cervántez's Maestras curation included several prominent Chicana printmakers featured in these publications. Pairing these elder artists and the younger generation further progressed Chicana and BIPOC women's contribution to feminist art by creating a multigenerational cohort, a combined force of mentorship and skill sharing

between the older and younger artists. Despite the art historical neglect, the younger artists' recognition of the elder artists' work and their impact is a testament to the efficacy of their works among the Chicana artistic community. As Barbara Carrasco remembers, Cervántez's selections created an environment of self-respect among the artists:

> That's the great thing about this workshop is that Yreina Cervántez has really selected all the artists. That's what she wanted to do is connect younger artists with older artists, or more mature artists. And I think she did that really well because even among the older artists, we sort of all respect each other pretty much. And it's really nice to hear a young artist say that they were really inspired by my early work. And "Oh, I know this work." Or "I know that work. It's really me. I can relate to it." Or "I just really like it. It's inspired me to do this or that." It's just really great to be in a place where you can talk about all those influences.[29]

A younger participant, Laura Alvarez, remembers the initial group sessions diverting from printmaking and quickly realized that this grouping "isn't just about the print."[30] The air of camaraderie, support, and the noncompetitive environment were unfamiliar to Alvarez. She recalls anticipation in meeting elder Chicana artists she had heard of but never met. To her surprise, these artists, including Barbara Carrasco, would play mentorship roles for her throughout her print's development.[31] Alvarez's experience is a testament to the success of Cervántez's pedagogical objectives. This multigenerational curation is a supportive curatorial framework that contrasts elder artists' evolutionary tracks of solo exhibitions and cloistered younger artists' group shows of "emerging artists." Countering traditional professional arts formats of professional legitimacy and valuation, this framework showcases the fundamental effort informing Cervántez's selection of the cohort: to enact Xicana feminist change.

As Tomas Benitez requested, the atelier meetings began with an orientation.[32] What could have been a boilerplate interaction turned into a moment that would redefine the SHG protocol and the organization's relationship to the artists. While reviewing the initial certificate of authenticity between the artists and SHG, artist Yolanda López declared that she would not sign this SHG paperwork.[33] According to the SHG's initial agreement form, the artists would not retain the full copyright of their finalized image; instead, SHG would hold the sole copyright of the artists' created work.[34] Benitez recalled that Sister Karen put this in place as a way to "protect the artist."[35] However, after López declared her opposition to this clause of the certificate of authenticity, Diane Gamboa and several Maestras also refused to sign their agreements because they could not retain their artistic copyright.

Looking back, Cervántez argues that López's participation was crucial to educating all the artists, including herself, regarding artists' rights.[36] This initial contestation began an extended process between Benitez, Cervántez, and the participating artists

FIGURE 4.3

Yreina D. Cervántez, *Mujer de Mucha Enagua, PA' TI XICANA*, 1999. Screenprint on paper, image: 17⅞ × 26 in., sheet: 22 × 30⅛ in., edition of sixty, printed by José Alpuche, Maestras 1/Atelier 33. Self Help Graphics & Art Archives, California Ethnic and Multicultural Archives 3, University of California, Santa Barbara Library. © 1999 Yreina D. Cervántez. Courtesy of the artist.

decades. In developing her Maestras print *Mujer de Mucha Enagua, PA' TI XICANA*, she decided to engage with the historical, seventeenth-century nun Sor Juana Inés de la Cruz (fig. 4.3).[44] Despite being a significant historical scholar and poet of the Spanish Golden Age, Sor Juana was not a recurring feminist icon within Chicana visual culture at this time.[45]

Sor Juana's reclamation from the annals of history is associated primarily with recognizing her as a feminist icon of the Americas, but also with distancing Sor Juana readings from Octavio Paz's previous, heteronormative—and, as contemporary Chicana scholar Alicia Gaspar de Alba bluntly puts it, "homophobic"—interpretations of her life.[46] Paz notoriously denounces any queer readings of Sor Juana that suggest she was in a lesbian relationship, among other feminist approaches.[47] Alicia Gaspar de Alba reclaims Sor Juana's legacies, using modern, queer nomenclature to identify Sor Juana as a lesbian separatist feminist who cross-dressed as a nun.[48]

Cervántez then continued a practice similarly invoked throughout the annals of Chicanx art history, wherein the artwork would serve as an aestheticized, alternative history: a graphic pedagogical form that facilitates the learning of elided historical

subjects. The rearranging of temporalities in a visual maelstrom is quintessential to Cervántez's artwork. Fusing her own likeness with ancient Mesoamerican forms is part of this artist's visual lexicon. She often places herself at the nexus of these anachronistic interplays, as in 1983's *Danza Ocelotl,* produced at SHG (fig. 4.4). This practice is a commonly inculcated approach among Chicanx artists. However, Cervántez's incorporation of literature and her amalgamation of ancient, colonial, and contemporary writing systems, particularly in reference to the subject of women characters and authors, makes her contribution to the Maestras Atelier all the more appropriate for diversifying Chicana artists and feminist art history.

To resurrect and interconnect Sor Juana's legacies, Cervántez's *Mujer de Mucha Enagua* incorporates and recalls portraits of Sor Juana, of Zapatista leader Comandanta Ramona, and of early twentieth-century poet Rosario Castellanos (1925–74) as part of an honorific trinity (fig. 4.3).[49] Cervántez's works are a pastiche of literary devices, connecting her aesthetic approach to the poetry and prose of her featured feminist historical figures. Beginning with the objective of this print's title, a Zapatista honorific phrase acts as a prologue to the decolonial feminist goal that undergirds the work. Ellen Calmus's essay "We Are All Ramona: Artists, Revolutionaries, and Zapatistas with Petticoat" details the phrase's origins: "They told me that when a woman is very *activista,* they call her *mujer de mucha enagua:* 'woman with a lot of petticoat.'" Calmus notes that this "revealing image" is "key to understanding the women Zapatistas: unlike the European tradition of women who may assume political and military prowess, but whose doing so is assumed to involve a loss of femininity, these women consider a woman's activism to mean she has 'a lot of petticoat': she is a real woman."[50] Cervántez uses this honorific in her print's title, *Mujer de Mucha Enagua,* and she directly dedicates this work to feminist and Indigenous-centered women in its dedicatory title, *PA' TI XICANA* (for you Xicana).

The central figures' identification projects through their referent talismans: Sor Juana in her habit, wielding a plumed pen; a Zapatista family with a child holding a Zapatista doll; and a photograph of Rosario Castellanos on Sor Juana's *escudo,* or nun's shield.[51] Cervántez creates a rich tapestry of women's resistance that spans across geographies and time, activating the scene with flowery, ancient speech scrolls to construct a dynamic conversation among her figures.[52] A myriad of referents to text—ancient glyphs, colonial poetry, contemporary activist chants such as the Zapatista saying "Todos Somos Ramona" (We Are All Ramona)—are found throughout the image.[53] The bespeckled backdrop of *Mujer de Mucha Enagua* continues the use of ancient jaguar references found throughout Cervántez's body of work.

Cervántez states that her graphic scene is an affirmation of the "subversive feminine spirit."[54] In each of their contexts, the featured women represented the ambivalent connotations of these changemakers: a threat, an exception, and a visionary. Sor Juana Inés de la Cruz was a writer, intellectual, and scholar who advocated for women's education in famous works such as *Respuesta a Sor Filotea de la Cruz* ("Answer to

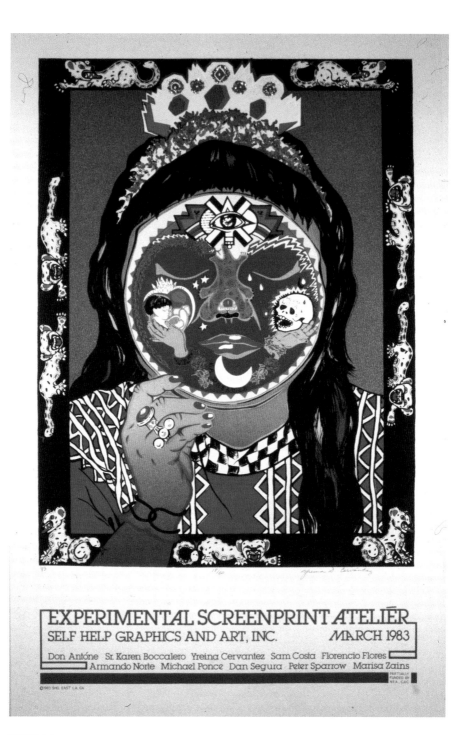

FIGURE 4.4

Yreina D. Cervántez, *Danza Ocelotl*, 1983. Screenprint, image: 37 × 24½ in., sheet: 41¾ × 28½ in., edition of sixty, printed by Stephen Grace, Atelier 1. Self Help Graphics & Art Archives, California Ethnic and Multicultural Archives 3, University of California, Santa Barbara Library. © 1983 Yreina D. Cervántez. Courtesy of the artist.

Sister Filotea").[55] Her many published languages included Nahuatl. As a referent to Sor Juana's advocacy for the Indigenous groups of Mesoamerica, Cervántez overlays a Sor Juana Nahuatl morning prayer invoking the Aztec goddess Tonantzin.[56] Cervántez highlights Sor Juana's supportive relationship to the Indigenous groups of then New Spain while dually reflecting the overwhelming presence of the Indigenous world across a broad temporal chronology.

Captured on Sor Juana's *escudo* is Rosario Castellanos, a Mexican poet native to Chiapas. Castellanos was an advocate for the rights of native groups, such as the Tzotzil in Chiapas, and for feminist rights in Mexico.[57] Her literary efforts rethink the patriarchal oppression bestowed on Mexican mythical figures—La Malinche, for example, in her essay "Once Again Sor Juana."[58] Castellanos, like Sor Juana, used prose as a way to critique the cultural institutions that unfairly waged war on women's access to education. Cervántez overlays Castellanos's poetic excerpts from her poem atop a hand referencing the Great Goddess forms from the murals at Teotihuacan, Mexico.[59]

Cervántez continues her homage to Mexican women with a nod to Ramona, the famous officer of the Zapatista Army of National Liberation (Ejército Zapatista de Liberación Nacional, EZLN). The iconic Zapatista ski masks and bandanas achieved multiple objectives: to conceal the guerrillas' identities, to visually unify them, and to make visible Indigenous communities that have long felt invisible in Mexico.[60] As part of the efforts of the EZLN to decentralize their movement and move away from the public face of Subcomandante Marcos, the revolutionary organization emphasized the role of Comandanta Ramona. She quickly became a favorite among Indigenous women. The women chant the phrase "Todos Somos Ramona" in support of her, further promoting the concept that everyone can participate in social change.[61] Ramona's role in the Zapatista uprising aided in the introduction of the Revolutionary Women's Law, passed by the EZLN in 1993. This document features ten points related to Indigenous women's demands for equality and justice.[62] Unlike Castellanos and Sor Juana, Ramona does not appear as an iconic portrait in Cervántez's print. Instead, an unnamed woman and her children represent the Indigenous community in solidarity with the Zapatistas. The small Zapatista doll is the closest likeness to iconic images of Ramona, but it carries the general silhouette of a skirted Zapatista.[63] The text overlaid across the mother's skirt is an excerpt of the Popul Vuh, a Quiché-Maya ancient document, featuring Mesoamerican creation mythologies, that is one of the most prominent examples of extant ancient Indigenous writings.[64]

For Cervántez, *Mujer de Mucha Enagua* is an anthologized space of interdisciplinary accomplishments by women. Her conflation of the ancient and the contemporary role of feminist leaders challenges a patriarchal perspective of evolutionary history. More broadly, *Mujer de Mucha Enagua* decolonizes the notion of time itself because Cervántez suggests the presence of ancient Mesoamerica as a prominent influence on each of the modern changemakers. This reflection on time is a quintessential Cervántez lens

that also reverberates in the Maestras structure of intermixing multigenerational thought.

LA VETERANA: BARBARA CARRASCO'S DOLORES

Influenced by the provocative and inundating color field of the mural and using her technical capabilities to achieve delicate lines, Carrasco's 1999 *Dolores* print calls for immortalizing Dolores Huerta as a feminist icon (fig. 4.5). Applying the term *icon*, in the secular sense, to a person denotes a symbolic role. In this work, Carrasco uses Huerta as a synecdoche for Chicana empowerment and women's roles in the historic Chicano Movement.

The necessity to historicize Huerta is surprising, given her more than half-a-century role in labor, Chicana, and feminist activism. Significant achievements include developing the National Farm Workers Association with Cesar Chavez in 1962; her pivotal roles in securing policy changes, such as state aid for dependent families and the California Agricultural Labor Relations Act of 1975; and her advocacy in such efforts as the Feminist Majority's Feminization of Power campaign beginning in 1987. Huerta received the Presidential Medal of Freedom from President Obama in 2012.[65]

Huerta's most recognizable likeness is from Paul Richards's 1965 photograph featuring a young Dolores brandishing a "*Huelga*" (strike) sign (fig. 4.6). The composition is iconic because the singular Huerta commands the space with the protest sign. Often Huerta appears in a visual partnership with Cesar Chavez's legacy, the two figures paired side by side as the symbolic founding couple of the United Farm Workers (UFW). Carrasco's *Dolores* print differs from most by prioritizing only Dolores Huerta, represented as an elder figure with slight wrinkles decorating her face, her hair neatly coiffed, and her collared shirt evoking professionalism.

In contrast to the urgency of typical 1960s images of Huerta, with a megaphone in hand, wielding a protest sign, or strategizing in the fields with Chavez, Carrasco's approach was to show the stylistic transformations of the labor leader. The nod to her UFW past is in the small pin attached to Huerta's shirt, featuring the UFW eagle and the "*Si Se Puede*" (Yes we can) slogan. By making these images ancillary to the overall portrait, Carrasco focuses her veneration entirely on Dolores as an individual role model.

Carrasco began her political advocacy as a young student making artwork, banners, and signage for the UFW.[66] The continued relationship with Chavez and Huerta extended for decades, coinciding with the UFW's ongoing social justice and labor rights campaigns. As Carrasco gained prominence in her practice, with exhibited works such as the 1978 print *Pregnant Woman in a Ball of Yarn* and the controversial commission for the 1981 mural *L.A. History: A Mexican Perspective*, her practice centered on many of the same tenets as the UFW, prioritizing giving a voice to the underserved and unrecognized. Carrasco's works often center on a feminine form, whether anonymous or representational; women and their experiences are her favorite subject matter.

FIGURE 4.5

Barbara Carrasco, *Dolores*, 1999. Screenprint, image: 26 × 18 in., sheet: 30 ⅛ × 22 in., edition of sixty-six, printed by José Alpuche, Maestras 1/Atelier 33. Self Help Graphics & Art Archives, California Ethnic and Multicultural Archives 3, University of California, Santa Barbara Library. © 1999 Barbara Carrasco. Courtesy of the artist.

and Huerta through policy. Carrasco channeled Huerta's teaching at the Maestras workshop meetings, carrying on the legacy of Chicana feminist contestation in the face of patriarchal adversities.

FAVIANNA RODRIGUEZ: DIGITAL PUSSY POWER IN
DEL OJO NO SE ESCAPA NADIE

Favianna Rodriguez embodies the new generation of feminist Chicana artmakers: mentored by influential, elder Chicana artists; politically active; and a practitioner of digital strategies. Like San Diego Chicano artist Mario Torero, Rodriguez is of Peruvian descent but applies the *Chicana* identity to her practice to align herself with that term's political identities and activist positions.[71] Her political consciousness of Chicana visual culture was partly due to Yreina Cervántez. In 1998, Cervántez taught Rodriguez during a course at UC Berkeley.[72] The two held mutual respect for one another, and Rodriguez fondly remembers Cervántez suggesting "you should be doing art as more of a part of what you do."[73] Beyond the support of a respected artist, Rodriguez recalls, one of the most significant takeaways from this undergraduate class was finding out there was a "Chicana art world" to join.[74] As the youngest participant in Maestras, at the age of twenty-one, she faced a unique conundrum in not fully mastering screenprinting, but this conversely freed her to approach the medium in her own style.

Rodriguez's atelier print *Del Ojo No Se Escapa Nadie* (fig. 4.8) is a brightly colored bilingual scene featuring a splayed nude woman. The image takes on an erotic, pulpfiction-cover style with its anticipatory and exclamatory suggestions of "Real . . . Pulsing Drama! Primitive Passion!" in its upper register. Using the concept of the Huichol sacred woven object called *Ojo de Dios* (God's Eye), Rodriguez reimagines the vagina as an additional conduit to higher consciousness.[75] The supine figure's spread legs and the overlaid central eye suggest that the figure's vaginal entrance acts as a third eye engaged in active discourse. Rodriguez summons Sandra Cisneros's call to enliven the *panocha* (a slang term for vagina) and use it as a liberating space.[76]

According to Rodriguez, her objective was to present sexual freedom and embody dominance and heightened consciousness.[77] Her allusion to the figure's nudity in an impassioned yet vulnerable position against the bed frame creates an evocative and candid mid-coitus boudoir scene. The undulating text surrounding the horned figure is from the Mexican rock band Caifanes' 1988 song "La Bestia Humana" (The Human Beast).[78] The printed lyrics correlate to the slithering tongue emanating from the zoomorphic creature. This vitriolic sensibility may also be a reference to Émile Zola's 1890 novel *La Bête humaine* (The Human Beast), wherein the lead character Jacques Lantier has murderous rages specifically against women.[79] Without an overt declaration to a moral dialectic, the horned figure acts as a harbinger of an incoming threat. As Laura E. Pérez recalls in a conversation with the artist, the central *Ojo de Dios* saw "everything, including men's objectifying and abusive sexual behavior."[80]

FIGURE 4.8

Favianna Rodriguez, *Del Ojo No Se Escapa Nadie,* 1999. Screenprint, image: 26 × 18 in., sheet: 30¼ × 22 in., edition of sixty-four, printed by José Alpuche, Maestras 1/Atelier 33. Self Help Graphics & Art Archives, California Ethnic and Multicultural Archives 3, University of California, Santa Barbara Library. Courtesy of the artist.

FIGURE 4.9

Favianna Rodriguez, *Pussy Power*, 2012. Digital print, 17 × 12 in. Courtesy of the artist.

Despite her unfamiliarity with screenprinting, Rodriguez's *Del Ojo No Se Escapa Nadie* is a nine-color screenprint, which is no easy feat for a newcomer.[81] She readily admits to her inexperience in the print setting: "I showed up the first day to print, a bit unprepared. I had not completed my tasks and I was running behind. I was intimidated by Joe [José Alpuche] who huffed and puffed. . . . He was giving me a hard time because I was unprepared. Throughout the entire process, he pushed me to be exact, to be a perfectionist with my process. He was patient with me, but firm."[82] Alpuche's and Rodriguez's balance as working creative partners also had to contend with the technological approach Rodriguez brought to the process, one that no other Maestras artists used in their artmaking.

Digital technology, and image editing software in particular, is a vital component of Rodriguez's practice. Fellow artist Jesus Barraza taught her to use a raster graphics editor, Adobe Photoshop, and together they scanned and digitally separated the colors for Rodriguez's print. According to Barraza, "We did it totally wrong, but we did it."[83] This would be one of the earliest engagements with this method for SHG.[84] Therefore, while still a novice at traditional screenprinting practices, Rodriguez brought a new technology and technique to the elder artists in her Maestras cohort.[85]

Rodriguez completely shifted her professional endeavors after Maestras, eventually dropping out of school and engaging with art and design full-time.[86] Digital image-making techniques would continue to define her art practice. The speed afforded her by the communication networks of social media and the internet has allowed her to be a prolific multimedia artist. *Del Ojo No Se Escapa Nadie* would be an initial, cerebral undertaking for Rodriguez's feminist rights and body politics stance. Her later work, such as 2012's *Pussy Power*, would continue that sentiment (fig. 4.9). Much more aligned with public policy, Rodriguez's contemporary work acts as a form of political advocacy and emphasizes an urgency toward policies that affect women's bodies.

CODA

One may recognize the success of the Maestras Atelier in its iconic images that reside in major museum collections, but other takeaways from the residency should be duly acknowledged. For several Maestras artists, the workshop space provided a pathway to sustainable mentorship. Delilah Montoya remembers that Yolanda López, Yreina Cervántez, and Barbara Carrasco were extremely supportive of her and the artists. They all were eventual guest lecturers while she was teaching at Cal State LA.[87] Patricia Gómez fondly recalls working with Noni Olabisi after she moved from SHG and continued her career as a murals manager.[88] Gómez proclaims that the Maestras Atelier had a pivotal "impact on my career, on me in every level, [it was a] major chapter in my life."[89] For younger artists, such as Favianna Rodriguez, the Maestras Atelier demarcated a turning point in their professional careers, from student to full-time, professional artist.[90] As Olabisi succinctly reviews her takeaways from Maestras, she simply says, "Overall . . . the experience was beautiful."[91]

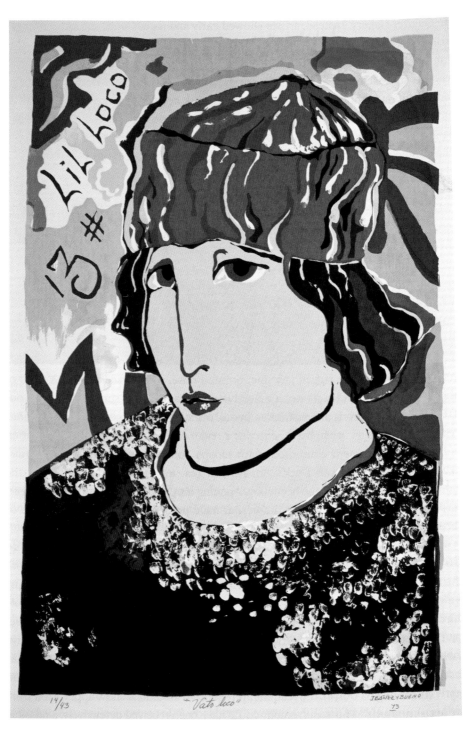

FIGURE 5.2

Carlos Ibañez y Bueno, *Vato Loco*, 1973. Screenprint, 22½ × 17½ in., edition of forty-three. Photograph by Alan Pogue. Courtesy of Gilberto Cárdenas Collection of Latino Art.

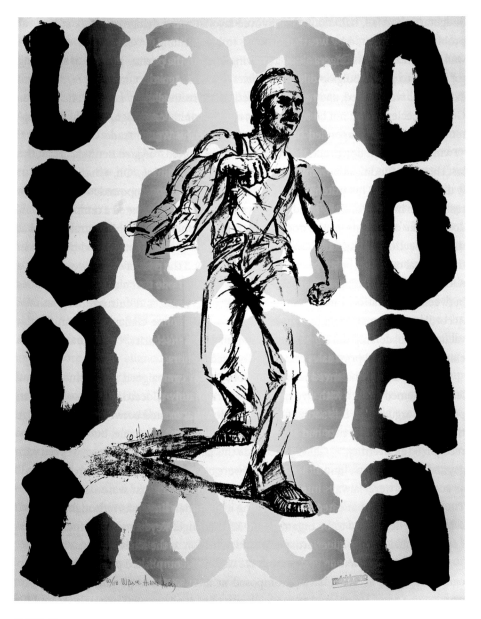

FIGURE 5.3
Wayne Alaniz Healy, *Vato Loco Vida Loca*, 1977. Screenprint, 28%₁₆ × 22⅝ in., edition of 118, printed by Mechicano Art Center. Center for the Study of Political Graphics collection, California Revealed. Courtesy of the artist.

death. If Durón could not resolve a stalemate over organizational propriety, the obstacle presented by the artist's passing required a shift in direction. With more elegiac intentions, he elected another means to honor the memory of his late friend.

More than the problem of decorum and process, SHG's fiscal health took a downward turn. In 2005, the nonprofit organization faced a financial crisis: a $140,000

the cellular level through a powerful drug regimen governed by the Federal Drug Administration, corporate pharmaceutical companies, and health and human services bureaucracies. The death world enunciated here echoes the "traumatic fissure[s] upon linear time" stoked by HIV's irreversible sting, of being outside of cis-heteronormative biologically determined temporality, of dying in delay.[58] With so-called "Lazarus men," a term referencing a biblical story of Jesus's power of resurrection, Huereque imbues *Positive + Spirit* with a queer Latinx seropositive biography. He shows how "living dead" queer of color subjects manage their desires and physical contact through a tenuous balance of "chemoprophylaxis" regulation, biomedical regimes, and a personal drive for self-renewal.[59] No artist's work more completely confronts these dead zones than that of fellow *Homombre LA* contributor Rigo Maldonado.

UNTIL THE BITTER END

Born and raised in Orange County, California, Rigo Maldonado's pathway to artmaking and queer self-expression was shaped by the vernacular practices he observed in his Santa Ana home, from the wood scraps his father harvested from carpentry jobs to his mother's "*domesticana* sensibilities" in homemaking and altar design.[60] His self-description as a mixed-media contemporary artist waited until college, when a chance conversation with Chicana muralist Judith Baca sent him on a path of artistic discovery and creative experimentation. Neither a painter nor a draftsman, Maldonado was inspired by broader questions of "loss and desire," having witnessed the brutality of gun violence in his barrio and being driven to test the limits of his sexual desires as a recently self-professed gay man.[61] Too young to know sex outside the terms of HIV, Maldonado adapted brazen conceptualizations of printmaking, blurring the generic boundaries of painting, performance, documentation, and art installation. Always with concerns chief to Chicanx ritual and folk traditions, Maldonado infused community-based and politically informed social art strategies with a broad experimental impulse in printmaking.

However, it was not Maldonado's contribution to *Homombre LA* that appeared at the Quarter Gallery's *Remembrance* exhibition. Instead, he showed another kind of Chicanx print. In *Pos/Neg* (2010), Maldonado presents two unstretched canvases blotched in muted acrylic paints of grayscale and crimson accents (fig. 5.7). The frenetic expression of these smears rhymes with a broader performance art repertoire like the "living brush" experiments of Yves Klein's *Anthropométry* series in the early 1960s or David Hammons's "body prints" of the mid-1970s, in which his physical appendages (including skin, limbs, and penis) became the printing plate for works on paper.[62] Maldonado's practice is a consonant expression innovating the collaborative process through an explicitly homoerotic and infectious key. Imprints of handprints and fingers reveal evidence of something more carnal happening on canvas. Traces of an engorged cock raise questions about the risky sexual practices that transpired here, and the consequences of such raw activity between men. Thus, Maldonado's canvases

FIGURE 5.7

Rigo Maldonado, *Pos/Neg*, 2010. Acrylic on canvas, 52 × 216 in. Reinstalled at *Remembrance* (2017), Quarter Gallery,
University of Minnesota, Twin Cities. Photograph by and courtesy of the artist.

are more corporeal in appearance, tracing the primal scene of queer Latinx copulation
and, possibly, seroconversion or the process of becoming infected. By collaborating
with a serodiscordant couple procured from Craigslist, he broadens the terms of what
Tere Romo calls the "points of convergence" in Chicano printmaking and adjusts them
to "points of conversion," bringing the deadly end points of the rectum into the lively

beginning points of the artist's hand. By "mobilizing bareback sex as a historical category" in his body prints, Maldonado impresses another timeline onto the canvas, a creative expression aligned with the anus "as the very site of a grave of and for the queer male sexual subject" according to queer theorist Ricky Varghese. Maldonado's visual record detaches from heteronormative measures of procreation and, in turn, futurity. Rather, his examination of seroconversion in body printing espouses another dimension of queer necropolitical optics, seeing the ways in which the Chicanx barebacker "became simultaneously responsible for, and accused of, allegedly digging his own grave, a grave marked on his own body."[63] For him, printmaking is a viral and corporeal experiment with cautionary outcomes.

Alas, the radical and defiant queer sexual expressions central to Maldonado's contribution to the commemorative exhibition for Jesus Estrada-Pérez were evocative of SHG's art and performance culture. In his *Homombre LA* print, *Hard to Swallow* (2008), the viewer sees a self-portrait of the artist rendered in hues of brown, white, and cobalt (fig. 5.8). Face forward, with a deadened gaze, his self-portrayal is somber yet direct. His bare chest reveals a Chicanx man caught between youth and middle age. A blue bird hangs from his mouth, gagging his speech, words, cries, fulminations, and revelations. Unable to confess to the things that bring him to this honest portrait, he is entrenched in a repressive regime of heteropatriarchal emotional control and the self-inflicted violence young Chicanos enact upon each other and themselves.

The blue bird is equally without the whimsy of flight or song. Its feet curl, settled in rigor mortis, expiring in Maldonado's jaws. Riffing on his youth growing up in the shadow of Disneyland, his woodland creature, appropriated from an animated feature film, is a campy rendition of queer Chicanx suffering. Choking on his words, he refuses the presumptive utopian innocence granted by this symbol of the Magic Kingdom. Rather, he reveals that outside the amusement park gates and firework show dazzling the night sky, there were secrets in nearby Santa Ana. The culture of silence stoked by patriarchal structures of heteromasculinity and *machista* affectlessness made boyhood "hard to swallow." Despite a cheeky nod to fellatio, the work is covert in its attentions, exposing the chokehold of sex abuse for young Chicanx men.

Continuing a practice of other *Homombre LA* contributors, Maldonado's work employs image and text to tackle the objectives of the atelier. Like Terrill, Donis, and Huereque before him, Maldonado's screenprint also returned to earlier work. For him, it was an art piece with the same title, *Hard to Swallow*. Premiering at SomArts Gallery in *Personal Secrets/Public Spaces* (2007), a show guest curated by Rebeka Rodriguez for QueLaCo, a queer Latinx arts organization in San Francisco, the triptych depicts the artist in three close-up photo portraits.[64] Each frame shows a different stage of the taxidermied bird's evisceration until ingested. Unlike the screenprint, the photographs clarify how the artist's lipstick-stained mouth hints at a gender-nonconformist idiom omitted from the *Homombre LA* iteration. By substituting the red lip, the

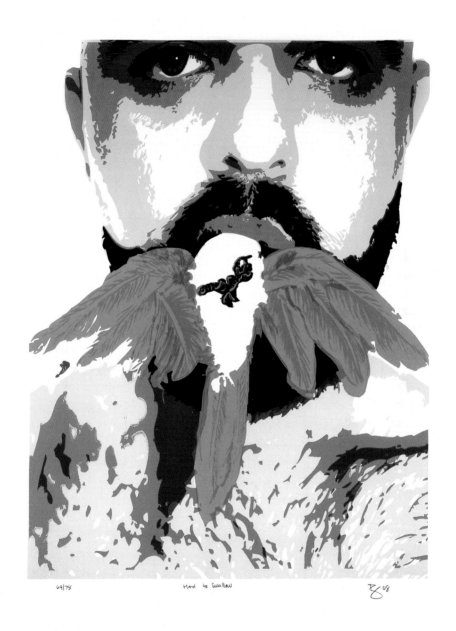

69/78 Hard to Swallow

FIGURE 5.8

Rigo Maldonado, *Hard to Swallow*, 2008. Screenprint, image: 20½ × 15½ in., sheet: 26 × 20 in., edition of seventy-eight, printed by José Alpuche, *Homombre LA*/Atelier 49. Courtesy of the artist.

print's color schema declines a gender-variant variable eclipsed in the silk-screening process. It is worth considering what a more faithful translation of the photograph would have meant for the suite, adding a transgender visual potential to a work that also engages in cunning language, sexual violence, and radical sex cultures. Of course, Chicanx gender-nonconformity would manifest in his other SHG activities, as discussed below.

Maldonado's attention to the masticated blue bird enhances another area central to his interests: autoerotic asphyxia. His past work explored collaborative fetish photography contemplating humiliation, risky sex, and sploshing—sexual stimulation aroused from wet and sticky substances. *Pos/Neg* continues a dialogue with this line of artistic inquiry, paint becoming the principal material to rouse desire, document, and imprint queer Chicanx seroconversion onto loose muslin fabric. In this way, *Hard to Swallow* is not only an elevation of his aesthetic and social concerns but also a foray into the "everyday death worlds," consistent with his burgeoning creativity ignited by SHG's artistic circuits.[65]

Hard to Swallow rhymed with the artist's personal attachments to loss and desire, adding an unseen yet elegiac expression caught in his throat. In truth, Maldonado's friend Max Torres was in hospice care, and this travesty shaped the artist's newfound attention to an unequally distributed public health system and biased systemic assignment of human worth.[66] Torres's AIDS diagnosis included a life-threatening case of pneumonia. His lungs filled with fluid, which recast Maldonado's considerations of asphyxiation and drowning anew. After Torres died, Maldonado entered SHG's thirty-fifth-anniversary Día de los Muertos with a gravity-defying take on the traditional *ofrenda*: a collaboration with his friend Alma López entitled *Nepantla 35* (2008), in which the pair draped cascades of yellow chiffon from the gallery's ceiling to the floor (fig. 5.9). Strings of flowers, vases, and frames were suspended in midair, activating an ethereal and nonlinear environment. The installation refortifies Chicana lesbian feminist theorist Gloria Anzaldúa's take on the Nahautl term *nepantla*, materializing that "state of transition between time periods, and the border between cultures" in the Americas.[67] Together, they expand on the social and political conditions expediting the murderous vulnerabilities of queer and transgender people of color.

Their reimagining of the altar format exposed the way "transgender Chican@s are the absent presence and the audible silence" in cultural iconography and creative practice, as Francisco Galarte notes.[68] Using photo transparencies, they transferred portraits of those subjugated to a system of state violence, public health neglect, unprovoked harassment, and police abuse. Maldonado and López's gravity-defying windows create offerings for the victims of anti-transgender violence, like Gwen Araujo; for those caught in the depressive cycle of suicide, like Maldonado's friend Gia; and for the vulnerable bastions of Latinxs still dying from AIDS, like Max Torres.[69] In *Nepantla 35*, the deceased (and diseased) join a weightless combination between life and death,

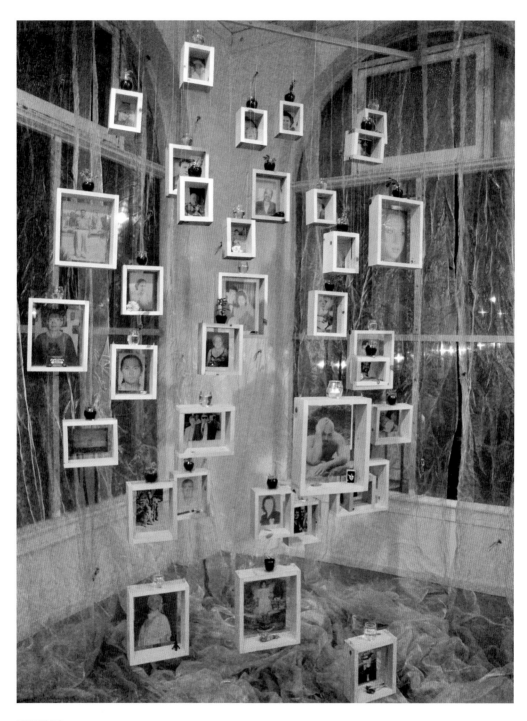

FIGURE 5.9

Rigo Maldonado and Alma López, *Nepantla 35*, 2008. Mixed-media installation, variable dimensions. Installation shot at SHG. Photo by and courtesy of Rigo Maldonado.

expanding the creative schema whereby LA's "Days of the Dead practices, even those that are artistic rather than religious ritual proper, allow for greater individual and communal integration with the community of our dead," as Laura Pérez suggests.[70] Maldonado and López's queer necropolitical optic reimagines the *ofrenda*, unhinging it from the weighted and monumental form and, in turn, redirecting this Chicanx folk tradition to question a state-sanctioned system exposing queers and transgenders of color to further disposability, detention, infection, and murder.

END OF THE LINE

Overall, *Homombre LA* was a significant addition to the atelier program, proffering a provocative queer and transgender aesthetic language in a post-9/11 sociopolitical context. By mediating an organizational infrastructure at a difficult time, its realization was a mark of deft curatorial know-how on Reyes's part, and of the unapologetic spirit the artists had procured from decades of AIDS cultural activism and heteropatriarchal defiance. Ironically, it was not Maldonado's *Hard to Swallow*, with its attention to HIV seroconversion, fetish subcultures, and sexual assault, that raised concerns—rather, it was Huereque's *Positive + Spirit* that did. The depiction of male nudity moved Reyes to seek approval. According to Durón, "Miguel Angel told me that Jef felt strongly that the male need[ed] to be naked."[71] Notwithstanding previous examples of male nudes in SHG's inventory (Reyes's own work being the most emblematic), Huereque's look at portraiture post–AIDS antiretroviral therapy was enough for Durón. With the suite of ten prints complete, Durón was able to symbolically reconcile the organization's queer past and assuage the organizational legacy of his late friend, Carlos Ibañez y Bueno. That same year, Durón left the board leadership, and thus SHG's explicit engagement with queer visuality in the atelier program receded until 2020, when *Queerida* was curated by Guatemalan-Salvadoran artist Dalila Paola Mendez (see Kency Cornejo's essay in this volume).

Unbeknownst to Reyes and Durón at the time, *Homombre LA* would introduce younger, queerer facets to this Chicanx printmaking epicenter and create the means for activist-scholars like Jesus Estrada-Pérez to find a queer and racialized visual print archive central to his work, politics, and identity. *Homombre LA* was the catalyst for Estrada-Pérez's contact with Maldonado in 2010 and parlayed his subsequent search for artists Luciano Martinez and Joey Terrill. Estrada-Pérez said that scholarship about the suite of prints was something "I do want to write about . . . in the future but I'm waiting a bit."[72] But that future plan would never be realized. Before the end of his life, he appraised Martinez's graphite drawing *I've Given Up on Love* and Terrill's diptych painting *Just What Is It That Makes Today's Homos So Different, So Appealing?* in an unpublished paper entitled "Mariposas through the Window: Queer Domestic Practices and the Paradox of Discrete Space."[73] However, it was his friendship with Terrill that intensified, sparking a conversation that spanned the stretch of Southern California and the Midwest.

FIGURE 5.10
Photograph of Jesus Estrada-Pérez, July 5, 2011, Palm Springs, California. Courtesy of Joey Terrill.

A keepsake of Terrill's hints at the kind of cross-generational dialogues engendered by *Homombre LA*. In the candid photo, he captures the young man's first foray to Palm Springs on the Fourth of July weekend in 2011 (fig. 5.10). Estrada-Pérez interviews Terrill. Stories about queer Chicanx LA sparked new horizons in his dissertation research. Thereafter, he takes the plunge and treads water in a glimmering oasis. In the frame, we see his chestnut eyes focusing as he balances on a foam noodle, exercising a noncommitment to Terrill's camera. A half smile breaks the tension in a confusing moment of jubilance and concentration. Like the men depicted in the prints of *Homombre LA,* he shines in a moment of the unknown, balancing on an unstable floater. Keeping his head above the surface, he knows not impending tragedy. Like those screenprints guiding him to this moment, he teeters on the edge of total submersion. And yet, his desire to know queer Chicanx cultural expression brings him to the verge of another dead end: How does one literalize the unresolved fragments of a state system predicated on anti-queer and anti-immigrant death and dying in visual art? How might one enter the everyday death worlds brought to the foreground by SHG's queer creative nexus? Must you plunge, wade, or ride the current? As Estrada-Pérez would soon learn, queer Chicanx visuality is full of misconceptions even as a life-ending threat to SHG's survival during the first decade of the twenty-first century. It is the riskiness of falling out of time, out of favor, out of sight that remains *Homombre LA*'s imperative contribution. Dangerous times call for bold risks, and such bravery was something the queer printmakers at SHG understood. And it is that willingness to look over the edge, embrace the unknown, and dive into the deep end that remains the suite's enduring legacy and Estrada-Pérez's as well.

FIGURE 6.1

Alfredo de Batuc, *Emiliano con zuecos*, 1994. Screenprint, image: 36⅞ × 24 in., sheet: 44 × 30 in., edition of thirty-two, printed by José Alpuche, Atelier 24. Self Help Graphics & Art Archives, California Ethnic and Multicultural Archives 3, University of California, Santa Barbara Library. © 1994 Alfredo de Batuc. Courtesy of the artist.

FIGURE 6.2

Bain News Service, *Emiliano Zapata*, 1911. Photograph, George Grantham Bain Collection, Library of
Congress. Courtesy of the Library of Congress.

yellow, red, and light blue, Zapata's portrait depicts him holding an umbrella, rather than his rifle, and wearing nothing but wooden clogs from the waist down. In both the original photograph and de Batuc's print, the vertical lines of Zapata's striped sash direct the eye downward. Yet without the pants, the viewer's eye is led directly to Zapata's flaccid penis, thin legs, and the wooden shoes, the source of the visual pun, since *los zuecos*—formally, clogs—implies the Spanish colloquialism for "playing dumb."

The double entendre reinforces the absurdist intervention and visual reference to the parable of the emperor's new clothes, a tale originally recorded in medieval Spanish. By naming empty signifiers within Chicana/o/x art and disrobing Zapata, the print recalls the story in which the king's subjects pretend to see his clothes to protect their status. It is a tale of social hypocrisy, collective denial, and hollow display. When Chicana/o/x art received some attention in the 1980s and early 1990s from Southern California art galleries—namely from Robert Berman, Craig Krull, and Patricia Correia in Santa Monica, and from Koplin del Rio (formerly of Culver City)—SHG artists negotiated visual legibility in the mainstream arts scene. In effect, de Batuc disrobes Zapata to elicit a response from the viewer by literally uncovering the "Stock Cultural Images and Symbols" that are rendered "Inane" through "Overuse." While artists of the Chicano Movement sought to reference the Mexican Revolution as the historical precedent for and moral root of their activism, the print offers critical commentary on the "Overuse" of this and other images in Chicana/o/x art. Through absurdity, and perhaps abjection, de Batuc invites viewers to consider their collective role in expecting, exhibiting, or purchasing "Easily Recognizable" "Cultural and Political Symbols." This criticism pushes against representations of identity and suggests that cultural symbols may become, like the emperor's new clothes, an illusion.

I posit that the print gestures to the oversaturation of the *male pantheon,* a term artist Yolanda M. López (1942–2021) used to describe the abundant heteropatriarchal visualization of Chicano heritage in portraits of Zapata, Pancho Villa, Cesar Chavez, or anonymous Indigenous male warriors.[12] This reference to a masculine visual vocabulary finds credibility in the flaccid phallus, umbrella, and other compositional strategies. As Diaz observes of Luis Alfaro's monologue "Orphans of Aztlán," in which the performance artist dresses as a cholo, de Batuc mixes Mexican charro style and "drag to destabilize Chicano masculinity."[13] By replacing Zapata's rifle, a symbol of military and masculine authority, with the umbrella, the image invokes the dandy—the elegant male sensibility that developed in France, Britain, and the United States—and a racialized form of conspicuous consumption among eighteenth-century enslaved men, as well as a motif in the artistry of creatives such as Salvador Dalí.[14] The unfurled umbrella is a fashion accessory rather than a functional object that offers protection from the weather, and it queers the Mexican and Chicano cultural symbol, subverting its nationalist, revolutionary, and heteronormative weight. Zapata's mustache, now trimmed and groomed in the style of the dandy, rather than the full handlebar associated with Zapata's upper lip, further supports a queer critique of heteropatriarchal

nationalism. Similarly, de Batuc has retouched and enlarged Zapata's sombrero, making it look like a fanciful halo-hat. Therefore, de Batuc not only strips Zapata of his pants, but he removes the hypermasculine veneer of Chicano visual discourse. The lens of *bricozaje* allows us to ponder what else is unseen in our collective construction of Chicano nationalism and cultural production.

QUEER AESTHETICS

Emiliano con zuecos interrogates a blind spot of Chicano Movement ideology and social norms, namely heteronormativity and hypermasculinity. By queering Zapata and cultural nationalist politics, the print subverts social codes and histories, but without the penetrating force associated with a phallic erection or military might. Instead, the print references its social context to queer Chicano politics by literally disarming hypermasculinity with the removal of Zapata's pants and the addition of an umbrella, fancy hat, and cute mustache. Unlike Mexican audiences who, in 2019, protested the nude portrait of Zapata at the Palacio de Bellas Artes, SHG audiences, and gay collectors in particular, responded enthusiastically to de Batuc's queering of Zapata.[15]

This sartorial queer aesthetic and tacit fetishism of *Emiliano con zuecos* resonates with *Papillon* (2010), a print by Miguel Angel Reyes that unapologetically visualizes queer sexuality through performative adornment and gaze (fig. 6.3). Reyes's numerous works published by SHG depict queer attraction, and *Papillon* continues the radical potential that emerges from queer desire through a mingling of styles that reference their social contexts to upend the status quo. In this case, *Papillon* visualizes the interconnectedness of eros, a "communal relationship and care for self, other, and the planet" in the context of homophobia and the AIDS epidemic.[16] Although SHG's origins are truly an expression of queer eros, the arts organization has both supported and mystified its contributions to queer aesthetics, as Robb Hernández documents in this anthology. Carlos Bueno and his partner Antonio Ibañez were cofounders of SHG, but it seems as if their love for each other was unspoken within the organization, although their art visualizes queer desire.[17]

Papillon demonstrates that by the fourth decade of SHG, artists had mitigated queer silencing. The print depicts a profile of a Mexican gay man who wears a leather gag strap across his mouth, a binding holster around his shoulders and neck, Japanese-style tattoos across his bare chest and arms, and a mohawk hairstyle. Reyes was drawn to the "mix of cultural influences," from the Japanese kabuki mask tattoo to punk fashion and bondage gear.[18] Working from a photograph, the artist was inspired by fantasy imagery in fashion magazines, and his series *Instant Bondage* that encourages sitters to create a "bondage look" from the clothing they are wearing, implying that the sexual fetish is immediately available.[19] In this case, Reyes instructed the sitter to dress as if preparing for an encounter, and the sitter placed his belt across his mouth and added two of Reyes's items, a harness and a boa made of yarn, which he placed on his head. The print's solarized coloration electrifies the sexual energy of the figure and

FIGURE 6.3

Miguel Angel Reyes, *Papillon*, 2010. Screenprint, sheet: 26 × 20 in., edition of eighty-four, printed by José Alpuche, Special Project. Courtesy of the artist.

signifies the fetish context. Specifically, the contrast between the light blue line and the edge of the figure's black hair—actually, the yarn boa—that it follows generates the volatility of the image.

Reyes selected a profile to leverage the regal quality of classical portraiture.[20] By imitating the profile portrait of early Italian Renaissance and ancient medallions, the direction of the gaze dignifies the sitter and his desire. However, since the sitter gazes beyond the frame, the viewer does not have visual access to his queer fantasy. The print enacts "a Latino gay male sexuality that is simultaneously erotic and communal," but without representation of the partners' sexual act.[21] In this way, the regal profile elevates yet withholds representation of the forthcoming consensual, sexual encounter, suggesting that queer desire need not depend upon external recognition or visual enunciation. By withholding or refusing to depict the object of the sitter's gaze, the print avoids co-optation, particularly Eurocentric epistemology that values omniscience, and its ability to co-opt that which it sees, over nature, people, and culture.[22]

RASQUACHE AESTHETICS

As such, *Papillon* implies a queer refusal of Chicano homophobia, enacting a central but underrecognized element of *rasquachismo*. As Ella Diaz illustrates, "Rasquache is an act, a tone, a look, and a gesture . . . fashioned through an attitude made discernible by the content (props, movements, and materials) used in or *against* a context."[23] Here, I bracket how *rasquache* is always historicized as it references its context and thus anticipates *bricozaje* because I wish to draw attention to critics' overemphasis on *rasquache*'s innovation and ingenuity ("making do"). Alternatively, Diaz considers both reversal and refusal as central tactics of *rasquachismo*. Indeed, in his now classic essay, Chicano scholar Tomás Ybarra-Frausto performs *rasquache* aesthetics by refusing a definition.[24]

The print's refusal is embedded in its matrix of referents and restaging of these contexts for new significance, and thus it produces *bricozaje*. *Papillon* uses language, props, compositional strategies, and techniques to queer sexuality, pulsing with a *rasquache* stance against Victorian sexual sensibilities, heterosexism, and the presumed whiteness of the gay community in Los Angeles. Here, I unpack some of the print's referents. First, *papillon* is French for "butterfly." Using French, Reyes withholds the Spanish word for "butterfly," *mariposa,* which is slang for "gay." Second, a *papillon* is also a small, dainty dog with large, butterfly-like ears that are fringed in fluffy fur. The reference to the dog and the pointillist technique lend a tenderness to the image.[25] The portrait conveys the beauty and grace of a queer *mexicano* body and companionship, even if beyond the frame. Third, the figure's extravagant mohawk visually echoes the upward arch and furriness of the breed's ears. The height of the mohawk and the fluffs of hair connote the fragile beauty and grace of the figure and imply heightened sexual arousal. Finally, the work links queer communion and eroticism to punk and queer theatricality through the elaborate styling of the mohawk. As David Evans Frantz

observes about earlier gay Chicano art in Los Angeles, "queer publicness [is] playfully enacted and embodied" in sartorial design, in this case the fullness and height of the hair (how does he create such a tall mohawk?) and the gag across the mouth. Emblematic of *bricozaje*, this print references the "performative possibility of adornment and embodiment" of queer eros, and, through a regal tenderness and beauty, it repudiates homophobic violence.[26]

Los tenis de Cuauhtémoc (2018) by Dewey Tafoya also illustrates *rasquache* refusal and references the post-Conquest Indigenous tactic of withholding information (fig. 6.4). Tafoya was instrumental in the reincarnation of the Barrio Mobile Art Studio in 2014, and this commitment to SHG led his peers to nominate him for the commemorative Día de los Muertos print in 2018. *Los tenis de Cuauhtémoc* is a serigraph that depicts a pair of shoes hanging from an invisible wire against a tapestry of painterly flames that burn, but do not consume, a textile designed with an abstracted, pre-Conquest step-fret motif. The diamond step-fret pattern, an element also found in Tafoya's previous works, symbolically registers continuity and cyclical time and thus invokes the contemporary Indigenous context. The dangling shoes are in the style of a popular athletic shoe called Nike Cortez, but Tafoya has replaced the swoosh logo with an ancient motif found on the *chimalli,* or Aztec warrior shield, as depicted in the *Codex Mendoza* (fig. 6.5). Troubled by Chicanx and Indigenous youth who "are wearing the colonizers' shoes" even as they fashion themselves as critics of social norms, Tafoya redesigns the Nike Cortez to "decolonize what *cholos* do" in Boyle Heights and other barrios.[27]

Decolonization is a theme that Tafoya has deployed in his hometown of Boyle Heights and while working as an artist-teacher at SHG since 2002.[28] Resonant with Emma Pérez's notion of the decolonial imaginary, Tafoya's art proposes a world not traumatized by colonial logics even as he minimalizes textual information.[29] For instance, the Nike shoe is renamed for Cuauhtémoc, the last reigning ruler of the Aztec empire, who was tortured by Cortés to force a confession about a supposed treasure. Although Cuauhtémoc refused to comply with the conquistadors who burned his feet, hindsight tells us that Cortés's western epistemologies were incapable of recognizing the treasured feathers, jade, turquoise, obsidian, shells, or copper of the Aztec empire. *Los tenis de Cuauhtémoc* historicizes the resilience and tenacity of barrio youth by recalling the Aztec ruler and the now counter-hegemonic Indigenous epistemology. In the print, resiliency is conveyed by shoes and textile—which, unlike Cuauhtémoc's feet, do not burn. Moreover, the dangling shoes belong to the dead, one of many "urban myths" about tennis shoes suspended from telephone wires or electrical cables. For Tafoya, it is not the specific meaning that is important.[30] As *rasquache* counternarrative, Tafoya elevates an everyday urban practice into a mythic ritual of life, death, resilience, and social critique through *bricozaje* orientation of abstracted Indigenous visual elements and minimalism to deepen the decolonial strategy of refusal.

FIGURE 6.4

Dewey Tafoya, *Los tenis de Cuauhtémoc*, 2018. Screenprint, image: 26 × 17½ in., sheet: 30 × 22 in., edition of eighty-five, printed by Oscar Duardo, Día de los Muertos. Courtesy of the artist.

FIGURE 6.5

The figure in the bottom right corner holds a *chimalli*, or Aztec warrior shield, showing the step-fret motif. Folio 67 recto, *Codex Mendoza*, ca. 1541. Photo © Bodleian Libraries, University of Oxford. Terms of use: CC-BY-NC 4.0. Courtesy of the University of Oxford.

The print's minimalist composition echoes Cuauhtémoc's tactic of withholding, thereby reinforcing its *rasquache* position. As Armando Durón notes, the print "mentions nothing about SHG, Day of the Dead, where and when it will be held, or who will be performing," a common visual strategy of commemorative prints. Tafoya refuses the message, following "a long line of . . . Indigenous artists [who] hid messages among the angels [and] saints" of the Christian colonizers.[31] By 2018, argues Durón, SHG and its community were "secure enough to know that the *gente* come on this day [to SHG] because they know Day of the Dead will happen as it has for forty-five years." Thus, the minimalist design merges with a *rasquache* tactic of refusal by withholding basic information, staging a larger message about co-optation. Coming one year after Disney released *Coco,* an animated film about the Day of the Dead, Tafoya rejects the exploitation and commercialization of Día de los Muertos. The print's *bricozaje* orientation withholds proclamation yet sustains a counternarrative by referencing Indigenous tenacity through abstracted and minimalist visual forms.

DOMESTICANA AESTHETICS

As the feminist form of *rasquachismo, domesticana* theorizes an aesthetic "mode of exposing patriarchal control in the domestic sphere while subverting gendered ideologies through visual practices."[32] Amalia Mesa-Bains coined the term *domesticana,* offering a sophisticated theoretical position that simultaneously recognizes the critical edge and affirmative stance of Chicana *rasquachismo,* an insight that advances beyond dichotomous epistemologies. As such, *domesticana* articulates the complexities and juxtapositions of *bricozaje* in which dissent and reclamation can simultaneously exist.

Mujeres y Perros (1987) by Dolores Guerrero is a minimal rendering yet a potent depiction of *domesticana.* In this serigraph, the artist uses the pointillist technique that generated enthusiasm about her work at SHG and beyond (fig. 6.6).[33] The serigraph shows a singular female nude on a bed leaning against large red and pink pillows. Her eyes are closed, her left arm is propped on her forehead, and her right rests effortlessly at her side with the palm facing upward and fingers gently flexed. In pointillist style, the dots create volumetric shading and depth so that the figure appears to lean her full weight into the pillows. In the background, an open window framed by white shutters reveals a desert landscape and two red dogs howling at a rising orange moon or setting sun. Three saguaro cacti identify the cultural and spatial location of the print. The artist created two other prints in this series, *La Mujer y El Perro* (1988) and *El Perro y La Mujer* (1988), referencing the same Chicana/o/x social geography.

The first word in the title of this print—*mujeres,* rather than a singular woman, *mujer*—directs the viewer to a larger critique of gender norms and power dynamics, anchoring its *domesticana.* The print references the colloquial expression "*hombres como perros*"—men are like dogs—which Guerrero recalls was used by her aunt when the two spoke about men.[34] The howling dogs in the image are an allegory for heteronormative

FIGURE 6.6

Dolores Guerrero-Cruz, *Mujeres y Perros,* 1987. Screenprint, image: 24 × 36 in., sheet: 26 × 40 in., edition of forty-five, printed by Oscar Duardo, Atelier 9. Self Help Graphics & Art Archives, California Ethnic and Multicultural Archives 3, University of California, Santa Barbara Library. Courtesy of the artist.

sexual pursuit, the ubiquity of male voyeurism, and the threat of masculine power. Guerrero was inspired to portray women's daily experiences with harassment when her teenage daughter asked her, "Why do men whistle or make remarks like 'Hey *mamacita*' when I walk down the street?" The print's *domesticana* visualizes the catcalls and sexual violence that loom outside women's private spaces.

Yet the female figure leans against the propped pillows with eyes closed and head turned away from the window, where the shutters, doubling as theater curtains, open to a stage on which women are the object of sexual desire and conquest. This is similar to western depictions of the odalisque (concubine in a Turkish seraglio), but also to the pose of Goya's nude *maja,* her legs forming a relaxed arch, extending away from her body (figs. 6.7 and 6.8).[35] The composition also echoes Titian's *Venus of Urbino,* who reclines before an open window. With these classical references, the portrait depicts female serenity, which is visually reinforced by the position of the figure's left arm, her closed eyes, and the soft stippling surrounding her body. Asleep or absorbed in her own thoughts, her awareness is elsewhere, not on the dogs/hounding men. She has rejected their objectification of her. The print offers another world in which heteronormative sexual threat does not disturb feminist desires, visions, or bodies.

FIGURE 6.7

Jean-Auguste-Dominique Ingres, *Odalisque, Slave, and Eunuch*, ca. 1839–1840. Oil on canvas, 28⅜ × 39½ in. Harvard Art Museums/Fogg Museum, Bequest of Grenville L. Winthrop. Photo © President and Fellows of Harvard College, 1943.251.

FIGURE 6.8

Francisco de Goya y Lucientes, *La maja desnuda* [*The Naked Maja*], ca. 1795–1800. Oil on canvas, 97³⁄₁₀ × 190⅗ cm. Museo Nacional del Prado. © Photographic Archive Museo Nacional del Prado.

Through a mixing of pointillism, classical female portraiture, and *domesticana*, the print does not illuminate the figure's thoughts. By concealing the female figure's dreams and desires, the print reinforces Chicana empowerment. In this social landscape, Chicanas control their sexuality and refuse heteronormative attention, enunciation, consumption, approval, or gaze. They literally turn away from the injuries of heteropatriarchy. By depicting the figure in a relaxed pose, the print suggests that feminist power is internal and embodied.

Simultaneously, the artist has not imagined a world separate from one of masculine privilege and dominance. After all, the coloration of the bed and the landscape is identical—blue fields with green stippled shadows—blurring the public/private divide that animates heteropatriarchal politics. The print refuses a tidy representation of Chicana empowerment, and by extending *domesticana* beyond the household, it implies a complexity or contradiction of lived reality. The similar colors suggest, therefore, a fundamental aspect of *domesticana*: Chicana feminist critique allows for cultural affirmation, and the seeds of Chicana empowerment are found within Chicana cultural heritage. Guerrero values and troubles cultural heritage, enacting the intersecting complexities of *bricozaje*.

PUNKERA AESTHETICS

Shizu Saldamando's print *Vexing* (2008), commissioned by the Claremont Museum of Art for the eponymous exhibition, also affirms Chicanas, honoring their creative expressions and the music venue, The Vex, that showcased their artistry (fig. 6.9). *Vexing: Female Voices from East L.A. Punk* documented and celebrated the 1970s and 1980s *punkeras,* such as Alice Bag, Teresa Covarrubias, and Lysa Flores, and visual artists, including Diane Gamboa and Patssi Valdez, whose multimedia experimentations in sound, photography, fashion, and social norms complemented the innovations of the musicians. The exhibition also explored the influence of the East LA punk scene on contemporary artists, such as Sandra de la Loza's interventionist tactics through her creation and placement of official-looking but nonsanctioned plaques to record Chicana/o/x histories.[36]

Merging text and image, *Vexing* commemorates the East LA punk scene by depicting Saldamando's friend, artist Martha Carrillo, who was born and raised in East Los Angeles and participates in various music communities and at SHG. Sporadically placed hand-lettered phrases surround Carrillo, who applies makeup before a mirror, which permits the viewer to see both Carrillo's face and hand and the back of her head with its short-cropped hair and ear-plug. Safety pins appear in each corner of the image, declaring the punk sartorial technique of makeshift attachment, and the montage of various typefaces captures the rage and raw energy of punk music. It also duplicates the discordant visual field of punk graphics with its hand lettering, stencils, stamps, and rubbed lettering that suggest urgency over refinement, one of the central components of both punk culture and *rasquachismo*. In the top register of the image,

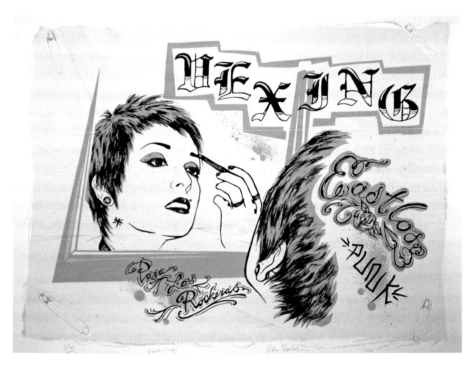

FIGURE 6.9

Shizu Saldamando, *Vexing*, 2008. Screenprint, image: 15 × 20 in., sheet: 20½ × 25 in., edition of 122, printed by José Alpuche, Special Project/Commission for the Claremont Museum of Art. Courtesy of the artist.

the word *vexing* appears in gothic-style or Old English typeface, the preferred lettering of graffiti writers since the 1960s who, according to artist Chaz Bojórquez, leverage the prestige of the font of the US Constitution and birth, death, and graduation certificates.[37] The angular lines that frame the word both reinforce the signification of the typeface and orient the chaotic composition of the print. Two styles of fancy cursive script popular in the 1970s float over and beneath the figure, imply the changing aesthetics of *punkeros* over time. "Para las Rockeras" appears below the mirror image, paying homage to the female *punkeras,* such as Bag and Covarrubias, and the word *Eastlos* shares space with the back of Carrillo's head. Written in an angular style distinct from the bubble letters and fancy script of earlier periods, the word *punk* is embellished by two accent marks popularized by cholos in the 1960s. Furthermore, a rose, used by tattoo and street artists to symbolically gesture devotion and loyalty, appears beneath *Eastlos* and reinforces the homage stated in the phrase "Para las Rockeras."

Saldamando and Carrillo were toddlers when The Vex opened at SHG in 1980 (a temporal slippage that I discuss below). The short-lived nightclub was proposed by artist and musician Willie Herrón and endorsed by Sister Karen Boccalero, the founding executive director of SHG. The Vex featured The Brat, Thee Undertakers, The

Current municipality not a problem of the past

The city was now home to a large number of Central American migrants and their US-born children, making it the largest population of Central Americans outside of Central America. The Salvadoran government, in fact, officially refers to Los Angeles as its fifteenth municipality, "Departamento 15."[10] Unsurprisingly, as was the case for Chicanas/os, younger and future generations of Central Americans became politicized when attending LA schools and universities, where they organized and participated in political and activist groups. In 2000, student activism led to the first Central American Studies Department in the nation, at California State University Northridge. More recently, in 2020, *Central American* was added to the official name of UCLA's Chicano studies department. For LA-based US Central Americans, the City of Angels is where they developed a sense of identity as a Central American diasporic community with a unique history similar to, but very different than, their Mexican immigrant, Mexican American, and Chicana/o peers. One cannot ignore that as SHG solidified its home in the city amid a strong local Chicana/o history, LA was officially becoming home for millions of Central Americans. How did these demographic shifts and shared neighborhoods impact LA's art spaces and artistic relations? Amid this demographic transformation to the city, and the solidarity movement that emerged from it, how did the art world respond?

JUAN EDGAR APARICIO EXHIBITS AT GALERÍA OTRA VEZ

Galería Otra Vez contribution of SHG four Central American activism.

In 1984, a now famous poster by US artist Claes Oldenburg, titled *Artists Call Against U.S. Intervention in Central America* circulated in the art world and print media. The poster was part of a national call to condemn US intervention in Central America and specifically requested artist participation. Twenty-three cities across the nation organized activities (fig. 7.1). That year, as head of the LA chapter for *Artists Call,* art historian Shifra Goldman organized a series of events throughout Los Angeles and reached out to Sister Karen requesting permission to hold an exhibition at SHG's gallery, known as Galería Otra Vez, and Sister Karen agreed.[11] A well-known John Baldessari poster, *Flowers of Life for Central America* (1984), promoted the literary readings, exhibitions, and events planned throughout Los Angeles, including an exhibition opening on October 7 at SHG (fig. 7.2). The exhibition featured Nicaraguan posters from Carol A. Wells's collection, documentation of Nicaraguan murals, and a literary reading at SHG on October 12 and 25.[12] This was the first time Central America had such a presence at SHG amid national attention to the region, and it set the stage for SHG's first exhibition featuring a Central American artist—a Salvadoran refugee—three years later.

Curated by Shifra Goldman, the exhibition featured Juan Edgar Aparicio (b. 1954), who drew from his experience in El Salvador to create high-relief wood carvings and three-dimensional objects that visually testified to the violence back home. Aparicio's personal involvement in El Salvador had made him a target and a refugee. While attending the National University of El Salvador, Aparicio joined the student movement and protested the military occupation of the university in 1975 and their killing

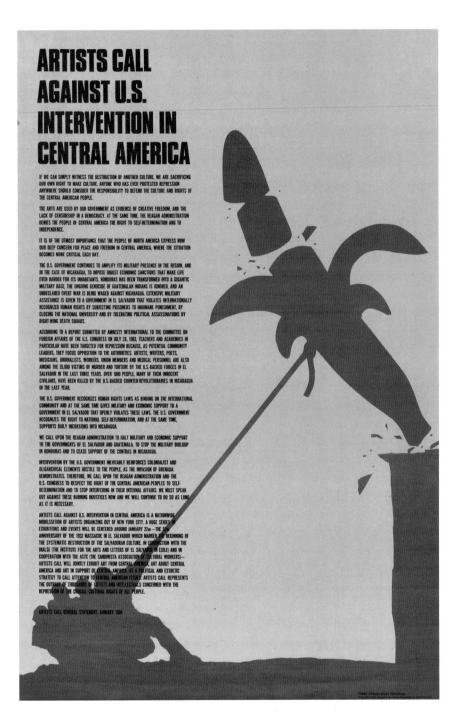

FIGURE 7.1

Claes Oldenburg, *Artists Call Against U.S. Intervention in Central America*, 1984. Offset lithograph, 37 × 24 in. Sam L. Slick Collection of Latin American Political Posters at University of New Mexico, Drawer 26, Folder 5. Courtesy of the Special Collections and Center for Southwest Research, University of New Mexico Libraries.

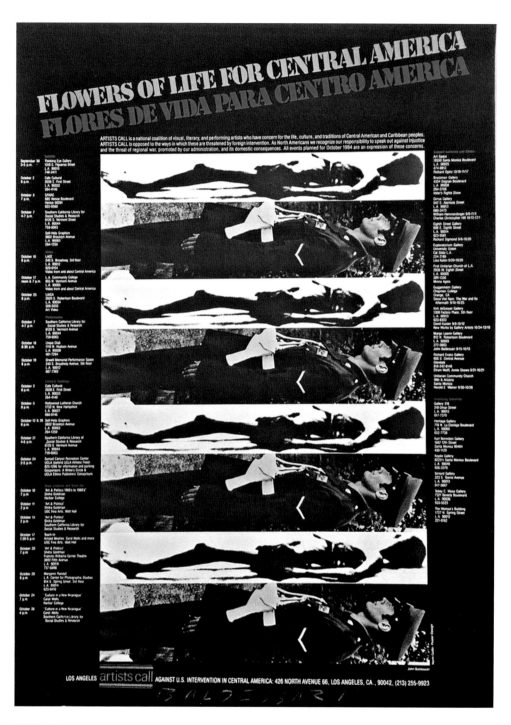

FIGURE 7.2

John Baldessari, *Flowers of Life for Central America*, 1984. Offset lithograph, 24½ × 18 in. American and European Prints and Drawings Post-1900 Collection, Art, Design & Architecture Museum, University of California, Santa Barbara. © John Baldessari 1984. Courtesy Estate of John Baldessari © 2023 and Sprüth Magers.

US military plane

FIGURE 7.3
Juan Edgar Aparicio, *Los milicianos bajo fuego*, 1985. Wood carving, 19 × 29½ × 3½ in. Courtesy of the artist.

of thirty-seven students.[13] Expelled from the university, Aparicio then fled to the mountains to join the guerrillas. He remained there from 1975 to 1981 as a member of Las Fuerzas Populares de Liberación (FPL). The FPL was a communist organization and one of the oldest of the five that eventually composed the Farabundo Martí National Liberation Front (FMLN) at the center of the twelve-year-long civil war (1980–92).

A high-relief wood panel titled *Los milicianos bajo fuego* (The militants under fire) (1985), included in the exhibition at SHG, hints at his experience (fig. 7.3). Aparicio situates two brown-skinned insurgents in mountain terrain, crouching with weapons in hand. Behind them a hut and a green palm tree evoke the Central American rural and tropical landscape. The *guerrilleros*' gaze into the distance leads viewers to the right side of the panel where, against a bright yellow sun, a US Air Force plane drops bombs over the land below. Dabs of green and yellow on the mountainous landscape further allude to the tropical climate while dashes of red, gray, and orange symbolize the flames that engulf villages as a result of the military attack. As I have written elsewhere, these types of scenes were often circulated to US audiences in the 1980s; typically they were from the perspectives of foreign journalists or photographers and not of Salvadorans.[14] Aparicio's *Los milicianos bajo fuego* was unique as a personal testimony to the Salvadoran conflict *by* a Salvadoran refugee.

Aparicio evaded death while in the mountains, but his family back home did not. In 1981, his eleven-year-old daughter, along with his aunt and uncle, were murdered by

Who are they really fighting?

Importance of personal testimonies

FIGURE 7.4

Juan Edgar Aparicio at Self Help Graphics & Art, 1987. Self Help Graphics & Art Archives, California Ethnic and Multicultural Archives 3, University of California, Santa Barbara Library. Courtesy of Self Help Graphics & Art.

the Salvadoran military, their bodies dumped in a garbage heap. His wife and brother were also murdered. Fearing for his life, in 1982 he fled to Mexico, where he spent three months in Nogales, Sonora, until he was able to cross the Arizona-Mexico border by passing as Manuel Velasques—a deceased Mexican man whose family had not yet reported his death and who encouraged Aparicio to use his identity. Their rationale was that if Aparicio were deported, he would be sent back to Mexico and not El Salvador, where he would likely meet his death.[15] Though he had no connections there, Aparicio headed to Los Angeles with the desire to support other Central American refugees, and he played a central role in establishing LA's Central American Resource Center (CARECEN).[16] While organizing among the Central American community, he began creating art again, drawing from a long tradition of carved reliefs in Salvadoran folk art, and produced the series of carved wooden panels reflecting the turmoil of the Salvadoran civil war that caught the attention of Shifra Goldman.

When Aparicio's exhibition took place at SHG in 1987, the civil war in El Salvador was still in full effect, and its bloodshed and displacement continued for five years. As part of the programming, Aparicio shared his personal journey and discussed his art, making SHG a platform from which to inform the LA Chicana/o community on the ways US imperialism and intervention were actively killing, torturing, and disappearing Salvadorans, as they had done with his own family (fig. 7.4). As the numbers of

[handwritten margin note, left:] also closer to the border for re-entry

[handwritten margin note, bottom:] Which is crazy to think because very much alive people are currently still displaced / in danger in El Salvador.

FROM EAST LOS ANGELES TO THE WORLD

Central Americans migrating to Los Angeles were still increasing, Aparicio's exhibition and dialogues at SHG were significant, as both were statements of Salvadoran presence in the City of Angels, and in the artistic community. Furthermore, Aparicio's exhibition at SHG posed a question to the local community that Goldman succinctly captured in an earlier newspaper article regarding the question of US policies in Central America. She asked: "Can Chicanos—who opposed the Vietnam War—be persuaded to accept this unpopular policy so close to home?"[17]

THE CHICA-NICA TOUR AND *ALERTA*

→ unity between Latinos

The Chicano Movement deeply influenced the revolutionary imagination of Chicanas/os in LA. Many acknowledged the parallels between US intervention in Central America and the Vietnam War, which they had indeed protested. One Chicana artist, Yreina Cervántez, captured this awareness in a 1983 silk-screen print made at SHG, titled *Victoria Ocelotl* (fig. 7.5). Facing a dark background, surrounded and protected by a series of jaguars, an armed Indigenous woman stands up to military helicopters. Maya people had just endured the worst massacre since the Conquest, under orders of Guatemalan dictator Efraín Ríos Montt, and Cervántez's print exalted the role of Maya women as resilient warriors in the face of genocide. Cervántez learned about the struggles in Central America from Los Angeles cultural spaces, including Café Cultural and Macondo, and houses of worship such as First Unitarian Church and La Placita Church on Olvera Street. These were frequent venues for events organized by Central American and Chicana/o poets, artists, and writers to raise funds and awareness in solidarity with the Central American people.[18] Lifelong friendships and camaraderie emerged out of these events.

erasure of indigeneity

Cervántez, along with Chicana artist Barbara Carrasco, Nuyorican artist Kathy Gallegos, and others, chose to amplify their solidarity by traveling to Nicaragua as part of a delegation organized by UCLA students Richard Verches and Isidro Rodriguez. To finance Cervántez's and Chicana poet Gloria Alvarez's travel, community activists Marialice Jacob and Reyes Rodriguez organized a fundraiser at the studio of East Los Streetscapers—a Chicano muralist collective whose famous murals, such as *Chicano Time Trip* (1975) and *Corrido de Boyle Heights* (1983), are historical icons of the LA landscape.[19] The event, titled "Artistas para Artistas," illustrated that beyond a political solidarity, a shared artistic identity drove their effort. Along with music by Los Perros del Pueblo, Umbral, Los Piratas, King Charles, Wilfredo, and Sergio Zenteno, they included poetry readings by Ruben Guevara, Cipitio Poets, Marilyn C. Rodriguez, and Carlos Gutierrez (fig. 7.6).[20] Additionally, more than thirty artists participated in an exhibition as part of the fundraiser, including Salvadorans Juan Edgar Aparicio and Milton Aviles, Chilean Leonard Ibanez, Chicanas and Chicanos Ofelia Esparza, Margaret Garcia, Diane Gamboa, Rudy Calderon, and Leo Limón, among others.

With the financial collaborative support of their Chicana/o and Latina/o artist peers, Carrasco, Cervántez, and Gallegos traveled to Nicaragua in 1986 as part of what they called "The Chica-Nica Tour." Their mission was to learn about the 1979 Sandinista

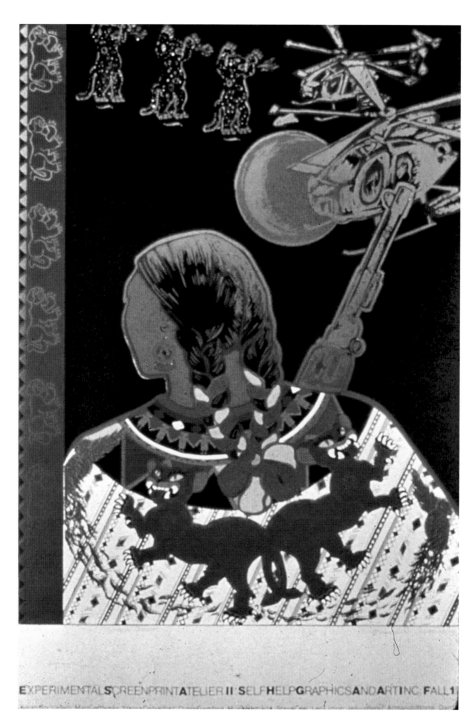

EXPERIMENTAL SCREENPRINT ATELIER II SELF HELP GRAPHICS AND ART INC FALL 1

Yreina D. Cervántez, *Victoria Ocelotl*, 1983. Screenprint, image: 24 × 18 in., sheet: 34 × 22 in., edition of seventy-seven, printed by Stephen Grace, Atelier 2. Self Help Graphics & Art Archives, California Ethnic and Multicultural Archives 3, University of California, Santa Barbara Library. Courtesy of the artist.

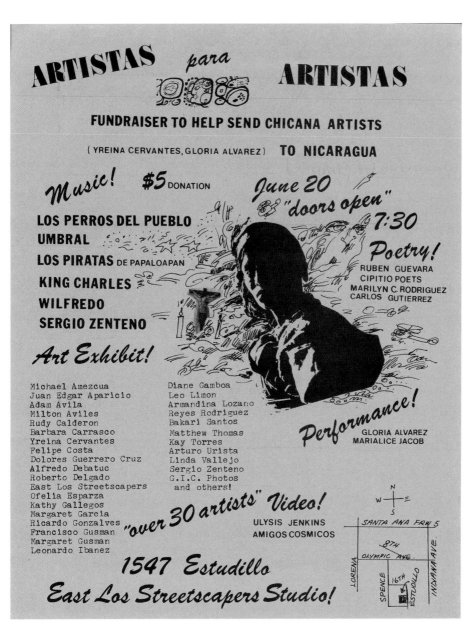

FIGURE 7.6

Yreina D. Cervántez, "Artistas para Artistas" flyer, 1986. Courtesy of the artist.

Revolution in Nicaragua, which was then opposed by Reagan's counterrevolutionary forces, known as CONTRAS.[21] Also key to their mission was to collaborate with local artists and offer their own visual gesture of Chicana/o solidarity. Along with the Chilean artist Francisco Letelier and the Chicano artist Carlos Callejo, the group completed a mural titled *La Unión del Movimiento Chicano con la Revolución Nicaragüense* in Managua,

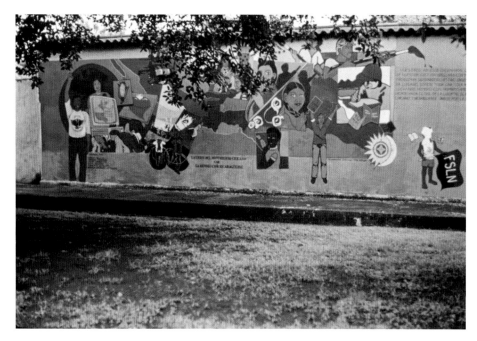

FIGURE 7.7

Photograph of *La Unión del Movimiento Chicano con la Revolución Nicaragüense* (1986), a mural created by artists Carlos Callejos, Barbara Carrasco, Yreina D. Cervántez, Kathy Gallegos, Francisco Letelier, and Brigada Orlando Letelier in Managua, Nicaragua, 1986. Photograph by Henry P. Houser. Courtesy of Henry Houser Collection, Special Collections and Archives, Knox College Library, Galesburg, Illinois.

Nicaragua, at the Plaza España in Parque Las Madres (fig. 7.7). The mural depicts a map of Mexico and Central America, overlain with a series of Chicano Movement–inspired images. On the far left, a Chicano student in a MEChA (Movimiento Estudiantil Chicano de Aztlán) t-shirt raises his fist in the air, behind him an image of Dolores Huerta and the United Farm Workers logo, and in front of him three farmworkers cultivating the land. In between those figures, a computer screen (which Carrasco describes as a sign of the times) shows a map of the United States with all the southwestern states checkmarked and a silhouette of the Nicaraguan revolutionary leader Augusto Sandino (fig. 7.8).[22]

With the phrase "Sandino Presente en Aztlán," the artists acknowledged the Nicaraguan diaspora as a welcomed group in the mythical homeplace of the Chicano community. This was a clear statement in opposition to Reagan administration officials who sought asylum only for Nicaraguan refugees, who they claimed fled a communist government, thus negating their own involvement in funding counterrevolution.[23] The mural then unfolds toward the right with images of helicopters, children running, and migrants crossing through barbed wire, as well as stoic Indigenous figures and youth with pens, paintbrushes, and books. Finally, there is an inscription in which the last line states: "The time has come, we are all one single America struggling shoulder

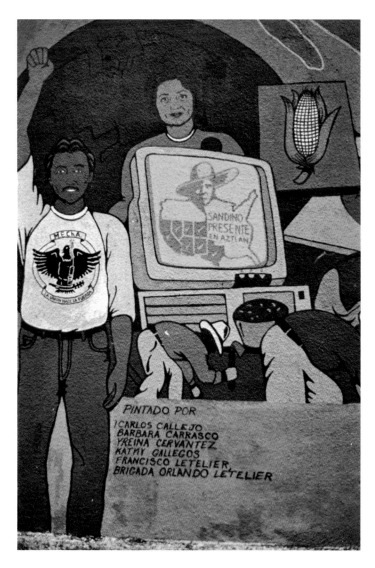

FIGURE 7.8
Detail of *La Unión del Movimiento Chicano con la Revolución Nicaragüense* (1986). Courtesy of Henry Houser Collection, Special Collections and Archives, Knox College Library, Galesburg, Illinois.

to shoulder, love to love, we go towards the sun of liberty, the Chicano and Nicaraguans united for peace."[24] Local community attended the inauguration, including revolutionary priest and minister of culture Ernesto Cardenal.[25]

Upon her return, impressed by the knowledge she had gained from the Chica-Nica Tour, Cervántez created a multimedia performance/installation at Galería Otra Vez in response to Central American migration to LA.[26] The event, titled *ALERTA*, was organized with fellow members of the Chicana, Asian, and Brazilian art collective Eastside Artists, including Gloria Alvarez (poet), Yreina Cervántez, Frances Salomé España (filmmaker and poet), Marialice Jacob (performance artist and musician),

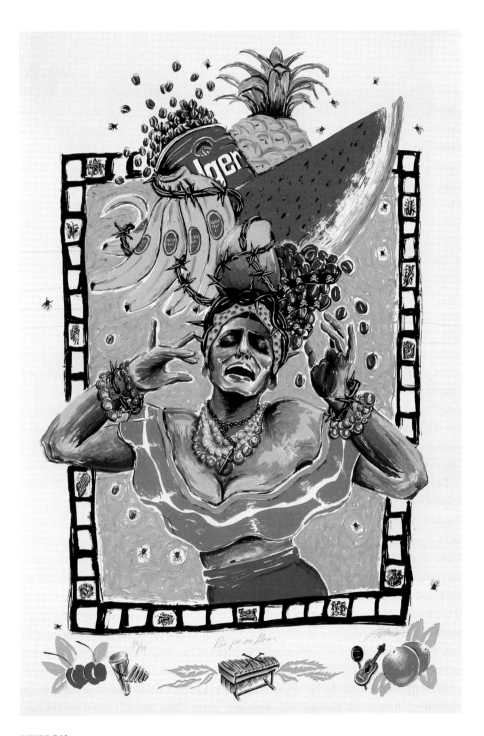

FIGURE 7.12

Alex Donis, *Rio, por no llorar*, 1988. Screenprint, image: 36 × 23 in., sheet: 39 × 26 in., edition of fifty-nine, printed by Oscar Duardo, Atelier 12. Self Help Graphics & Art Archives, California Ethnic and Multicultural Archives 3, University of California, Santa Barbara Library. Courtesy of the artist.

FIGURE 7.13

Alex Donis and Oscar Duardo printing *Rio, por no llorar* at Self Help Graphics & Art, 1988. Courtesy of Alex Donis.

artist Gloria Westcott further extended his network of Central Americans. For instance, Westscott organized the first Latino drag queen beauty pageant in LA at SHG in November of 1991, called LA QUEEN, for which Donis created the commemorative print with the same title (1991) (fig. 7.14). Many of the event's participants were Central American, including the emcee Herbert Sigüenza, a Salvadoran American and member of the performance troupe Culture Clash. In a 1999 print made at SHG, Sigüenza commemorates the group's fifteenth anniversary with a figure of Cantinflas flanked by pictures of the three members, including Richard Montoya and Ric Salinas, who is also Salvadoran (fig. 7.15).

For Donis, who gravitated to SHG for the artmaking opportunities and art community, the mentorship and friendships he received there were significant in encouraging

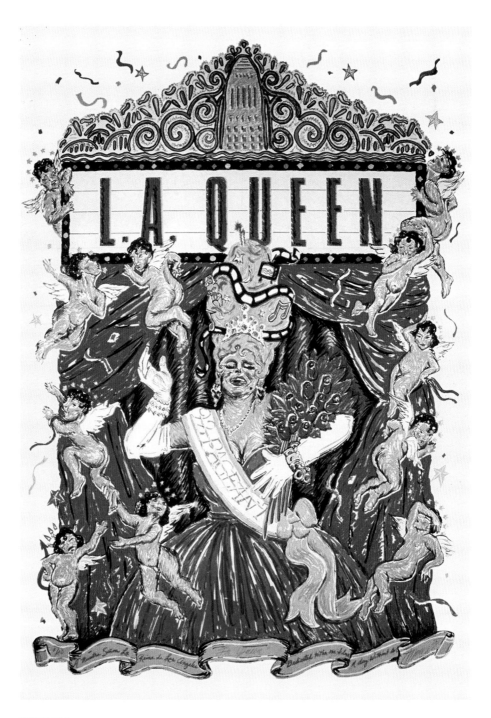

FIGURE 7.14

Alex Donis, *LA Queen*, 1991. Screenprint, image: 35 × 26 in., sheet: 40 × 28 in., edition of forty, printed by José Alpuche, Special Project/Day Without Art. Self Help Graphics & Art Archives, California Ethnic and Multicultural Archives 3, University of California, Santa Barbara Library. Courtesy of the artist.

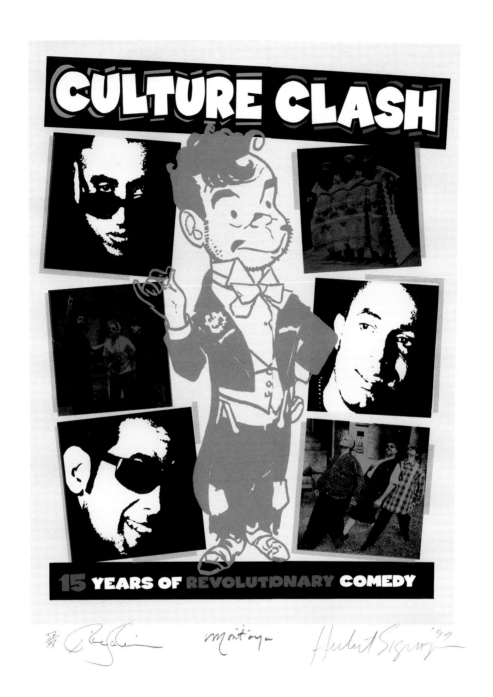

FIGURE 7.15

Herbert Sigüenza, *Culture Class: 15 Years of Revolutionary Comedy*, 1999. Screenprint, image: 26 × 20 in., sheet: 30 × 22 in., edition of seventy-eight, printed by José Alpuche, Special Project and Atelier 34. Self Help Graphics & Art Archives, California Ethnic and Multicultural Archives 3, University of California, Santa Barbara Library. Courtesy of the artist.

FIGURE 7.16
Alex Donis at Self Help Graphics &
Art during exhibition opening of
*Arts of Mexico: Its North American
Variant*, 1991. Photograph by Holly
Hampton. Courtesy of the artist.

him to explore a more personal subject matter in his art (fig. 7.16). The initial allure to SHG was not necessarily related to Central America, but rather to the community, mentorship, and resources SHG offered local artists and their political awareness. What he unexpectedly encountered was the support by certain Chicana/o artists who invited him to talk openly about his Central American identity and experiences. Because silence and censorship has been one of the painful consequences the Central American diaspora has inherited, due to both generational traumas of violence and the additional discrimination Central Americans endure, this welcome intimate dialogue with artists—to discuss heritage, violence, identity, art, and more—was restorative.[34]

WE ALL FOUND OURSELVES THERE

By the 1990s, the Central American struggle received less visibility in the United States. Peace accords were signed in El Salvador in 1992 and in Guatemala in 1996, officially ending civil war in Central America. Los Angeles organizers and activists continued to work with Central American refugees and migration continued, but the urgency of antiwar and anti-imperialist efforts that dominated the 1980s was no longer directly visible. The City of Angels witnessed new historical events, such as the 1992 LA uprising, which highlighted the police brutality LA's Black and Brown community had long endured, and the 1994 Zapatista uprising that brought light to Indigenous resistance in the face of centuries of colonialism followed by neoliberalism. This new context shaped the work created by another generation of US Central American artists at SHG, such as Mendez and Lemus.

Dalila Paola Mendez (b. 1975), a queer multimedia artist of Salvadoran and Guatemalan descent, grew up in Echo Park and Northeast Los Angeles. Though she frequented SHG as a high school student, she became more involved in the late 1990s as a college graduate and member of the collective Mujeres de Maiz (MdM). As with Donis, SHG became Mendez's first exhibition venue when the collective curated a show that included her artwork. The political consciousness and activism of SHG artists in the 1990s, such as their outspoken opposition to anti-immigrant Proposition 187, attracted Mendez to the unique space. Unexpectedly, it was at SHG that Mendez connected with other Central American activists and poets, such as Rossana Pérez, Raquel Gutiérrez, Hugo Chavez, Jessica Grande, Gustavo Guerra Vásquez, and artist Leda Ramos for whom SHG was also an important artistic foundation. Together they later founded the US Central American collective of writers, poets, and spoken word artists known as EpiCentro.[35] As Mendez explains, though SHG was mostly seen as a Chicana/o space, there was nothing else like it in LA, "and that's why we all found ourselves there."[36] Since that time, Mendez has remained an active artist at SHG, producing a wide body of work that evinces two concurrent themes drawn from her personal biography: honoring queer love, and honoring Indigenous memory and identity.

The difficulties with her own coming-out experience in the 1990s drew Mendez to honor queer love in an open and unapologetic manner, as seen in her popular print *Queerios* (2015) (fig. 7.17). Made at SHG, the print appropriates the Cheerios box, modifying the cereal's iconic name. Drawing on the cereal's advertisement campaign claiming that it can lower cholesterol and promote a healthy heart, Mendez surrounds a heart-shaped bowl with the words "Love your heart . . . so you can be who you are," thus altering the campaign to one that promotes queer self-love and queer self-acceptance.[37] Yet for Mendez, queer love does not look one specific way. Thus, as curator in 2018, she brought five queer artists together for SHG's 58th Atelier. Titled *Queerida*, a play on the words *queer* and *querida*, and a signal to Juan Gabriel's popular song "Querida," it was the first-ever all-queer Latina atelier at SHG.[38]

FIGURE 7.21

Nery Gabriel Lemus, *Thank You for the Game*, 2013. Screenprint, sheet: 50 × 36 in., edition of twenty, printed by José Alpuche, Special Project/LACMA's Futbol: The Beautiful Game. Courtesy of the artist and Charlie James Gallery.

evidenced by his work with incarcerated youth. But his personal commitment to racial solidarity, cultural awareness, and inclusivity influenced recent projects at SHG.[44] In his three-color silk-screen print *Thank You for the Game* (2013), exhibited in *Futbol: The Beautiful Game* at the Los Angeles County Museum of Art, Lemus centers a black-and-white photograph of a makeshift soccer ball midair, with red and black rays emanating from it toward the bottom right corner, all against a solid green background (fig. 7.21). The black, red, and green call to the pan-Africanist ideology in African territories and across the Americas as adopted by the Marcus Garvey organization, committed to the advancement of African diasporic people around the world. For Lemus, the improvised soccer ball and Black Power colors highlight the inventiveness in nations

economically affected by colonialism and empire, and exalt the creativity and resourcefulness in communities of color. As Lemus explains, throughout these geographical areas, regardless of economic hardship, any child can make a soccer ball out of plastic bags and other discarded material.[45]

More recently, in 2019, Lemus cocurated, along with Jimmy O'Balles of Subir Arts Collective, the exhibition *Black, Brown, and Beige* at SHG. Inspired by Duke Ellington's 1943 symphony performance "Black, Brown, Beige" that refuted the categorization of African Americans as a single color, this exhibition addressed colorism within the Black and Brown communities and highlighted the histories of diasporic peoples across the Americas. Racial and cultural unity, so central to much of Lemus's work, seeks to center creative resilience within our shared struggles for liberation. This is the path SHG is taking, Lemus explains, inclusive not just of US Central Americans but of other racialized communities. What remains constant for Lemus, as it does for Mendez, is the value in being part of a space committed to socially conscious artmaking in LA, to which they both contribute with their art and curatorial projects that call for sexual and racial inclusivity and solidarity, thus making SHG a more welcoming space to others.

CONCLUSION

While SHG is historically understood and performed as a Chicana/o art space, its print collection, the events and collaborations organized on site, and the artists, curators, and teachers who keep the space alive, reveal a broader community that better reflects the diverse city and people it serves. For US Central Americans, the "Other Than Mexican" or OTM logic operates beyond the US-Mexico border. It persists as a national hegemonic logic that continues to misrecognize Central Americans as Mexican, thus erasing them from the cities they inhabit. Subsequently, their unrecognized presence in cultural and art spaces constitutes part of that erasure. The result is an incomplete history of their artistic contributions to American art.

Yet, as I have shown, amid the rise of Central American migration to Los Angeles in the 1980s, SHG held events in solidarity with Central Americans, and many of its Chicana/o artists were active in the movement as well. Though it was less a center for activism against US intervention in the region than nearby religious and cultural spaces were, SHG was *different* from other venues in that it was an art-centered communal space, where local artists could use the available tools and mentors to create and discuss art that reflected their concerns. These unique offerings drew in local communities to experiment with ways of connecting art to the urgent political issues of the time, as they did for Cervántez, Carrasco, Gallegos, and many others. These events fueled conversations, awareness, connections, and collaborations between Chicanas/os and Central Americans that planted seeds for other generations of US Central American artists, such as Donis, Mendez, and Lemus, for whom SHG was a significant part of their artistic and political formation—and they remain active as artists/educators/curators who now mentor a new generation of artists. While this

history is crucial for expanding narratives of Chicana/o and US Central American art in Los Angeles, we are encouraged to ask what other encounters with radical solidarity in cultural art spaces across the nation are waiting to be unearthed. What lessons will they offer for our histories of art and resistance?

Uncovering this Central American presence in a historically Chicana/o art space does not take away from its history or identity, but rather enriches it by exposing an overlooked chronicle of Central American and Chicana/o camaraderie in the LA art world that may need highlighting now more than ever. These brief untold stories remind us that to embody camaraderie is to center silenced voices and to be a witness rather than a savior, as we learn with the experiences of Aparicio and Donis. Camaraderie is moving beyond illusions of similitude and toward radical compassion, to a place where revolutionary and artistic influence is reciprocal rather than unidirectional, as the Chicana/Latina artists Cervántez, Carrasco, and Gallegos showed. Camaraderie is expansive and extends into multiple struggles of racialized and gendered peoples, as Lemus and Mendez practice. Camaraderie should plant seeds that will persist and transcend the generational, as we see with all the artists. When mentorship and solidarity are based on artists' own work, and on their understanding of how imperialist, anti-immigrant, and racist ideologies affect different peoples, camaraderie extends beyond cosmetic acts of neoliberal multiculturalism and is truly transformational.

When these collaborations and moments of camaraderie between Central Americans and Chicanas/os in the City of Angels and in the local art scene are ignored, we lose a piece of our collective history and possible lessons for true solidarity. We risk forgetting that we are still in the midst of that unfolding history. For instance, the US intervention in Central America that occurred in the 1980s, as seen in Aparicio's and Donis's work, appears later in both Mendez's and Lemus's work on migration. They show how the violence that Central Americans have been fleeing since the 2000s is directly related to the unresolved injustices of decades prior. The repression and displacement of Maya peoples continues, and has led to the rise in femicide. These are leading causes of Central American migration today. Additionally, amid a global pandemic, we are now in the aftermath of a racist and anti-immigrant administration whose purpose was to unleash once-hidden hatred against Black, Brown, and immigrant communities in overt ways. It thus seems fitting to conclude by returning to Goldman's poignant question from 1984, which seems relevant for all of us today: Can we be persuaded to accept unpopular policy so close to home? Highlighting our points of convergence in solidarity and in radical artmaking in a historical LA art space is perhaps a timely and crucial reminder as we move toward a new phase and battle for our collective liberation.

NOTES

I am grateful to the University of New Mexico Southwest Hispanic Research Institute for awarding me a small research grant that made possible my travel to the California Ethnic and Multicultural Archives at UC Santa Barbara.

1. For more on SHG, see Kristen Guzmán, *Self Help Graphics & Art: Art in the Heart of East Los Angeles,* edited by Colin Gunckel (Los Angeles: UCLA Chicano Studies Research Center Press, 2005).

2. For more, see Deborah Cohen, *Braceros: Migrant Citizens and Transnational Subjects in the Postwar United States and Mexico* (Chapel Hill: University of North Carolina Press, 2011).

3. See Eduardo Obregón Pagán, *Murder at the Sleepy Lagoon: Zoot Suits, Race, and Riots in Wartime L.A.* (Chapel Hill: University of North Carolina Press, 2003).

4. See Ernesto Chávez, "*¡Mi Raza Primero!*" (*My People First*): *Nationalism, Identity, and Insurgency in the Chicano Movement in Los Angeles, 1966–1978* (Berkeley: University of California Press, 2002).

5. For an introduction to political history in Central America, see John A. Booth, Christine J. Wade, and Thomas W. Walker, *Understanding Central America: Global Forces, Rebellion, and Change,* 6th ed. (Boulder, CO: Westview Press, 2015).

6. Ana Patricia Rodríguez, "Refugees of the South: Central Americans in the U.S. Latino Imaginary," *American Literature* 73, no. 2 (June 2001): 387–412.

7. David E. Lopez, Eric Popkin, and Edward Thales, "Central Americans at the Bottom: Struggling to Get Ahead," in *Ethnic Los Angeles,* edited by Roger D. Waldinger and Mehdi Bozorgmehr (New York: Russell Sage Foundation, 1996), 280.

8. Ibid.

9. Maritza E. Cárdenas, *Constituting Central American-Americans: Transnational Identities and the Politics of Dislocation* (New Brunswick, NJ: Rutgers University Press, 2018).

10. Ana Patricia Rodríguez, "'Departamento 15': Cultural Narratives of Salvadoran Transnational Migration," *Latino Studies* 3, no. 1 (April 2005): 19–41.

11. "Resource Contact Sheet: Shifra Goldman," Self Help Graphics & Art Archives (hereafter SHGA), box 9, folder 1, California Ethnic and Multicultural Archives 3, University of California, Santa Barbara Library (hereafter CEMA, UCSB).

12. "Artists Call Release Statement: Nicaraguan Poster and Mural Exhibition," SHGA, box 9, folder 1, CEMA, UCSB.

13. Juan Edgar Aparicio, personal communication with the author, April 21, 2020.

14. See Kency Cornejo, "US Central Americans in Art and Visual Culture," *Oxford Research Encyclopedia of Literature,* February 25, 2019, https://doi.org/10.1093/acrefore/9780190201098.013.434.

15. Juan Edgar Aparicio, personal communication with the author, April 21, 2020.

16. CARECEN emerged in 1984 as a nonprofit designed to aid the millions of arriving Central American refugees, and it is now the largest Central American immigrant rights organization in the country. For more, see www.carecen-la.org (accessed January 14, 2021).

17. Shifra M. Goldman, "Chicano Cornucopia in Los Angeles," *Artweek* 15, no. 3 (1984).

18. I'm thankful to both Yreina Cervántez and Rossana Pérez for this confirmation. For more personal accounts on activism and events led by Central American refugees in Los Angeles, see Rossana Pérez and Henry A.J. Ramos, eds., *Flight to Freedom: The Story of Central American Refugees in California* (Houston, TX: Arte Público Press, 2007).

19. For more on East Los Streetscapers, see Karen Mary Davalos, *Chicana/o Remix: Art and Errata since the Sixties* (New York: NYU Press, 2017).

OLGA U. HERRERA

8

SELF HELP GRAPHICS AND GLOBAL CIRCUITS OF ART IN THE 1990s

SINCE ITS EARLY DAYS as a cultural space in a garage in Boyle Heights in 1970, Self Help Graphics & Art (SHG)—the quintessential Southern California and East Los Angeles nonprofit community visual arts center, incorporated in 1973—has enjoyed a seemingly rooted local Chicano identity.[1] Yet, in considering contemporary circuits of American art, I posit that with a look through both a local and a global lens a more complex picture emerges, pointing to a rather marked international orientation, beginning with SHG's founders: the Italian American, European-trained printmaker Sister Karen Boccalero (1933–97); the Spanish-speaking draftsman and muralist Carlos Bueno (1941–2001), born in Cuernavaca, Mexico; and Bueno's Mexican partner, photographer and self-taught muralist Antonio Ibañez (1949–95). John Tomlinson has argued—in reference to cultural identities, resistance, and localities that engender cultural heterogeneity—that "modernity is the harbinger of identity," that "globalization actually proliferates rather than destroys identities," and that "cultural identity, properly understood, is much

more the product of globalization than its victim."[2] With this question of identities in mind, this chapter explores the ways in which SHG, under Sister Karen's tenure, intentionally sought to solidify its international profile and stand, in the early to mid-1990s, at the height of a contemporary globalization with the exhibition *Chicano Expressions: Serigraphs from the Collection of Self Help Graphics,* which toured Africa, Western Europe, and Mexico from 1993 to 1997 (fig. 8.1); the UK/LA Exchange of 1994; and the Glasgow Print Studio Exchange of 1996 (fig. 8.2).

SISTER KAREN AND THE ORIGINS OF AN INTERNATIONAL SHG

There is no doubt that Bueno, Ibañez, and the Los Angeles–based artists Frank Hernández and (Ecuadorian) Milton Jurado, who also joined SHG, appeared at a critical juncture in Sister Karen's life, just as she had returned to Los Angeles after spending five years in Italy and one in Philadelphia.[3] This group initially came together, in a residential garage, to teach art classes and to form a community with shared art interests. Their fortuitous encounter and merging of artistic paths would significantly contribute, albeit temporarily, their various cultural backgrounds, identities, and international and transnational experiences to a compelling and enduring vision that has shaped this incubator of Latino and Chicano printmaking.

At the very center—and informing a steady and sustained national and international outlook for SHG—was Sister Karen, a nun in a mendicant Roman Catholic religious order, the Sisters of St. Francis of Penance and Christian Charity. Born Carmen Rose Boccalero in 1933 in Globe, Arizona—to an Italian father, Albert Boccalero, and an Italian American mother born in Colorado, Anne Guadagnoli—she moved with her family in 1938 to Los Angeles, where she spent most of her childhood and teenage years.[4] She returned to Globe temporarily for two years at age nine, and later lived with family in El Paso, Texas, during her freshman year in high school, coinciding with the World War II years, when many Italians and Italian Americans in the United States were discriminated against, persecuted, and surveilled.[5] After that sojourn, Boccalero returned to Boyle Heights to live with her mother and her mother's new Jewish husband in what was then a thriving, culturally mixed, Italian, Japanese, Jewish, Armenian, and Mexican working-class enclave.

Joining the Franciscan order as a postulant in April 1952, the Catholic Girls' High School graduate and deeply religious teenager was mostly interested in saving her "soul and help[ing] others, [and] to serve God."[6] Adopting the name Sister Mary Karen—later simplified to Sister Karen—she started her novitiate in the Mount Alverno Convent in the town of Sierra Madre, California. After presenting her temporary vows of poverty, chastity, and obedience in August 1955, she taught at diocesan schools in the Los Angeles County towns of Altadena, Sierra Madre, and Monrovia, tending to the needs of German, Japanese, Southern European, and Mexican Catholic immigrant families, as was the tradition in her congregation.

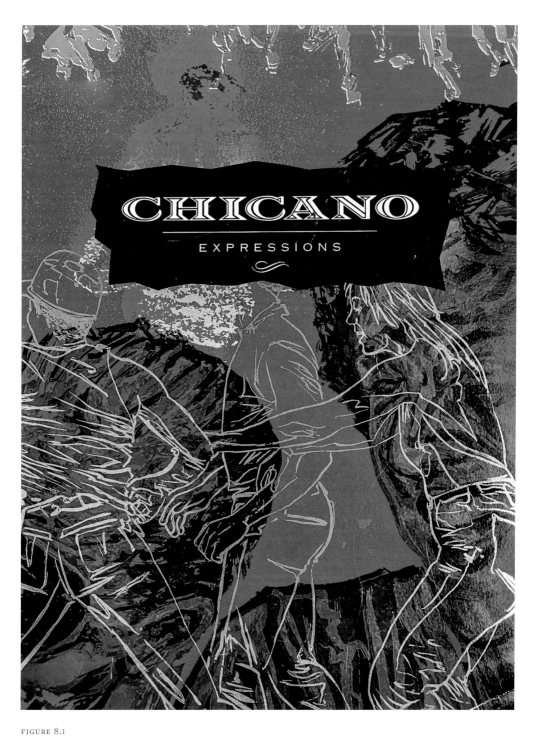

FIGURE 8.1

Chicano Expressions catalog cover, featuring a detail of John Valadez, *Untitled*, 1985. Screenprint, image: 35½ × 24¾ in., sheet: 35½ × 24¾ in., edition of eighty-eight, printed by Stephen Grace, Atelier 5. Courtesy of Self Help Graphics & Art and John Valadez.

FIGURE 8.2

Margaret Sosa, *Untitled* (Día de los Muertos, Los Angeles–Glasgow), 1996. Cutout tissue paper. Courtesy of the artist.

In the early 1960s, Sister Karen enrolled in Immaculate Heart College, a Catholic women's school in the Los Feliz neighborhood of Central Los Angeles, majoring in art and serigraphy and studying under the progressive head of its art department, Sister Mary Corita. After completing her studies, she was sent by her order to Italy in 1965 to teach at the St. Francis International School in Rome.[7] This assignment coincided with Chicago artist Richard Callner's time as founding director of Temple University's Tyler School of Art in Rome, established at Villa Caproni in 1966, and Sister Karen pursued graduate studies under him. Mostly working in serigraphy, she also explored other media, such as oil painting, bronze sculpture, intaglio, and lithography.

Upon her return to the United States in August 1970, she lived in Philadelphia for a year, receiving her MFA degree from Temple University in May 1971.[8] Now thirty-eight, Sister Karen moved back to a sprawling Los Angeles and settled in her old neighborhood. East Los Angeles was by now an urban hotbed of Mexican American politicized civil rights; anti–Vietnam War demonstrations; and actions for social justice, education, cultural affirmation, and empowerment against established structural mechanisms of disenfranchisement, discrimination, segregation, and economic inequality.[9]

With profound shifts in the turbulent social and political fabric of Los Angeles, and considerable mainstream anxiety over gender, sexuality, class, identity, civil rights, and racial identities, this was no longer the same place where Sister Karen had lived and worked in the 1950s and early 1960s. Sister Mary Corita, now Corita Kent, and others had left the Franciscan order and Immaculate Heart College, unfortunate casualties of a conservative local Catholic Archdiocese, one that was unwilling to recognize the significant social transformation and everyday norms of the 1960s or the most admirable aspects of Pope John XXIII's and Paul VI's pivotal Second Vatican Council reforms. As the council came to a close in late 1965, its *Perfectae Caritatis* or *Decree on the Adaptation and Renewal of Religious Life* became a directive the Franciscan nuns wholeheartedly embraced. The decree offered new ideas to integrate their mission with contemporary life and a new culture of social movements to end racial and ethnic prejudice, poverty, and injustice.[10]

Adhering to her Franciscan principles, Sister Karen decidedly set out to "create community" in the heart of East Los Angeles, "with the people with whom [she] live[d] and work[ed]."[11] She shared a group house with other nuns (who would at times assist her at SHG) on North Eastman and Gage Streets, not far from where she had grown up. There she established her printmaking practice in a garage with an old printing press while faithfully embracing her religious order's identity, values, and lifetime vows responding to human need, faith, and prayer.

It is logical, then, that Sister Karen would find her life's other true calling in printmaking, serving a local community in the unincorporated area of East Los Angeles.[12] An initial grant of $10,000 from the Order of the Sisters of St. Francis in 1972 allowed the group to rent space at 2111 Brooklyn Avenue in Boyle Heights, where SHG was born and would remain until 1979, when it moved to a one-dollar-a-year, Catholic Church–owned building on 3802 Broadway Avenue (renamed Cesar E. Chavez Avenue in 1994).[13]

Sister Karen's training at Immaculate Heart College and in the Franciscan order indeed made an imprint and was felt in the early SHG organization. As Isabel Anderson noted in 1992, Corita Kent's impact was palpable in the cooperative and collaborative nature of the printmaking workshop, the atelier model, the sharing of resources, and the permeating celebratory spirit of art, life, and culture.[14] Kent's theological pop and conceptual art wordplay, in well-known works such as *That They May Have Life* (1964) and *The Big G Stands for Goodness* (1964), foreshadowed the 1970s West Coast conceptualism that originated at the California Institute of the Arts. Although Kent's work was inspired by a doctrine of transubstantiation, the California approach to conceptual art would use a wordplay of text/image and visual puns. This also seeped into some of SHG's expressions embracing everyday life and the cultural celebration of Chicano aesthetics.

Propelled by that very spirit and the celebration of life, art, and culture, Sister Karen partnered with other artists to set about offering classes, studio and exhibition space, and a new hybrid form of Central Mexico's traditional observance of All Souls'

was magnified by a discussion televised through the USIA's Worldnet system, featuring Amalia Mesa-Bains and Tomas Benitez in conversation with faculty of the Evelyn Hone College of Art and with Zambian contemporary artists, who quickly "took over and took turns talking about the work." As Benitez recalled, in their responsive expressions, "they had taken the work to heart and could relate to it in their own national aesthetic."[37] The exhibition, and SHG itself, inspired artists to consider a similar workshop setup for Zambian artists.[38]

In Maputo, Mozambique, *Chicano Expressions* was the first major foreign exhibition ever presented at the National Museum of Art, and one that significantly contrasted with the country's contemporary art scene. Noted for the vibrant colors of the serigraphs—some featuring up to nineteen colors—Chicano art turned out to be a respite from a dark local palette and a preference for full pictorial planes that reflected "the turmoil experienced throughout the society with each succeeding year of civil war."[39] In this post-civil-war context, after the 1992 peace accords, as the country moved from a Marxist-Leninist sociopolitical model to a neoliberal democratic one, the exhibition was seen as new and unique and as an example of the Americans' bold freedom of expression, particularly with artworks marked by political undertones. Thus, *Chicano Expressions* in Mozambique acquired a subtle new message: that "democracy encourages the creation of brilliant works of art," becoming a demonstration of "America's most cherished commodity: freedom of speech."[40]

Chicano Expressions, now accompanied by SHG staff, traveled next to South Africa for a presentation at the Pretoria Art Museum from August 3 to 28, 1994, the first exhibition shown under a newly reorganized museum staff and board, after the demise of apartheid and the election of Nelson Mandela as president.[41] For Pretorian audiences, the art was characterized as bold, with brilliant colors; SHG was introduced as an "inner city community art programme"; and the artists were called "Americans of Mexican heritage," expressing a cultural identity.[42] Present at the opening on August 3 was Tomas Benitez, who lectured the next day on the history of SHG at the Pretoria Community Arts Project Centre, a teaching and exhibition space for the Black townships.[43] The audience was very receptive, with some calling the exhibition "the best American art they had ever seen."[44] As Benitez recalls, "it WAS American art (by Chicanos), from their perspective, and they knew a thing or two about race and color."[45] One local artist, Eric Lubisi, acknowledged that "*Chicano Expressions* had arrived in South Africa at a most appropriate time when Black South Africans were struggling to find their identity in their new country . . . liken[ing] their experience to the struggle of Chicanos over the years in finding their place in American society."[46] *Chicano Expressions* was also shown in the city of Durban, at the Durban Art Gallery, a few weeks later, from November 2 to 27, 1994.

In Kampala, Uganda, *Chicano Expressions* was presented at the Nommo Art Gallery in December 1994 through early January 1995. The US ambassador there, E. Michael Southwick, characterized it as an example of "America's rich diversity of cultural herit-

age."[47] The audience lamented that the original prints were not for sale. Visually reading the various works in the exhibition, members of the Makerere School of Fine Art and students of the School of Music, Dance, and Drama were intrigued and attracted to the symbols and traditions reflected in "skulls, car culture, and dancing shoes" in the work of Eduardo Oropeza (1943–2003), Ester Hernandez (b. 1944), and Margaret Garcia (b. 1951).[48]

Oropeza's *El jarabe de los muertiaños/The Dance of the Dead* (1984) (fig. 8.4), possibly inspired by the SHG's Día de los Muertos parade of 1977, treated a theme that he continued to explore in the serigraph *Onward Christian Soldiers* (1985).[49] Oropeza is mostly known for his sculpture, and the figurative composition features a group of clothed skeletons as musicians, including a cardinal wearing a mitre hat, dancing to a *jarabe* tune. Its striking colors and composition, with dynamic figures in movement, are reminiscent of Henri de Toulouse-Lautrec's posters.

Ester Hernandez's 1990 serigraph *The Cosmic Cruise* reflected California's fascination with cars (fig. 8.5). Yet her work more importantly conveyed spiritual experiences, memory, and a consciousness of Chicanas and Latinas. Inspired by the story of her mother as the first woman driver in the Central Valley, where she was a farmworker, Hernandez pays homage in this work to the women in her family, while acknowledging the centrality of the Virgin of Guadalupe in feminist Chicana culture.[50] A circa 1910s Ford Model T car with four passengers cruises through vast sidereal space, underscoring what the artist calls "our interconnectedness with each other and the universe. The car represents movement in space, and time is represented by the images of the women: 'La Virgen de Guadalupe' (the driver) the Mexican-Indian grandmother, the modern Chicana mother, and child [the artist]. The Aztec moon goddess-Coyolxauhqui signifies our link with the past. The print is part of my ongoing tribute to la Mujer Chicana."[51]

Produced in SHG's Atelier XI, Margaret Garcia's *Romance* (1988) is organized by a diagonal line, implied by a variety of chili peppers and a fork, that breaks the pictorial plane into two, highlighting the red stiletto pump shoes with green insoles placed abandonedly on both sides (fig. 8.6). The yellow background retains a painterly quality that reveals the color of the paper as medium. Highly symbolic and fraught with meaning, the three elements on the print—red shoes, chili peppers, and fork—have been described by the artist as "a sexual pun."[52] With a variety of green, red, yellow, and purple peppers as phallic symbols, the artist wished to explore "the sexual tensions in the first stages of 'Romance.' The fork foams on the appetite of those involved. Chili, sex, something that feels so good can burn so bad."[53]

Chicano Expressions developed into a de facto ambassador of the LA community-based art workshop in Africa and officially positioned SHG as "the progenitor of the modern Chicano Renaissance,"[54] and as a bridge between the local and the mainstream.[55] The success of the Africa tour prompted USIA program officer Robert L. Brown to call Sister Karen to tell her that "the show was the most popular exhibition

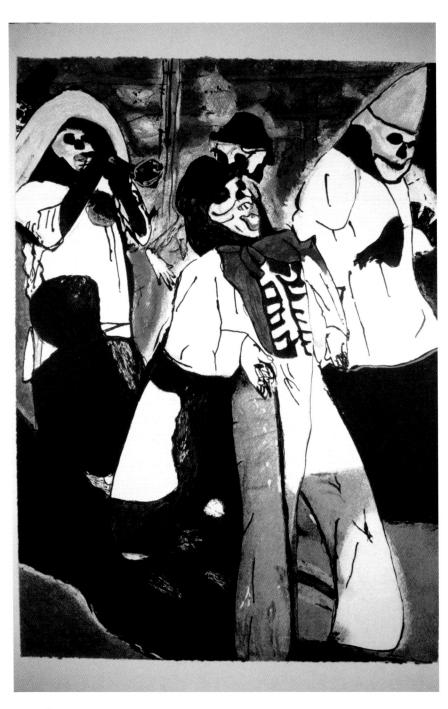

FIGURE 8.4

Eduardo Oropeza, *El jarabe de los muertiaños/The Dance of the Dead*, 1984. Screenprint, image: 35⅞ × 23¾ in., sheet. 3/⅞ × 25¼ in., edition of seventy-three, printed by Stephen Grace, Atelier 3. Self Help Graphics & Art Archives, California Ethnic and Multicultural Archives 3, University of California, Santa Barbara Library. Courtesy of the estate of the artist and Glenn Green Galleries.

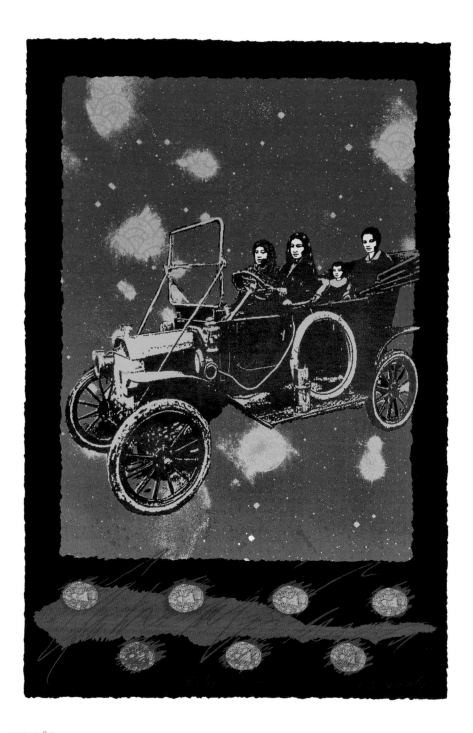

FIGURE 8.5

Ester Hernandez, *The Cosmic Cruise*, 1990. Screenprint, image: 36 × 24 in., sheet: 38 × 26 in., edition of sixty, printed by Oscar Duardo, Atelier 15. Self Help Graphics & Art Archives, California Ethnic and Multicultural Archives 3, University of California, Santa Barbara Library. Courtesy of the artist.

FIGURE 8.6

Margaret Garcia, *Romance*, 1988. Screenprint, image: 24½ × 35½ in., sheet: 26½ × 40 in., edition of thirty-six, printed by Oscar Duardo, Atelier 11. Self Help Graphics & Art Archives, California Ethnic and Multicultural Archives 3, University of California, Santa Barbara Library. Courtesy of the artist.

they ever hosted" and to suggest a one-year extension.[56] USIA Arts America amended the cooperative agreement for an additional $38,400 to tour the exhibition in Western Europe throughout early 1996.[57]

CHICANO EXPRESSIONS IN WESTERN EUROPE AND MEXICO

Contemporary Chicano art had certainly made rounds in Europe already, with exhibitions such as *Imágenes de la Raza*, organized by Amerika Haus Berlin for the second Festival of World Cultures ("Horizonte '82," held in June–July 1982 and circulated through Europe until 1985); Wayne Alaniz Healy's curated exhibition at the Triskel Arts Centre in Cork, Ireland, in 1983; and *Le Démon des Anges: 16 Artistes Chicanos Autour de Los Angeles*, in 1989–90.[58] There were also highly visible mural projects, such as Berlin's seven-story-high *Global Chessboard*, a collaboration between Paul Botello and Eva Cockcroft. Even so, *Chicano Expressions* became, in the early 1990s, the new showcase for Chicano works on paper, with the official sponsorship of the US government.[59]

Presented at Casa de América in Madrid from February 2 to 26, 1995, *Expresiones Chicanas* became one of the events of the art fair ARCO 95.[60] With the United States as the guest country, Chicano art entered the global contemporary in a fair designed to show the latest artistic trends. The exhibition became a reflection of art in the border-

lands (*arte en la frontera*), with Chicano artists in search of a cultural identity marked by lives in the United States and roots in Mexico.[61] Not surprisingly, given the presentation in the old metropole, the exhibition was also positioned, stylistically, somewhere between Mexican popular art and American pop art. Representing SHG was Yolanda González, who offered a series of illustrated talks exploring diversity of vision and themes.[62] The exhibition then traveled to Barcelona for a presentation at Instituto de Estudios Norteamericanos in March 1995.

Around this time, Jörg W. Ludwig wrote to Sister Karen asking for a Berlin showing, in a recently reunified Germany, as "a special celebration of Los Angeles' multicultural urbanity and a tribute to . . . two cities' special relationship."[63] When Amerika Haus Berlin became the venue for *Chicano Expressions* in May 1995, the total of ninety prints, the history of SHG in its social and cultural context, and a literary component guaranteed an appeal to the new German citizens of diverse backgrounds. The wide range of styles and techniques underscored the importance of SHG in an international setting. Artworks like Artemio Rodríguez's *Caballo Trompeta*, Larry Yáñez's *Sofa So Good*, and Yreina Cervántez's *The Long Road* received particular attention, and color images of them illustrated reviews and articles about the exhibition.[64] With the two-day seminar *The Chicano Experience: Its Social, Cultural and Literary Perspectives*, featuring José Antonio Aguirre, Tomas Benitez, Ana Castillo, Rolando Hinojosa-Smith, and Horst Tonn (the preeminent German Chicano expert) talking about current trends in Chicano literature, the exhibition reached a much wider German audience before traveling to Bremen and to Amerika Haus Frankfurt.[65]

The US Embassy in Berlin saw *Chicano Expressions* as an effective display of colorful prints that highlighted "the richness and vitality of American multi-ethnic culture in a European capital that takes pride in its multicultural present and future."[66] The exhibition became part of a discourse, serving both nations, about how to embrace multiculturalism in terms of nationality, while not always wishing the cultural differences to be visible. As noted above, Germany had just been reunified, as an enlarged Federal Republic of Germany—that is, as a continuation of the West German state—and ethnic Germans from the former East Germany were experiencing integration problems in language, education, and socialization, among other issues.[67] The image selected to promote the exhibition was Gronk's *Iceberg* (1982), a serigraph (part of a 1982 special project at SHG) featuring a woman's face prominently emerging in the left top corner from a multitude of faces and figures below (fig. 8.7). This was an aesthetic that appealed to Berliners, with its figurative yet abstracted linear composition that formed patterns in what seemed to be a crowded urban landscape.

Traveling next to France, *Chicano Expressions* opened on October 5, 1995, at the Musée Faure in Aix-Les-Bains, housed in a Genoese-style villa and renowned for its collection of impressionist paintings and Rodin sculptures. In introducing the exhibition, curator André Liatard noted the pluralism of the United States and the inherent ethnic identity of the artists. The local press, such as *La Gazette de Drouot,* ran a note

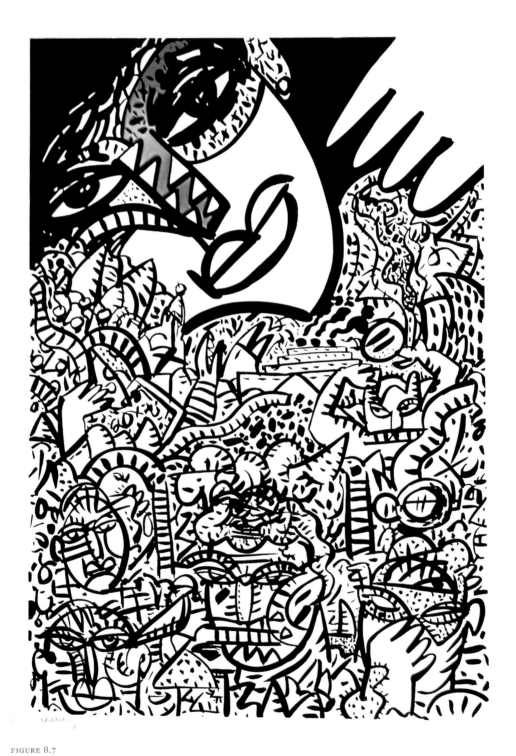

FIGURE 8.7
Gronk (Glugio Nicandro), *Iceberg*, 1982. Screenprint, sheet: 29½ × 21½ in., edition of twenty-five, printed by Stephen Grace, Special Project. © 1982 Gronk. Courtesy of the artist.

defining *Chicanos* as men and women with Mexican descent, born in the United States but considered second-class citizens, who fiercely embraced their culture and aspirations.[68] The newspaper *Le Dauphiné libéré* described the exhibition as a "cultural chronicle" of a mixture of Indigenous, European, Mexican, and American societies.[69] Additional presentations in France followed at the Musée du Nouveau Monde at La Rochelle in November 1995, and Cité du Livre in Aix-en-Provence, where the exhibition was complemented by a workshop at the School of Arts in January 1996, before it returned to the United States.[70]

After a thirty-month tour of Africa and Western Europe, *Chicano Expressions* entered a new phase in late 1995, with a renewed grant from the USIA for an extended tour to four cities in Mexico. Sister Karen selected twenty additional SHG Atelier Program and special project prints that complemented the original selection of thirty.[71] Opening at the Centro Cultural de Tijuana on December 13, 1996, *Expresiones Chicanas* had now made it to a venue closely familiar with Chicano art and with SHG's body of work, for Tijuana was the site of past collaborations with El Colegio de la Frontera Norte and its Festival Internacional de la Raza. A more informal and subdued presentation in Mexicali, the capital of Baja California, was also included in the itinerary. The exhibition traveled next to Museo Metropolitano de Monterrey, where it opened in late January 1997; and to Museo de las Artes, Universidad de Guadalajara, for April–May 1997, with a mono-screenprint workshop at the local Instituto Cultural Cabañas.

Most significant for the traveling *Expresiones Chicanas* was its presentation at Museo del Instituto Nacional de Bellas Artes in Ciudad Juárez in July 1997, coinciding with another show on the other side of the border, *Across the Street: Self Help Graphics and Chicano Art in Los Angeles,* organized by the Laguna Art Museum for exhibition at El Paso Museum of Art from July to October. The two border cities thus became an homage of sorts—a site for a larger US-Mexico stage for Chicano art. Curated by Sister Karen (who had passed away days before the opening) and Bolton Colburn, respectively, this was a triumphant coming together of two exhibitions highlighting SHG and its artists. For a period of at least six weeks, the audiences in this border region benefited from the collaboration of SHG with the Laguna Art Museum, which had acquired in 1992 an entire set of prints produced in the SHG Atelier Program.[72]

Although *Expresiones Chicanas* traveled to its last USIA-sponsored venue in November 1997 for a brief presentation at Universidad Autónoma Metropolitana/Azcapotzalco in Mexico City, the short viewing window became a prescient warning of troubles ahead for the federal agency. Budget cuts in the Arts America program in fiscal year 1998 shelved plans for a larger hemispheric tour in Central America and South America. Ultimately, the USIA and Arts America were abolished in 1999.

CHICANOIZING GLASGOW

While *Chicano Expressions* was circulating in sub-Saharan Africa, the City of Los Angeles held the second UK/LA Festival in September–November 1994, a celebration of British

FIGURE 8.8

Ashley Cook at the UK/LA Exchange, October 1994, at Self Help Graphics & Art. Self Help Graphics & Art
Archives, California Ethnic and Multicultural Archives 3, University of California, Santa Barbara Library. Courtesy
of Self Help Graphics & Art.

arts that brought together artists from the islands of the United Kingdom and the US
Pacific Coast.[73] One remarkable artistic exchange and collaboration was that of SHG with
the Glasgow Print Studio in the month of October. In consultation with the British
Consulate-General in Los Angeles and the UK/LA Foundation funded by the British
Council, Sister Karen chose Scottish printmakers Ashley Cook (b. 1964) and Janie Nicoll
(b. 1965), who arrived in Los Angeles on a Sunday evening in early October and were
immediately taken to the home of Yolanda González (figs. 8.8 and 8.9).[74] As they would
later recount, as soon as they entered their temporary digs, they knew they "had arrived!"[75]

The exchange, in SHG's professional serigraphy studio, was set up as a collabora-
tive work between the Scottish artists and Wayne Alanis Healy (b. 1946) and Magdalena
Audifred (b. 1960), to create one eleven- or twelve-color silk-screen print edition of
seventy prints, etchings, and mono-screenprints in a period of two weeks.[76] Working
with master printer José Alpuche, Nicoll would produce *Monuments, Machinery and
Memorials* (1994), "a phallic like arrangement . . . [dealing] . . . with the masculine
nature of wars."[77] She noted that "the images used in this print were collected during
a year spent in Eastern Europe. The two young men were Russian soldiers killed while
liberating Hungary in 1945. The steam powered machine was from an old negative on
glass (daguerreotype)."[78] Cook created *I Will Never Be Satisfied, Will I Ever Be Satisfied?*

(1994), a "game board with 100 squares with a black and blue/green checkered pattern. Five women, four nude, are displayed on the board with snakes and ladders."[79] While Audifred produced a mono-screenprint, *Disfrutando de la Vida* (1994), and *Dreaming* (1994), featuring a bust portrait of a woman under an arch structure set against a blue background, Healy completed *The Scottish-Mexican Thorn Conspiracy* (1994), a black and white mono-screenprint depicting an attired pachuco dinosaur and a female nude figure holding a champagne glass, walking away toward a field of burrs.

Closing with an exhibition at SHG and a *tardeada* (open house), the 1994 UK/LA Exchange highlighted a rich sharing of ideas and the creative and technical processes of the four artists. During their two-week October stay in East LA, Cook and Nicoll

lived the excitement as SHG and artists prepared for the annual Day of the Dead celebration. As Tomas Benitez recalls, "They were taken with the significance and impact of Día de los Muertos upon this community," as an artistic celebration of life that honors the dead.[80] In a series of additional trips and residencies—Cook returned to SHG in 1995, and Healy and Audifred spent three weeks as artists-in-residence at the Glasgow Print Studio in June 1996, where they worked with etching and lithography—plans for a 1996 LA-Glasgow Day of the Dead celebration emerged.[81]

In late October 1996, Ofelia Esparza, Margaret Sosa, and Yolanda González traveled to Glasgow, staying in the flat of Jane Hopkinson, an art history professor at the Glasgow School of Art.[82] Contributing an authentic SHG–East LA Day of the Dead flair to a wintery UK event were the three Chicana artists-in-residence at the Glasgow Print Studio, with Esparza in charge of creating an altar installation (fig. 8.10), Sosa demonstrating the art of *papel picado* in workshops (fig. 8.11), and González providing the historical context for the exhibition and celebration (fig. 8.12).[83] They adapted the celebration to a new geography and culture with an altar installation featuring local red and gray tartan fabric, vintage photographs in handmade frames, paper flowers, and candles. Freshly painted in pink and gold, the gallery at the studio served as the backdrop to Esparza's altar.[84] As she worked, she explained "the elements of the altar as I [had] learned from my mother along with the symbolism with the many objects found there."[85] Adding a personal touch, she included her own traditional "Mexican artifacts and votive cards in remembrance of my own loved ones."[86] Sosa, who had been working for weeks to prepare a series of *papel picado* with traditional motifs and the SHG and the Glasgow Print Studio logos, complemented the altar with the colorful and artistic paper decorations.[87]

Finally, the artists performed a ceremony, lighting candles and copal incense and raising these offerings to the four cardinal directions, with accompanying Native American flute and drum sounds. This proved to be "one of the most moving moments of [Esparza's] experience there."[88] Esparza, Sosa, and González witnessed the excitement as children from nearby elementary schools in the studio's education program, college art students, and adults prepared tissue paper lanterns for a procession (figs. 8.13 and 8.14). In constant communication with their colleagues back in Los Angeles, the three kept SHG informed as preparations progressed. Sister Karen exclaimed, "It's exactly what the L.A. artists did 25 years ago and continue to contribute even *today*."[89] The three artists were interviewed by BBC Radio, and according to Sosa they were treated "like royalty."[90]

On November 1, 1996, a simultaneous transcontinental event for the Day of the Dead was held. Glasgow, eight hours ahead of Los Angeles, relished in a new cultural celebration thanks to two print studios and Scottish and Chicana printmakers who, along with a number of local sponsors, made this inaugural event an astounding success.[91] At 6:30 P.M., in the rain, a procession began walking from the Ramshorn Graveyard, next to the Gothic St. David's Church, to the Glasgow Print Studio four blocks

FIGURE 8.10

Ofelia Esparza installing an altar at the Glasgow Print Studio Gallery in Glasgow, Scotland, October 29, 1996. Self Help Graphics & Art Archives, California Ethnic and Multicultural Archives 3, University of California, Santa Barbara Library. Courtesy of Self Help Graphics & Art and Ofelia Esparza.

FIGURE 8.11

Margaret Sosa installing *papel picado* at the Glasgow Print Studio, October 29, 1996. Self Help Graphics & Art Archives, California Ethnic and Multicultural Archives 3, University of California, Santa Barbara Library. Courtesy of Self Help Graphics & Art and Margaret Sosa.

FIGURE 8.12

Yolanda González in Glasgow, Scotland, celebrating Day of the Dead, October 31, 1996. Self Help Graphics & Art Archives, California Ethnic and Multicultural Archives 3, University of California, Santa Barbara Library. Courtesy of Self Help Graphics & Art and Yolanda González.

away, with "*three* hundred children [marching] down the main street holding candles and dressed like *calacas.*"[92] Battling crowds, the artists reached the gallery of the studio, which was already filled to capacity, to find the altar illuminated by candles, and dead marigolds guiding the path to the spirits of the departed beloved ones.

Sosa would also recall the crowds at the Cantina del Rey Mexican Restaurant at the end of the children's parade: "Hundreds of children and adults were dancing and carrying the beautiful lanterns they had made. A band all dressed up in *calavera* attire were playing music and beating drums. Never mind that it seemed the only 'Mexican' tune they knew how to sing was 'Tequila.'"[93] Informed by the traditional SHG yearly celebration, and lasting over three weeks until November 23, 1996, the first Day of the Dead in Glasgow featured an exhibition of thirty-four SHG mono-screenprints and serigraphs by Chicano artists, selected by Tomas Benitez, in the gallery of the Glasgow Print Studio.[94] Galería Otra Vez held a concurrent exhibition of forty-four Scottish prints.[95] Glasgow became, in the words of artist Roberto Delgado, "a tour de force."[96]

CONCLUSION

While there is no doubt that the extensive tour of *Chicano Expressions,* and the UK/LA and Glasgow exchanges, elevated SHG to a global contemporary art stage in the 1990s,

FIGURE 8.13
A painted *calavera* from a
papier-mâché workshop for Day of
the Dead at the Glasgow Print
Studio, November 1, 1996. Self
Help Graphics & Art Archives,
California Ethnic and Multicultural
Archives 3, University of
California, Santa Barbara Library.
Courtesy of Self Help Graphics &
Art and Glasgow Print Studio.

the untimely death of Sister Karen Boccalero in June 1997 truncated a long-term vision for future international activities and partnerships and a wider global visibility for SHG artists. For Chicano art, the exhibition and exchanges achieved what other 1990s exhibitions unfortunately could not: to travel and circulate widely abroad and to develop transatlantic relationships that benefited artists in an ultracompetitive art world. An example is the show *Chicano Art: Resistance and Affirmation, 1965–1985* and its plans to travel to Mexico and Spain, which ended at the San Antonio Museum of Art just as *Chicano Expressions* was initiating its tour.

Although *multiculturalism* became a buzzword of the mid-1980s in the United States, and a subject of much debate regarding cultural integration and assimilation to

FIGURE 8.14
First Day of the Dead in Glasgow,
Scotland, organized by the
Glasgow Print Studio, November
1, 1996. Self Help Graphics & Art
Archives, California Ethnic and
Multicultural Archives 3,
University of California, Santa
Barbara Library. Courtesy of Self
Help Graphics & Art and Glasgow
Print Studio.

a single national identity (obscuring plurality), the reaction to the globalization of culture in the 1990s resulted in more value being given to difference and to heterogeneous identities. The alternative globalizations that ensued, and the emerging concept of a more encompassing "global contemporary art," created larger spaces for recognition of other cultures and visualities, just as John Tomlinson asserted: modernity as harbinger of identity. SHG's activities at this moment in the mid-1990s—and its enthusiastic reception as it encountered other cultures—marked a new, albeit short-lived, high in the history of the organization. Arts organizations that seek to create the conditions for artists to grow and become fulfilled in their creative endeavors could well use these activities of the 1990s as models of artistic promotion that can achieve

the kind of visibility, including international exposure and recognition, that the artists in *Chicano Expressions* and the international exchanges experienced.

NOTES

1. For excerpts of an early history of SHG recounted by Sister Karen Boccalero, see Isabel Anderson, "Self-Help Graphics: Merging Art with the Chicano Community," *Screenprinting,* October 1992, 69–71, 172–73, 209.

2. See John Tomlinson, "Globalization and Cultural Identity," in *The Global Transformations Reader,* edited by David Held and Anthony McGrew (Cambridge, UK: Polity, 2003), 271.

3. Sister Karen Boccalero quoted in Lalo Lopez, "Power Prints," *Hispanic* (October 1995): 70.

4. Boccalero was named after her maternal grandmother, Carmen Boccalero, who was born in Italy. See "Annie Guadagnoli," https://ancestors.familysearch.org/en/L6GC-5JY/annie-guadagnoli-1914–1985 (accessed September 26, 2019).

5. Although there is no evidence that this was the case for the Boccalero family, nevertheless it was a reality for over six hundred thousand people of Italian ancestry in the United States. See Erin Blakemore, "Why America Targeted Italian-Americans during World War II," *History*, January 14, 2019, www.history.com/news/italian-american-internment-persecution-wwii.

6. "Application Form for Candidates to the Congregation of the Sisters of Saint Francis of Penance and Christian Charity, Mount Alverno, Sierra Madre, Carmen Rose Boccalero, April 9, 1952," Sister Karen Boccalero Archive, Sisters of St. Francis of Penance and Christian Charity, St. Francis Province, Redwood City, California (hereafter "Sister Karen Boccalero Archive").

7. "Dear Sisters, Artists and Friends, July 25, 1997" (correspondence) and "Personal Information Sheet," Sister Karen Boccalero Archive.

8. Boccalero also received an honorary Doctor of Fine Arts degree from Otis Art Institute of Parsons School of Design of the New School for Social Research (now Otis College of Art and Design) in May 1990, in recognition of her "outstanding achievement in the service of mankind." See "Otis Art Institute Citation and Diploma," Sister Karen Boccalero Archive.

9. See Mario T. García and Sal Castro, *Blowout! Sal Castro and the Chicano Struggle for Educational Justice* (Chapel Hill: University of North Carolina Press, 2011). Boccalero, who was in Italy at the time, did not witness the 1968 East LA High School Walkouts or the August 1970 Chicano Moratorium antiwar protest.

10. See Colleen McDannell, *The Spirit of Vatican II: A History of Catholic Reform in America* (Philadelphia: Perseus Books, 2011).

11. "Saint Francis Province," Sisters of St. Francis Province of Penance and Christian Charity, Sacred Heart Province, https://franciscanway.org/sir-james-condi (accessed September 27, 2019).

12. As Tomas Benitez noted, SHG was open to artists of any nationality, racial, and ethnic group. Anyone who came in automatically received Chicano cultural citizenry. Tomas Benitez, interview with the author, June 12, 2018.

13. The Catholic Archdiocese of Los Angeles and the Catholic Welfare Bureau connections to SHG, to Boccalero, and to her congregation were critical to the early success and sustainability of SHG up until 2008, when the building was sold.

14. Anderson, "Self-Help Graphics," 1992, 70.

15. See Peter Tovar in Karen Mary Davalos and Colin Gunckel, "The Early Years, 1970–1985: An Interview with Michael Amescua, Mari Cárdenas Yáñez, Yreina D. Cervántez, Leo Limón, Peter Tovar, and Linda Vallejo," in *Self Help Graphics & Art: Art in the Heart of East Los Angeles*, 2nd ed., edited by Colin Gunckel (Los Angeles: UCLA Chicano Studies Research Center Press, 2014), 64. Mexico City's Day of the Dead celebration did not include street processions until 2016.

16. The first SHG altar built by Bueno and Ibañez in 1974 is confirmed by Mari Cárdenas Yáñez. See Davalos and Gunckel, "Early Years, 1970–1985," 64. Sybil Venegas states that Boccalero credited Bueno and Ibañez with suggesting the Day of the Dead celebration, one that was not familiar to Chicano artists in East Los Angeles. See Sybil Venegas, "The Day of the Dead in Aztlan: Chicano Variations on the Theme of Life, Death and Self Preservation," in *La Calavera Pocha, Self Help Graphics & Art 40th Anniversary Día de los Muertos Celebration*, November 2, 2013, curated by Daniel González, exhibition catalog, 7, www.lindavallejo.com/wp-content/uploads/2016/05/La-Cavalera-Pocha-brochure.pdf.

17. Although Margarita Nieto noted in 1995 that SHG's Day of the Dead was "stimulated and influenced in part" by the short film *Day of the Dead*, produced by Charles and Ray Eames for the Museum of International Folk Art in Santa Fe, New Mexico, in 1957, I argue that this narrow interpretation obscures and reduces the influence of Bueno's and Ibañez's firsthand knowledge, cultural experience, and identity as Mexican citizens to the celebration, and of Boccalero's own Catholic faith. See Margarita Nieto, "Across the Street, Self Help Graphics and Chicano Art in Los Angeles," in *Across the Street: Self Help Graphics and Chicano Art in Los Angeles*, exhibition catalog, edited by Bolton Colburn (Laguna Beach, CA: Laguna Art Museum, 1995), 30. Film scholar Chon A. Noriega erroneously articulated a similar assertion in 2003: "Inspired by a Charles and Ray Eames film on the Mexican festival. . . ." See Noriega's introductory note in Harry Gamboa Jr., "Self Help Graphics: Tomas Benitez Talks to Harry Gamboa, Jr.," in *The Sons and Daughters of Los: Culture and Community in Los Angeles*, edited by David E. James (Philadelphia: Temple University Press, 2003), 195.

18. In the 1980s, SHG developed successful collaborations with Gilberto Cárdenas's Galería Sin Fronteras in Austin, Texas, and with Universidad Nacional Autónoma de México (UNAM) and Colegio de la Frontera Norte (COLEF), leading to the exhibition *Gráfica Chicana* at El Museo del Chopo, UNAM, 1984, and participation in the various editions of COLEF's Festival Internacional de la Raza, 1986–95.

19. Amalia Mesa-Bains, ed., *Chicano Expressions: Serigraphs from the Collection of Self Help Graphics*, exhibition catalog (Los Angeles: Self Help Graphics, 1993), 44.

20. Ibid.

21. As Tomas Benitez intimated, they were aware that the USIA also served as a front for CIA activities, just as the Congress for Cultural Freedom had been used for the CIA's covert operations during the Cold War (see Frances Stonor Saunders, *Who Paid the Piper? The CIA and the Cultural Cold War* (London: Granta, 1999). Tomas Benitez, interview with the author, June 12, 2018.

22. Here the cultural Chicano identity was fluid and flexible enough to include artists born in other countries who became part of the SHG family. For the budget, see "Cooperative Agreement

IA-EDMA-G2190170," 2, Self Help Graphics & Art Archives (hereafter SHGA), box 25, folder USIA/Germany, California Ethnic and Multicultural Archives, University of California, Santa Barbara Library (hereafter CEMA, UCSB). For the list of artworks, see Mesa-Bains, *Chicano Expressions*, 44–45.

23. The funds originated in the Bureau of Educational and Cultural Affairs of the USIA under the Fulbright-Hayes Act of 1961 to increase mutual understanding between the United States and other countries. The USIA Arts America program's mission was to support "fine arts exhibitions which portray the creativity, diversity, and democratic quality of American achievement in the visual and performing arts." See "United States Information Agency, Press Release," Tomás Ybarra-Frausto research material on Chicano Art 1965–2004, box 25, folder 25.32, Self Help Graphics 1991–1994, Archives of American Art, Smithsonian Institution (hereafter AAA).

24. The 1992 quincentenary celebration of the arrival of Columbus to the Americas elicited forced conversations about the meaning of cultural imposition, colonialism and neocolonialism, erasure of cultural pasts, and a somewhat tepid recognition and validation of a multicultural social fabric in the United States.

25. General Conditions, Article III, C, p. 6, SHGA, box 25, folder USIA/Germany, CEMA, UCSB.

26. Robert L. Brown to Tomas Benitez, August 28, 1995. Ibid.

27. "United States Information Agency, Press Release," Tomás Ybarra-Frausto research material, box 25, folder 25.32, AAA.

28. Ibid.

29. Ibid.

30. Ibid.

31. Tomas Benitez, email to the author, April 5, 2018.

32. The United Nations International Commission of Inquiry for Burundi confirmed in 2002 that the 1993 mass killings were a genocide.

33. M. Jumeer, "Chicano Expressions," *Samedi Magazine*, September 27, 1993, 2.

34. Ibid.

35. Ibid.

36. USIA Telegram, July 1994, SHGA, box 103, folder Chicano Expressions, CEMA, UCSB.

37. Tomas Benitez, email to the author, April 5, 2018.

38. USIA Telegram, July 1994, SHGA, box 103, folder Chicano Expressions, CEMA, UCSB.

39. Telegram-Arts America, "Exhibition *Chicano Expressions* Final Report," July 1994, Tomás Ybarra-Frausto research material, box 25, folder 25.32, AAA.

40. T. Ballard, Maputo-Arts America Exhibition "Chicano Expressions" Final Report, SHGA, box 103, folder Chicano Expressions, CEMA, UCSB.

41. Tomas Benitez accompanied the exhibition to Pretoria, South Africa. Tomas Benitez, email to the author, April 5, 2018.

42. Orielle Berry, "Bold Exhibition from the United States," *Pretoria News*, August 3, 1993.

43. USIA, "Subject: Chicano Expressions/Benitez Travel," SHGA, box 103, folder Chicano Expressions, CEMA, UCSB.

44. Tomas Benitez, email to the author, April 5, 2018.

45. Ibid.

46. Eric Lubisi quoted in Tomas Benitez, "Chicano Expressions 'The Little Exhibition That Tried Harder,'" Tomás Ybarra-Frausto research material, box 25, folder 25.32, AAA.

47. Ambassador E. Michael Southwick Speech, *Chicano Expressions* Exhibit in Kampala Evaluation, SHGA, box 25, folder USIA, CEMA, UCSB.

48. Ibid.

49. There are striking similarities, in posture and dress, between Oropeza's figures and participants in the 1977 parade. See the photograph *Day of the Dead Procession '77* in the UC Santa Barbara, Special Research Collections, https://oac.cdlib.org/ark:/13030/hb6v19p1mc/?docId=hb6v19p1mc&brand=oac4&layout=printable-details (accessed January 9, 2022).

50. For a discussion of Hernandez's *The Cosmic Cruise,* see Karen Mary Davalos, *Exhibiting Mestizaje: Mexican (American) Museums in the Diaspora* (Albuquerque: University of New Mexico Press, 2001), 127; and Laura E. Pérez, *Chicana Art: The Politics of Spiritual and Aesthetic Altarities* (Durham, NC: Duke University Press, 2007), 45–46.

51. Ester Hernandez quoted in Salvador Güereña, "Guide to the Self Help Graphics Archives, 1960–2003," in Gunckel, *Self Help Graphics & Art,* 172.

52. Margaret Garcia quoted in *Across the Street: Self Help Graphics and Chicano Art in Los Angeles, a Teacher's Guide* (Laguna Beach, CA: Laguna Art Museum, 1995), 17.

53. Margaret Garcia quoted in Güereña, "Guide to the Self Help Graphics Archives, 1960–2003," 168.

54. Ibid.

55. "United States Information Agency, Press Release," Tomás Ybarra-Frausto research material, box 25, folder 25.32, AAA.

56. Tomas Benitez, email to the author, April 5, 2018.

57. Ada Pullini Brown to Catherine Williamson, September 15, 1995, SHGA, box 25, folder USIA/Germany, CEMA, UCSB.

58. See Jörg W. Ludwig, Ricardo Romo, and Arnulfo D. Trejo, *Imágenes de la Raza. Selbstzeugnisse mexikanisch-amerikanischer Kultur. Self Portrayals of Mexican-American Culture* (Berlin: Amerika Haus Berlin, 1982).

59. In 1994, Cockcroft and Botello completed *Global Chessboard,* the largest outdoor mural in Berlin, on the side of the old Loretta Biergarten at 89–91 Lietzenburger Strasse, later covered by new construction in 2006.

60. "Tomas Benitez to Dear Artist, February 4, 1995," Tomas Benitez personal archive, East Los Angeles.

61. Luis de Zubiaurre, "Arte en la frontera," *Cambio* 16, no. 1212 (February 13, 1995), Tomas Benitez personal archive, East Los Angeles.

62. "Madrid, 1/13/95." SHGA, box 103, folder Chicano Expressions, CEMA, UCSB. Also see "Tomas Benitez to Dear Artist, February 4, 1995."

63. Jörg W. Ludwig to Sister Karen Boccalero, March 1, 1995, SHGA, box 25, folder USIA/Germany, CEMA, UCSB.

64. See "Farbenprächtige mexikanische Kunst in Berlin," *Berliner Morgenpost*, May 12, 1995; "Kunst Au LA," *Berliner Morgenpost*, May 7, 1995; "Amerika-Haus: Bilder aus der menschen-fressenden Großstadt," *Berlin Daily*, May 11, 1995.

65. Jörg W. Ludwig to Sister Karen Boccalero, June 26, 1995, SHGA, box 25, folder USIA/Germany, CEMA, UCSB.

66. USIA, *Chicano Expressions* Exhibition at America [*sic*] House [*sic*] Berlin, box 25, folder USIA/Germany, CEMA, UCSB.

67. See Frank Eckert, "Multiculturalism in Germany: From Ideology to Pragmatism—and Back?," *National Identities* 9, no. 3 (September 2007): 235–45.

68. "Aix-Les-Bains Chicano Expressions," *La Gazette de Drouot*, October 13, 1995, Tomás Ybarra-Frausto research material, box 25, folder 25, AAA.

69. "Deux grandes expositions," *Le Dauphiné libéré*, October 6, 1995, Tomás Ybarra-Frausto research material, box 25, folder 25, AAA.

70. USIA, Chicano Expressions Exhibit, 11/07/94, SHGA, box 103, folder Chicano Expressions, CEMA, UCSB.

71. For the list of artworks, consult "USIA 'Chicano Expressions'/Mexico," SHGA, box 25, folder USIA, CEMA, UCSB.

72. Susan M. Anderson, "Foreword," in Colburn, *Across the Street*, 1995, 5. The Laguna Art Museum most recently held the exhibition *Self-Help Graphics 1983–1991*, from January 17 to September 22, 2019.

73. The UK/LA Festival was first held in 1988. The 1994 iteration was sponsored by British Airways, the British Council, the UK/LA Foundation, Inc., and local organizations and individuals. Presented as a platform to underscore diverse cultures, the UK/LA Festival was a sixty-seven-day celebration of British theater, opera, film, television, music, dance, visual arts, architecture, and graphic design in over forty venues throughout the city, the "largest event of its kind in North America" and predating any Getty Pacific Standard Time (PST) event.

74. See Boccalero to Glasgow Print Studio, September 20, 1994. SHGA, box 28, folder UK/LA, CEMA, UCSB.

75. Janie Nicoll, "Anita and Juanita Go A.W.O.L.," *Printers' Press: The Journal of the Glasgow Print Studio* 1, no. 3 (January–February 1995): 1.

76. Ibid. See Boccalero to Ashley Cook and Janie Nicoll, June 15, 1994, SHGA, box 103, folder Chicano Expressions, CEMA, UCSB.

77. Janie Nicoll quoted in Güereña, "Guide to the Self Help Graphics Archives, 1960–2003," 179.

78. Ibid.

79. Ashley Cook quoted in ibid., 163.

80. Tomas Benitez quoted in "Self Help Graphics to Present Día de los Muertos (Day of the Dead) Annual Celebration in Los Angeles and Glasgow in '96," Press Release, SHGA, box 25, folder Self Help Graphics: Write Ups and Information, CEMA, UCSB.

81. Magda Audifred Postcard to SHG Crew, June/21/96, and Wayne Alaniz Healy Postcard, June 28, 1996, SHGA, box 103, folder Chicano Expressions, CEMA, UCSB.

82. Ofelia Esparza, "Glasgow," 2, Ofelia Esparza personal archive, East Los Angeles.

83. Yolanda González has had a long association with SHG. See www.yolandagonzalez.com.

84. "Mexican Madness in Glasgow City," *Printers' Press* 3, no. 1 (October–December 1996): 1.

85. Esparza, "Glasgow," 2, Ofelia Esparza personal archive, East Los Angeles.

86. Ibid.

87. Margaret Sosa, "Scotland," 2, Margaret Sosa personal archive, East Los Angeles.

88. Ibid.

89. Boccalero quoted in "Self Help Graphics to Present Dia de los Muertos," Press Release. SHGA, box 25, folder Self Help Graphics: Write Ups and Information, CEMA, UCSB.

90. Sosa, "Scotland," 2, Margaret Sosa personal archive, East Los Angeles.

91. Among the sponsors were Scotland Art Council, Visiting Arts, The City of Glasgow, Glasgow City Council's Project Development Fund, José Cuervo, Stravaigin Restaurant, and Cantina del Rey Mexican Restaurant.

92. Tomas Benitez, email to the author, April 8, 2018.

93. Sosa, "Scotland," 2, Margaret Sosa personal archive, East Los Angeles.

94. Tomas Benitez, interview with the author, June 12, 2018. For artworks in the Glasgow exhibition, consult "Glasgow 'Day of the Dead' 1996," SHGA, box 70, folder Johannesburg, S. Africa, Request for Muralists, CEMA, UCSB.

95. For Scottish artists featured in the SHG exhibition, see Janie Nicoll to Tomas Benitez, August 10, 1996, SHGA, box 70, folder Johannesburg, S. Africa, Request for Muralists, CEMA, UCSB.

96. *Roberto "Tito" Delgado,* interviewed by Karen Mary Davalos, November 5, 7, 9, and 16, 2007, Los Angeles, CSRC Oral Histories Series, no. 8 (Los Angeles: UCLA Chicano Research Studies Center Press, 2013), 93.

ARLENE DÁVILA, KAREN MARY DAVALOS, AND TATIANA REINOZA

9

CREATING INFRASTRUCTURES OF VALUE

Self Help Graphics and the Art Market—a Conversation
with Arlene Dávila

—————

ARLENE DÁVILA'S SCHOLARLY WORK has always centered the role of culture and its relation to economies of value. Her book *Latinx Art: Artists, Markets, and Politics* examines how Latinx art is often conflated with Latin American art, and rendered invisible, through the racist practices of the art market.[1] With its constructions of quality, cosmopolitanism, and internationalism, and in particular what Dávila describes as "national privilege," the art market—one of the largest unregulated markets in the world—marginalizes the work of diasporic, racialized, and ethnic artists in order to maintain the value of a white male art establishment.[2]

While preparing this book, we—Karen Mary Davalos (KMD) and Tatiana Reinoza (TR)—sat down for the following conversation with Arlene Dávila (AD). We discuss the role of Latinx arts organizations like Self Help Graphics (SHG) in combating marginalization and erasure by creating infrastructures of value for Chicanx and Latinx artists. We highlight the various methods SHG has employed over the past five decades to advance the

career trajectories of its artists. SHG's exhibition venue, Galería Otra Vez, and its Experimental Screenprint Atelier have made headway into opening market opportunities for underrepresented artists. Dávila highlights the stakes of working toward cultural equity, promoting sustainable cultural ecologies, and confronting the politics of collecting. She urges artists and scholars to move past the "culture versus commerce" binary, which stems from mythical, moral, and naive assumptions, in order to imagine an art world that includes Latinx art futures.

LATINX ARTS ORGANIZATIONS: CAPITAL AND COMMERCE

KMD: What do you see as the larger trends in Latinx arts organizations and how they approach capital and commerce? What have you observed over time?

AD: The issue of commerce is one that our institutions have seldom brought to the forefront. We have tended to think that culture and the arts are incommensurable with commerce: that we cannot think of commerce without tainting our institutions, their mission, and their history. Most of our Latinx arts and cultural institutions grew out of civil rights struggles, as a quest for representation, and to highlight both inclusivity and antiracism in the arts. In fact, we must acknowledge that commerce was not a concern. The issues were antiracism, inclusivity, and equity. Fifty years ago, we also did not recognize matters of commerce as key elements of cultural equity, as we do today. Instead, the issue at the forefront was "let's have a place at the table," and because we're not at the table, "let's make our own institutions."

Our institutions grew in parallel with the growth of state funding for the arts. New York State Council for the Arts (NYSCA), the first such state council founded in the 1960s, soon dedicated support for "underserved" populations. This support paralleled the so-called "war on poverty" policies of the time that made available more funds for urban-based cultural groups. State funding ultimately became a way of containing and accommodating our institutions, because it didn't change the structure of inequity, but instead it funneled money for secondary institutions or parallel institutions that remain under-resourced.[3] A lot of this funding dried out by the 1980s and '90s, during the culture wars. The point here is that matters of money, sustainability, and capital were not as central to our institutions in their start. However, today—due to the diminishing and disappearance of government funding for the arts—they are more pressing and urgent than ever.

PRINTMAKING AND ARTIST AUTONOMY

KMD: But by the '80s, as you observe, state funds dry up. That's precisely when Self Help Graphics launches the Experimental Screenprint Atelier, in which they eventually decide to have a regular practice of splitting each edition between the artist and the organization. They formalize the sales and make a structure that recognizes artists as economically autonomous workers. SHG also uses print sales as a revenue stream to rely less on federal grants, state funds, and external philanthropy.

AD: The Bob Blackburn studio in New York City has a similar model, which may be intrinsic to the ways in which other print workshops are organized.[4]

TR: Most print workshops do split editions and that's been the norm. But I think the Blackburn Printmaking Workshop is another alternative for underrepresented artist networks.

AD: Absolutely. This is what is so powerful about the idiom of printmaking and prints. It is an accessible and collaborative medium. Additionally, in our community, prints have always been more accessible and have often served as the first conduit for collectors. Growing up in Puerto Rico, I remember that the first time I saw art in people's homes it was prints. We have this tradition of making prints as a way of communicating and memorializing events. This is a tradition from the 1950s onwards with the work of DIVEDCO (Division of Community Education) in Puerto Rico.[5] For decades, families would collect and display the posters for all of the *festivales* they attended. The prints are framed and displayed proudly in their living rooms. The print studios have played a key role by introducing people to the art of printmaking but also to the possibility of art collecting through prints.

TR: I think one of the things that stands out in terms of Self Help Graphics and the Latinx art field is that it was heavily funded by Catholic charities. It came out of a Catholic-left movement and that's something that's unique.

AD: That's interesting. I don't think that's the case with the Taller Boricua workshop. In New York, state funding was always more important. I don't think Taller Boricua would have survived if it weren't for the "special arts" type of programs by NYSCA, the Department of Cultural Affairs, and other state funding programs targeting "diverse audiences," which has always served as a euphemism for Black and Latinx cultural institutions. But the key issue here was always local and state government funding for the arts, rather than churches.

KMD: Well, here's the irony. Self Help Graphics does get its launch from the Catholic Church, but the Archdiocese of Los Angeles causes the near-closing of SHG in 2005 when it sells the property that SHG leases from the Sisters of St. Francis. The new landlord asks for $6,000 to $7,000 a month for rent. There's an iconic photograph taken by Harry Gamboa, where the gates that surround the parking lot are padlocked because SHG can't afford to operate (see fig. 0.9).

AD: This precarity is visible everywhere in New York City (NYC), where the not-for-profit/government sector has always played a greater role in sustaining our local institutions. We see this pattern across most of our institutions, not only the print shops, but all Latinx cultural institutions from Taller Boricua to El Museo del Barrio. They have been primarily sustained by the public rather than the private sector. I cannot think of one Latinx arts group in NYC that owns their building—with the exception of Pregones Theater in the Bronx. This dependency on government-owned buildings brings up debates about the sustainability of these projects in light of the ongoing privatization of public space. At the same time, rents in the private market continue to rise, absorbing

all the operation and program budgets of local groups and making community cultural groups extremely vulnerable to gentrification. Pepe Coronado recently closed his studio in East Harlem (and relocated to Austin, Texas) because of these processes. So, indeed, these are very vulnerable times. In particular, the exorbitant prices of real estate in NYC hinders the ability to buy land. Brandywine Workshop in Philadelphia did purchase land early on and became sustainable by leasing properties or rental units in their building. Right now, this fight for sustainability is everywhere evident. For instance, Galería de la Raza has lost its struggle to acquire a permanent home in the Mission District. At the same time, relying on the model of private property—and of purchasing a brick-and-mortar space as the only medium to guarantee sustainability—is also extremely limiting because it normalizes a logic of sustainability that few organizations can actually afford to pursue.

ALTERNATIVE ART MARKETS OF LATINX ARTS ORGANIZATIONS

KMD: Let's address the alternative art market that Latinx arts organizations and cultural centers are creating.

AD: As we know, Latinx artists are practically nonexistent in the gallery system. Most Latinx artists lack any type of gallery representation or access to formal markets. This is why the not-for-profit sector has been most foundational to the visibility of Latinx art and artists. Unfortunately, this sector has not been very active in creating markets for our artists. This is why grassroots projects and projects creating alternative markets are so key. Interviewing artists for my book, I learned about so many interesting collaborative projects where artists support each other, often serving as curators and dealers of each other's works as a means of expanding opportunities for others.

However, what we most need is public visibility, an institutional foothold. We need recognized and accessible space/place/institutions where people can learn about Latinx artists and purchase their work.

KMD: SHG functions as a gallery, which is open to the public, and it also sells directly to the public with annual print fairs, started in the late '90s. The print fairs helped to launch artists such as Patssi Valdez, Gronk, John Valadez, Margaret Garcia, Leo Limón—to name a few. Now, I'm not claiming that it's sustaining them, but it certainly gave them a spotlight and increased visibility within mainstream galleries and museums. During the '80s and '90s, commercial galleries began to focus on Latinx art, such as Robert Berman Gallery and Patricia Correia Gallery in Santa Monica. It's a very small and fragile market, and Correia eventually closed, but these galleries cultivated an audience.

AD: I'm so glad to hear that Self Help Graphics is exhibiting and promoting artists this way. This is the number one thing we need: more spaces where people can learn about Latinx artists and know where to find them. We need the physical places and the digital platforms. The fact that SHG provided this space for all types of artists is won-

derful. Artists accrue value by working with an institution with such national visibility in Chicanx and Latinx art.

At the same time, we must recognize that prints have a cap on commercial value, especially for artists who are racialized and will never be valued or marketed at the same level as white artists.

TR: Well, not only that, but I think there's something to be said about trying to create a market in which people of color who are working class or middle class can actually acquire something they can afford, and it's an original work.

AD: Absolutely. Oftentimes artists will participate in portfolios or create series without knowing exactly how they will sell and circulate their work. SHG's role as intermediary is key, especially for adding financial value to artists' work. It is customary for workshops to keep half of the edition, and artists have to consider whether to sell it at that same price as it sells through the workshop, which is one way to feed and maintain the value of the work. But often this is not what ends up happening, which opens the door for speculation. This doesn't happen as much with prints, though it's an issue our artists must face.

Our artists are used to donating work. Our artists are used to participating in fundraisers and contributing their work by donating prints or giving them at discount prices. But these donations have tended to favor the collectors and the people that buy the prints, not necessarily the artists.

PHILANTHROPY AND THE DISENFRANCHISEMENT OF LATINX ARTISTS

KMD: Actually, this alternative art market of fundraising through donated art is problematic. When a cultural or social justice organization approaches artists and asks them to donate work that will be auctioned during a fundraiser to support their operational budget, it has a negative impact on the value of Latinx art. This strategy has been one of the ways that some collectors developed a Latinx art collection. In the twenty-first century, SHG made a conscious decision not to use that model anymore. The new approach has roots in the social justice movements. Artists coined the phrase *cultural workers*, which declares that they also have labor to contribute. At SHG, the policy creates consistency. If we value the labor of artists, then we cannot ask them for pro bono work, unless we're also going to ask the doctors and the lawyers and the other professionals to work pro bono.

AD: The inequity is also embedded in US tax law, which is inherently unfair to artists. US tax law is developed to benefit collectors, never artists. People must know this when they ask artists to donate work: artists can only deduct from their taxes the price of their materials for creating the work, never the total value of the work in the market. So, with most nonprofit donations, the artist is always at a disadvantage. An artist may be able to deduct $25 of materials, for instance, whereas the collector who purchases the work in a not-for-profit auction could deduct the entire price they paid for the

term *collector* because of the elitist implications of the term is something we must acknowledge and learn to understand.

KMD: I think it's more than elitist implications. I learned that Chicanas associate collecting with colonialism.[6] Those who did not completely reject the term *collector* reconciled their purchases by thinking of themselves as stewards. They also shared the same concerns you mention. They didn't want to see all these white dealers and collectors benefiting from an art market. The Chicana/o/x collectors observed, "Who are these people buying our work? They're all white."

AD: We also need to recognize the different logics that are behind a purchase. The few Latinx collectors I know purchase work because it resonates with them, because they want to support artists, and so many other reasons are at play. Yet we live in an art world that seeks to reduce everything to speculation and consistently treats the art world as something almost akin to the stock market.

KMD: It's exactly like a stock market.

AD: Certainly, the art market is buying cheap and selling high. However, what I find exciting about Latinx collecting is that it promotes alternative views about art and collecting that center artists. These innovations may help us imagine new ways of creating value. This is one area where I like to talk about intangibilities, even though I am careful about not fetishizing art and markets as irreconcilable. I think that we should also rescue those moments, those discomforts of realizing we can't put a price tag on things because they signal that something else may be at play. For instance, art can never be reduced to commercial determinations when Latinx art and artists are concerned. There is always something else that pushes us to see the works in different ways and forces us to narrate different stories. I think that any of us, who've talked to artists, learn that this quest for complexity is one of their greatest demands. The reduction of their work to selling points is one of the greatest pet peeves shared by artists. Because artists may have all of these great ideas about their work, and things they may want to communicate that are oftentimes entirely lost on white curators, dealers, and collectors. So there's an incredible disjunction between how artists want to be seen and how they're seen by others that has to do with racism and the highly racialized context of the contemporary art world.

What's exciting about having more Latinx collectors is the possibility that they approach Latinx artists with greater appreciation for our stories, or their stories, and with a commitment to promote and advance them in greater society. And as you said, steward what should be at the table, because if not, we're going to succumb to this ridiculous speculation in this neoliberal art world that cannibalizes everything and that does not respect what's behind an artwork and the stories that may be involved. In all, what we're talking about is very complex. We're promoting art markets and our ability to insert our artists into markets and to develop greater equity in art markets more generally. At the same time, though, we don't want to reduce what we do and the richness of the work and our artists to economic terms.

KMD: I think that's precisely what our arts organizations have been trying to do. They knew they had to create their own spaces, but they also knew they had to interpret their work. SHG generates alternative epistemologies through their practices in artmaking, exhibitions, and sales. Those are new ways of thinking about the world and the art. These innovations are largely unknown or unrecognized in the art market, an infrastructure that's very Eurocentric. As you observe, Latinx art collectors are also thinking and doing things differently; they value a relationship with the work or artist. This is lived reality and precisely why collectors want to purchase the work. It looks like them, it reminds them of their family, or it tells a story they know.

AD: Yes, especially with figurative work that we can recognize. But even with abstract work, this connection with artists is also key. I'm thinking of the communities of artists that Pepe Coronado created when he brought together so many Latinx artists in his East Harlem studio to make prints, and how he made it possible for artists to know each other and for people to learn about these artists in new ways.[7] One of the most beautiful prints in his studio is an abstract print by Freddy Rodríguez. Few of us can purchase a painting by Freddy, but many of us can say that we know Freddy, or know about Freddy's story, and either purchase a print or see the work exhibited alongside other Latinx artists. We must cultivate ways of collecting that foster support of artists and of larger communities of artists, and we must cultivate the spaces that support these collectivities so that we can ensure their long-term sustainability.

TR: I like what you're saying about also educating the Latinx art collector, in that it's not just about this cultural or aesthetic attachment. The work that they're doing is also resisting this capitalist machine that will co-opt this work very quickly, because it is already being positioned as the next "frontier," that hasn't been colonized yet.

AD: Clearly, we're on the same page about what is most needed, which is promoting, supporting, and creating value for our artists while resisting reproducing the same extractive dynamics that rule contemporary art markets. We need to work together to make this happen.

CREATING INFRASTRUCTURES OF VALUE
THROUGH ART FAIRS

AD: It goes back to the need to support the institutional structures—the entrepreneurs, galleries, dealers, and not-for-profits that serve as stakeholders for our artists. We must ensure that Latinx creatives control and are behind all of these initiatives. Otherwise, we will see the same exclusive dynamics that we see in contemporary African American art, where it is primarily white dealers and white gallery owners who are selling and profiting from the valuation of the work of these artists. To me it is extremely troubling to only see white dealers selling work by Black artists at the most profitable "blue chip" end of the market. When you look at who is selling Latinx art as a general rule, the same thing is happening. It is almost the same white dealers that are working with Black artists who are beginning to represent the few Latinx artists in the

gallery system. With the African American market, you see at least a growing number of Black-owned galleries and spaces supporting Black artists across the United States. Where are the art stakeholders, the dealers, in the Latinx community? You know, why isn't Self Help Graphics, for instance, participating, or applying to participate, in some of these art fairs?

TR: Because they're extremely expensive.

AD: Yes and no. Art fairs have different price points, and there are projects that are by invitation only, where invited galleries and not-for-profit projects pay very little or nothing at all. This is one way in which these art fairs maintain and project some sense of cultural and artistic legitimacy. We should also create our own art fairs that are more accessible to all types of projects. We need to learn how galleries create value for artists and realize that the galleries, intermediaries, and institutions that create value need to be sustained too. Because sustaining them ensures our ability to support more artists now and in the future. During my research I went looking for the Latinx dealers, and simply could not find them! So yes, I would like to see Self Help Graphics and other Latinx institutions, with a history of working with our artists, represented in some of these art fairs.

KMD: The entire ecology or infrastructure needs to be built.

AD: In an ideal world, artists shouldn't be as dependent on the gallery ecosystem. They would be empowered to sell their work, and also have access to alternative markets. Unfortunately, what we see now is a growing dependence on the gallery system, exactly when the gallery model is becoming unsustainable—many are disappearing because of higher rents that no one can pay. Still, galleries remain the key entry point for how artists are known, because you cannot, as an artist, participate in an art fair without the representation of a gallery or a group.

KMD: Around 2012, Warnock Fine Arts, a gallery in Palm Springs, California, started representing SHG artists, and for several years, the gallerist identified *Chicano and Latino art* on the website. From my understanding, it was a 50/50 split with Warnock. A local dealer, Manny Rodriguez, also represented SHG artists for 30 percent commission, but the net profits for SHG were very low (under $2,000 in 2012), making the arrangement unsustainable. When SHG tried to join the LA Print Fair in the 2020s, the price was too high. We could not justify that cost at the time. Sister Karen also tried to show work at print fairs and art fairs.

AD: Participation in these fairs is often about visibility, not necessarily about making any profit. Some people do break even, and some people actually will make money. But many others just go for the advertising—to say you went and make an Instagram post. Collectors will post "Oh, I bought this in Miami" as opposed to "I bought it in Los Angeles," and this is the elitism of the art market, but that spin circulates and creates value. It is marketing. It is the branding that tells the world these artists are in the same category, that a given artist is equal to any other artist that is represented in the same art fair.

TR: Specific to the print market, though, is the International Fine Print Dealers Association, and it is a very elitist group. Membership is by invitation only, which means that a publisher or dealer must be nominated by an existing member. Very few Latinx printmaking studios have ever been a part of it. Segura Publishing was one of them.[8]

AD: I would like our community to organize our own art fairs. You may recall the Latinx Art Sale that coincided with the 2016 Ford Latinx Art Futures Conference at the Ford Foundation, organized by Teresita Fernández. New York–based arts advocate José Vidal organized these sales for a number of years, and one year the focus was on Dominican prints. We need to nurture similar events and spaces everywhere. We also need to support artist-led initiatives to sell their work. Whatever it is—I don't want to live in a world where Latinx art suddenly becomes valuable, and it is white Americans who become the stakeholders profiting, and serving as the intermediaries, rather than institutions like SHG, who have the history, the knowledge of our community, and should be taking the lead in the representation of Chicanx and Latinx artists in the national and international spheres.

KMD: That's precisely what Sister Karen was doing in the 1990s through collaborations with Gilberto Cárdenas's Galería Sin Fronteras in Austin, our annual print fair, as well as curating international traveling exhibitions. Self Help Graphics is doing many things you've touched on: production, interpretation, presentation, exhibition, sales, and then it's increasing value by putting art in other locations beyond its own gallery.

AD: We're talking about prints, but the same applies to Latinx art more broadly. Self Help Graphics is probably one of the oldest institutions that has remained truest to its mission of focusing on Chicanx art and Latinx artists, so a key question is: What can we learn from its history that we can use to promote Latinx art and artists more generally? As speculation in the art market grows and there is more interest in our artists, what can we do to ensure that Latinx artists are not exploited but are fairly rewarded for their work (including receiving resale royalties for their work in the future)? How can we ensure that Latinx stakeholders have access and are involved in all processes of production, circulation, and consumption of Latinx art? How can we avoid the dominance of white dealers and collectors, as we see happening with the Black art market, and with contemporary art markets in general? I believe that answering these questions requires addressing head-on the "culture versus commerce" dyad that dominates conversations around art markets, and begin centering the idea that creating markets for our artists is also an issue of cultural equity. This involves claiming control and ownership of the right to be entrepreneurial and seeing it as being also a matter of cultural equity. And, for once, resisting the idea that engaging with commerce is "selling out," because we would be implicating ourselves in the cultural appropriation of our art markets.

We need to be very savvy in realizing that our society is unfair, racist, and riddled with inequalities and that, as a result, art markets are riddled with the same racist

definitions of value that have historically devalued our artists. Challenging these inequalities head-on will require structural transformations to the funding structure of the arts, the cultural and copyright legislation around creative work, and more. All of these things need to be at the table for us to really address matters of cultural equity. In other words, we need to discuss the economy of markets proactively, rather than avoid these conversations, which will not lead us to change. I've always felt that studying the political economy of culture and exposing its secrets, how elites use it to their advantage, is central to any arts-focused activist scholarship. For instance, we need to expose how museum boards and collectors push museums to collect their artists. We need to discuss these processes openly, because inequalities in art markets thrive when we are silent about their myths, such as the idea that "art is universal" and that "value" is something that just is, rather than something that is socially created. These and other false beliefs keep us from probing and extricating how art markets work and how unfair and racialized they are. We're at a moment where we need to center racism, racial capitalism, and racial inequality in our understanding of how art works. We need to ask these questions not only to contest these processes, but to develop more equitable practices to promote, defend, and advance our artists.

NOTES

1. Arlene Dávila, *Latinx Art: Artists, Markets, and Politics* (Durham, NC: Duke University Press, 2020).

2. Nick Paumgarten, "Dealer's Hand: Why Are So Many People Paying So Much Money for Art? Ask David Zwirner," *New Yorker*, December 2, 2013; and Maximilíano Durón, "In a New Book, Scholar Arlene Dávila Writes about the Invisibility of Latinx Art in the Market," *ARTnews*, September 16, 2020.

3. Arlene Dávila, "Culture in the Battlefront: From Nationalist to Pan-Latino Projects," in *Mambo Montage: The Latinization of New York*, edited by Agustín Laó-Montes and Arlene Dávila (New York: Columbia University Press, 2001), 168–69.

4. According to art historian and curator Deborah Cullen, Robert Blackburn's Printmaking Workshop, founded in 1948, is the "oldest continually operating non-profit, artist-run printmaking studio in the country." Her dissertation is the first monograph dedicated to analyzing the life and work of Robert Blackburn (1920–2003). Cullen places special emphasis on contextualization and chronology, reviewing his sixty-year oeuvre. She tracks his trajectory as an important figure who connected the Works Progress Administration's printmaking projects with the 1960s print boom, to which his work served as a precursor. His experimental and abstract lithography would greatly influence figures such as Larry Rivers, Grace Hartigan, and Robert Rauschenberg. Blackburn's workshop was strategically incorporated in 1971, shortly after the founding of the National Endowment for the Arts. As a lithography, relief, and photo process studio, its goals were high-quality printmaking, innovation, the inclusion of third world and minority artists, and fostering public appreciation of prints. Despite his impressive record of leadership and remarkable output, other figures would come to overshadow Blackburn's interventions. Deborah T. Cullen, "Robert

Blackburn: American Printmaker" (PhD dissertation, City University of New York, 2002), 193–97, eventually republished as *Robert Blackburn: Passages,* exhibition catalog (College Park: The David C. Driskell Center at the University of Maryland, College Park, 2014). For more on the workshop, visit www.rbpmw-efanyc.org/.

5. For more on DIVEDCO, see Teresa Tió, "El cartel en la División de Educación de la Comunidad: Instrumento de identidad nacional," in *El archivo de Luis Muñoz Marín: vehículo útil para fortalecer el conocimiento de la historia de Puerto Rico* (San Juan: Fundación Luis Muñoz Marín, 2002), 25–33; and María del Mar González-González, "La Hoja Nacionalizada: DIVEDCO's Graphic Arts," *Aztlán: A Journal of Chicano Studies* 42, no. 1 (Spring 2017): 163–78.

6. Karen Mary Davalos, "A Poetics of Love and Rescue in the Collection of Chicana/o Art," *Latino Studies* 5, no. 1 (2007): 76–103.

7. For more on Pepe Coronado, see Tatiana Reinoza, *Reclaiming the Americas: Latinx Art and the Politics of Territory* (Austin: University of Texas Press, 2023), 151–90; and her article "The Island within the Island: Remapping Dominican York," *Archives of American Art Journal* 57, no. 2 (Fall 2018): 4–27; for information on his print studio, visit www.coronadoprintstudio.com/.

8. For more on Segura Publishing, see Reinoza, *Reclaiming the Americas,* 73–111; Cassandra Coblentz, *Right to Print: Segura Publishing Company* (Scottsdale, AZ: Scottsdale Museum of Contemporary Art, 2007); and Sarah Kirk Hanley, "Segura Reborn at University of Notre Dame," in *Images of Social Justice from the Segura Arts Studio,* curated by Joseph Segura and Jessica O'Hearn (Notre Dame, IN: Snite Museum of Art, University of Notre Dame, 2016).

ATELIER HISTORY

Compiled by Kendra Lyimo

Gronk
DOD Commemorative 1981

Leo Limón
DOD Commemorative 1981 (Legs)

SPECIAL PROJECTS—1981

Leo Limón
Quetzalcoatl
Reina de Maiz

DAY OF THE DEAD 1982

Leo Limón
Día de los Muertos (Calaveras and Cars)
Untitled (Come in Costume)

Armando Norte
Día de los Muertos 10th Anniversary

SPECIAL PROJECTS—1982

Gronk
DOD Commemorative Poster
Exploding Cup of Coffee
Flying Coffee Cup
Friends
Iceberg
Molotov Cocktail
Pearl
Pedestrians
Rebey
Untitled
Untitled No. 1
Untitled No. 2
Untitled No. 3

1 ATELIER I—1983

Don Anton
The Single Word

Sister Karen Boccalero
Without

Yreina D. Cervántez
Danza Ocelotl

Sam Costa
Media Madness

Florencio Flores
Jagar (Scot Rex)

Armando Norte
Savagery & Technology

Michael Ponce
Familia

Dan Segura
Like Father, Like Son

Peter Sparrow
Omens

Marisa Zains
Phantom Fear II

2 ATELIER II—1983

Sister Karen Boccalero
In Our Remembrance/In Our Resurrection

Mari Cardenas
Untitled (Purple Bird)

Yreina D. Cervántez
Victoria Ocelotl

Diane Gamboa
She's My Puppet

Miles Hamada
Untitled (Handcuffed Male w/ Red Stripes)

Steve Leal
Untitled (Asian Woman)

Leo Limón
Dando Gracias

Armando Norte
Untitled (Red Background)

Jesús Pérez
Arreglo

Dan Segura
This Is Pain

3 ATELIER III—1984
Barbara Carrasco
Self Portrait

Roberto "Tito" Delgado
Untitled

Richard Duardo
Untitled (Boy George)

Diane Gamboa
Self Portrait

Eduardo Oropeza
El Jarabe de los Muertianos

Barbara Carrasco, Robert Delgado, Richard Duardo, Diane Gamboa, and Eduardo Oropeza
Atelier III, Announcement Poster for

4 ATELIER IV—1984
Lorraine Garcia
Untitled

Willie Herrón III
Untitled (Human Figures & Animals)

Ralph Maradiaga
Lost Childhood

Eloy Torrez
The Pope of Broadway

Linda Vallejo
Untitled (Purple Woman)

Lorraine Garcia, Willie Herrón III, Ralph Maradiaga, Eloy Torrez, and Linda Vallejo
Atelier IV, Announcement Poster for

5 ATELIER V—1985
Yreina D. Cervántez
Camino Largo

Alonzo Davis
Act on It

Richard Duardo
Untitled (Woman Flexing)

Dolores Guerrero-Cruz
The Bride

Peter Sparrow
*Untitled (Purple Strokes and Pale
 Brown Circle)*

John Valadez
Untitled (Red w/ Suited Figures)

6 ATELIER VI—1985
Alfredo de Batuc
Comet over City Hall

Roberto "Tito" Delgado
Loto

Dolores Guerrero-Cruz
Peacemakers

Leo Limón
Wovoka's Corazon

Eduardo Oropeza
Onward Christian Soldiers

Jesús Pérez
Untitled

Frank Romero
Untitled (Blue Beetle)

Elizabeth Rodriguez
Untitled

Mathew Thomas
Untitled (Pink, Green, Orange)

Eloy Torrez
Untitled (Mother and Child)

Bob Zoell
Sunflower for Gauguin

7 ATELIER VII—1986
Glenna Boltuch Avila
Untitled

Qathryn Brehm
Untitled

Alberto Castro Leñero
Susana

José Castro Leñero
Camine, No Camine

Yreina D. Cervántez
*El pueblo chicano con el pueblo
 centroamericano*

Diane Gamboa
Three

Margaret Garcia
Untitled
Untitled (Red Dog)

Leo Limón
Soñando

Gilbert "Magu" Lujan
Cruising Turtle Island

Frank Romero

Carro

Pingo con Corazón

8 ATELIER VIII—1986–1987

Diane Gamboa

Untitled

Margaret Garcia

Anna Comiendo Salsa

Gerry Grace

Ancient Dreamers

Bernard Hoyes

Macumba Ritual

Leo Limón

Madre Tierra, Padre Sol

*The Sun Burns, The Stars
 Shine*

Daniel J. Martinez

The Promised Land

Jesús Pérez

Try Angle #1

Juan Perez

Vertigo

Elizabeth Rodriguez

Untitled

Frank Romero

Untitled

DAY OF THE DEAD 1986

Leo Limón

Vida y Muerte

SPECIAL PROJECTS—1986

Diane Gamboa

Untitled (I)

Untitled (II)

Untitled (III)

Untitled (IV)

Frank Romero

*Untitled (Blue Beetle, City Hall, Vase,
 Freeway)*

9 ATELIER IX—1987

José Antonio Aguirre

Calaca Alucinada en L.A.

Alex Alferov

Icon

Samuel Baray

Santuario

Alfredo de Batuc

Seven Views of City Hall

Yreina D. Cervántez

La Noche y Los Amantes

Alonzo Davis

King Melon

Dolores Guerrero-Cruz

Mujeres y Perros

Vijali Hamilton
Sight One

Wayne Healy
Sawin' at Sunset

Arturo Urista
Welcome to Aztlan

Linda Vallejo
Black Orchid

10 ATELIER X—1987

Samuel Baray
Recuerdos y Memorias de Doña Inez

Guillermo Bert
Dilemma in Color

Rudy Calderón
Manifestation of Trinity

Bernard Hoyes
Journey to the Astral World

Victor Ochoa
Border Bingo/Loteria Fronteriza

Elizabeth Rodriguez
New York Boy I

Neal Taylor
Balance of Knowledge/Balance of Power

Matthew Thomas
Cosmic Pattern Print II

Arturo Urista
Duel Citizenship

Patssi Valdez
Scattered

TALLER DE MEXICO USA/MEXICO PROJECT—1987

José Antonio Aguirre
El Compadre y La Comadre se Fueron a Pachanguear . . .
Y Entre Humo y un Tequila Se Aventaron un Danzón II

Dolores Guerrero-Cruz
Hombres Ouridos y Lindos

Leo Limón
Bailando Together
Hermanos del Fuego

Jesús Pérez
Carnales
Light?
The Best of Two Worlds

Arturo Urista
Juego de Pelotá

Patssi Valdez
L.A./T.J.
Split Image

SPECIAL PROJECTS—1987

Felipe Almada
Lado a Lado

Juan Cervantes
De Colores

Yreina D. Cervántez
Alerta!

Ricardo Favela
Aquí Estamos . . .

Leo Limón
La Ozone Burns II
Muchachas Talk

Amelia Malagamba
A Rosalba in Memoriam

Malaquias Montoya
Declaraciones de Amor
Carnal del Sur

Gerardo Velasquez Navarro
La Movilidad Social
La Amistad Perdida . . .

11 ATELIER XI—1988
Alex Alferov
Koshka

Michael Amescua
Mara'akame

José Antonio Aguirre
Firedream

Ann Chamberlin
Stadium

Alonzo Davis
Now Is The Time

Richard Duardo
The Father, The Son and the Holy Ghost

Margaret Garcia
Romance

Robert Gil de Montes
Movie House

Dolores Guerrero-Cruz
El Perro y La Mujer
La Mujer y El Perro

J. Michael Walker
Mexico Frantico

Frank Romero
Cruz Hacienda Martinez
Cruz Arroyo Seco

NATIONAL CHICANO SCREENPRINT
TALLER/ATELIER—1987–1988
Alfredo Arreguin
Encantación

Mario Castillo
Resistance to Cultural Death, An
 Affirmation of My Past

Yreina D. Cervántez and Leo Limón
Estrella of the Dawn

Carlota Espinoza
We the People

Dolores Guerrero-Cruz
Flores para Las Mexicanas

Leonardo Ibáñez
Sueños y Mitos

Leo Limón
Cultura Cura!

Lalo Lopez Alcaraz
White Men Can't

Rudy Martinez
Kill

Martin Phillip Durazo
General Electric

Sister Frances Shimotsuma
Los Angeles—(S/P)

Eloy Torrez
Under the Spell

Peter Tovar
L.A. '92

Gloria Westcott
¡Adiós Hollywood!

20 ATELIER XX—1991–1992
Mario Calvano
Portrait of the Artist's Mother
 (1991)

Gronk
Dumbbell

Willie Herrón III
Lecho de Rosas—(DOD)

Armando Norte
Niña Héroe

Peter Tovar
No Tears No Nada

John Valadez
Novelas Kachina

Patssi Valdez
Calaveras de Azucar

21 ATELIER XXI—1992
Yolanda González
Women Know Your Strength!—
 (S/P)

Dolores Guerrero-Cruz
Phoenix

Robert Gutiérrez
Self Help Graphics in East Los—(S/P)

Alma López
Genesis Women—(S/P)

Cecilia Sánchez-Duarte
Chacahua

Sergio Zenteno
Untitled

SPECIAL PROJECTS—1992
Leo Limón
Buenos Días–L.A. River I & II

Sister Frances Shimotsuma
Obon

Gloria Westcott
Have Aliens Landed Here?

Alex Alferov
Passport

José Alpuche
Another Aftershock Hits LA

Vincent Bautista
Ethereal Mood

Poupée Boccaccio
El Politico

Janet Cooling
The World Is on Hard

Raoul De La Sota
Spanish History

Margaret Garcia
SiDa Que Amor Eterno

Nancy Kittredge
More Than We Seem

Gloria Longval
La Curandera

Daniel Lucas
Koo Koo Roo

Christopher Ramirez
Alpha/Omega—(S/P)

Lynn Schuette
*"Crossfire/Truth" From the Bloodstorm
Series*

Mario Uribe
The Voyage of the Akatsuki Maru

Cristina Cardenas
La Virgen de los Pescados

Robert Gutiérrez
Avenida Cesar Chavez

Otoño Luján
Break It

Paul Martinez
Cesar's Memory

Ann Murdy
Life as a Doll: Cracked Doll

Tony Ortega
Los de Abajo

Christopher Ramirez
Target Market

Vincent Ramos
Por Vida

Maria Rendon
Trinidad

Armando Cepeda
Buenos Días

Alejandro Romero
Curandera

Arturo Urista
Spiral y Bones

Salvador Vega
Volador

Larry Yáñez
Once Juan Won One

Michael Amescua
Buenos Días

Raul Baltazar and Zack de la Rocha
Culture of Consumption

Samuel Baray
Aurora—El Primer Milagro de Día

Alfredo de Batuc
Emiliano con zuecos

Chaz Bojórquez
New World Order

Richard Duardo
Veronika's Flight

Ricardo Duffy
Primavera

Felipe Ehrenberg
Garden Bananas
Otra Canelita

Primero de Enero-I
Primero de Enero-II

Ofelia Esparza
Cesar Vive

Michiko Furukawa
Obsesión de la Muerte

Diane Gamboa
Lost and Found

Margaret Garcia
De Colores

Martin V. Garcia
Observando

Dolores Guerrero-Cruz
Jugo de Naranja

Wayne Healy
Domingo Deportivo

Leo Limón
Espíritu de Olvera Street

Arturo Urista
Califas State Badge
Chicano P.D. Badge

Ashley Cook
I Will Never Be Satisfied, Will I Ever Be Satisfied?

Leo Limón
Hummingbird Spirit

Isabel Martínez
Raza & Culture

John V. Montelongo
El Día de Una Vida—(S/P)

Janie Nicoll
Monuments, Machinery & Memorials—
 (S/P)

Tony Ortega
A la Frontera de Aztlán

Teddy Sandoval
Angel Baby

Eloy Torrez
Deceit under the Lurking Eye

26 ATELIER XXVI—1995
Alfredo Calderón
Manto a Tamayo

Yolanda González
Alma de una Mujer

Salomón Huerta
Cara de Chiapas

José Lozano
La familia que nunca fue/The Family
 That Never Was

Paul Martinez
Mi Amor

Ada Pullini Brown
The Fruit of Discord

David Serrano
Fandango

Kathleen D.R. Yorba
The View

27 ATELIER XXVII—1995
Magdalena Audifred
Floating

Tony de Carlo
Saint Sebastian

Yolanda González
Metamophosis

José Lozano
La Diosa de Dia y de Noche

Ada Pullini Brown
Untitled

David Serrano
Untitled

DAY OF THE DEAD 1995
Artemio Rodriguez
Day of the Dead

SPECIAL PROJECTS—1995
Manuel Alcalá
El Canto de Quetzalcotl

Alex Alferov/Michael Amescua
Cultural Madonna

José Alpuche
El Espiritu Guerrero

Lawrence Colacion
Veterano

Alex Donis
*Altar de Honor: Notes on Paper Blacony
 Conduct*

Felipe Ehrenberg
Tiankistli
Untitled (Mi Hogar en Istelai)

Carlos Gonzalez
La Madona

28 ATELIER XXVIII—1995–1996
Michael Amescua
Fire in the Forest

Maria Antionette Argyropoulos
The Labyrinth of the Soul

Rudy Calderón
Omnipresence

Bernard Hoyes
Mystic Drummer

Yolanda M. López
*Woman's Work Is Never Done: Your
 Vote Has Power*

Daniel Marquez
Enseñanza del Sahuaro

Ernesto Montaño Valle
Divine Pollution

John V. Montelongo
Lenguaje de mis Padres

Delilah Montoya
*They Raised All of Us; City Terrace, LA,
 CA, 1955*

Refugio Posadas
Festín de Aromas

Ada Pullini Brown
Mother of Sorrow

Israel Rodriguez
Extraño tu Boca

David Serrano
Rapto
Power

29 ATELIER XXIX—1995–1997
Manuel Alcalá
La Partida

José Alpuche
Material Girl

José Antonio Aguirre
Santa Patria—(S/P) 1995

Samuel Baray
Señora en su jardín—Harvest

Pepe Coronado
Bailando con el Sol

Mita Cuaron
Virgen de la Sandía

Ricardo Duffy
The New Order

Sonya Fe
*Don't Become a Dish to a Man . . . You
 Will Soon Break*

Manuel Gomez Cruz
Barrio Flag

Andy Ledesma
Flor de Esperanza—(S/P)

Julio Martinez
. . . Del Altar a la Tumba

Eduardo Oropeza
Chicuelina

Israel Rodriguez
Armagedon

DAY OF THE DEAD 1996
Andy Ledesma
Day of the Dead

SPECIAL PROJECTS—1996
Felipe Ehrenberg
Nudos-Ties-SHG L.A. (X-95)

30 ATELIER XXX—1997–1998
Samuel Baray
Virgen de la Guardia

Chaz Bojórquez
L.A. Mix

Armando Cepeda
Una Noche en Tejas

Richard Duardo
Zen

Martín V. Garcia
Amor Eterno

Victor Gastelum
Dos Caras A.D.

Dolores Guerrero-Cruz
Fall of the Innocent

Annette Maria Ruiz
Sagrada Sandía

Daniel Marquez
Por Que

Isabel Martínez
Woman of Color

Pedro Martinez Rios
Mexico sin Espinas

31 ATELIER XXXI—1997–1998
Felipe Ehrenberg
Anafre

Paella

Adriana Yadira Gallego
Luna Roja

Lalo Lopez Alcaraz
Ché

Annette Maria Ruiz
Sagrada Sandía

Poli Marichal
Arbol de la Sabiduría (S/P)

Rudy Martinez
Legend

Jerry Ortega
Neo-Mexico

Jesus Chuy Rangel
Puro Lovers Lane

DAY OF THE DEAD 1997

Carlos Castro Gonzalez and José
Alpuche
DOD 1997, Viva la Vida

SPECIAL PROJECTS—1997

José Antonio Aguirre and José
Alpuche
Mongo Santamaria

Jon Baitlon
Para Karen, Eastlos

Genaro Velasquez Navarro
Algo Quedó

32 ATELIER XXXII—1998–1999

Paul J. Botello
Inner Nature

Damian Charette
Many Horses

Leo Limón
The Mission

Aydee Lopez Martinez
Sadness, Madness, Anger, Hate!

José Lozano
La Sonambula

José Ramirez
25 Calakas (DOD 1998)

Miguel Angel Reyes
Dozena

33 ATELIER XXXIII—MAESTRAS
ATELIER I—1998–1999

Laura Alvarez
*The Double Agent Sirvienta: Blow Up
the Hard Drive*

Vibiana Aparicio-Chamberlin
La Chola Blessed Mother

Barbara Carrasco
Dolores

Yreina D. Cervántez
Mujer de Mucha Enagua: Pa' ti Xicana

Diane Gamboa
Altered State

Margaret Garcia
Memory of a Haunting

Patricia Gómez
The Trappings of Sor Juana

Margaret Guzmán
Veil/Velo

Yolanda M. López
Woman's Work Is Never Done (Jaguar Woman Warrior)

Delilah Montoya
El Guadalupano

Noni Olabisi
King James Version

Rose Portillo
Sor Juana Rebelling Once Again

Favianna Rodriguez
Del Ojo No Se Escapa Nadie

DAY OF THE DEAD 1998

Margaret Garcia
Memory of a Haunting (It was the last time I saw her)

Frank Romero
Vida/Muerte

Patssi Valdez
November 2

SPECIAL PROJECTS—1998

José Alpuche, Michael Amescua, and Alex Alferov
Without You

Joseph "Nuke" Montalvo
Todos Somos Chusma

Tuan Phan
Untitled

Salvador Roberto Torres
Viva la Raza

Mary Yanish
Pericardium

34 ATELIER XXXIV—1999

Wayne Healy and Tomasz Sarnecki
Smokers' Game (S/P)

Betty Lee
Seekers of Gold (S/P)

Alma López
Mnesic Myths (S/P)

Herbert O. Sigüenza
Culture Clash = 15 Years of Revolutionary Comedy (S/P)

Mark Steven Greenfield
Untitled (So Tell Me Who's the Nigger Now?)

Frank Romero
Heart (S/P)

DAY OF THE DEAD 2001
Chaz Bojórquez and Omar Ramirez
The Here & Now

SPECIAL PROJECTS—2001
Wayne Healy
Bolero Familiar

Leticia Huerta
Elegie

Sally Mincher
Echo Park

Artemio Rodriguez
The King of Things
The King of Things book edition
The King of Things silk-screen poster

Frank Romero
Untitled
California Plaza

40 ATELIER XL—MAESTRAS III—
2002
Victoria Delgadillo
Knowingly Walking through the
Imaginary River towards Divine
Destiny

Elena Esparza
I Know Her . . . All About Her

Lysa Flores
The Making of a Trophy Grrl!

Diane Gamboa
Revelation Revolution

Alma López
Chuparosa

Isis Rodriguez
Self-Portrait with Muse

DAY OF THE DEAD 2002
Artemio Rodriguez
Posada y su Hijo

SPECIAL PROJECTS—2002
Miguel Angel Reyes
Epoca de Oro

David "Think Again'" Attyah
No Bullshit

Jerolyn Crute
The Key

Wayne Healy
Bolero Familiar

Bernard Hoyes
Block Party Ritual

Salomón Huerta
Untitled

Garland Kirkpatrick
¡No Más Tratos! (No More Deals!)

Beatriz Mejia Krumbein
Caution

Ricardo Mendoza
Respect

Favianna Rodriguez
Community Control of the Land

Alex Rubio
La Placa

Weston Takeshi Teruya
They Mistook the Determination in Our Eyes for Hopelessness

Vincent Valdez
Suspect: Dark Clothes, Dark Hair, Dark Eyes, Dark Skin

Mark "Memphis" Young
Cliché Inversion

41 ATELIER XLI—2003

Wayne Healy
Achealy's Heel (S/P)

Alma López
Our Lady of Controversy

Aydee Lopez Martinez
Moved by Your Rhythmic Eyes

Laura Molina
Cihualyaomiquiz, The Jaguar (S/P)

Juanishi V. Orosco
Angel de la Vida

Esteban Villa
Homefront Homeboy

42 ATELIER XLII—MAESTRAS IV—2003

Yolanda González
La Reyna

Consuelo Jimenez Underwood
La Virgen de los Nopales

Marissa Rangel
Untitled (Purple Man w/ Magenta Streak)

Cici Segura Gonzalez
Props and Scenery

43 ATELIER XLIII—2003

Jesus V. Barraza
Sobreviviendo

SPECIAL PROJECTS—2003

José Alpuche
La Virgen de la Comunidad

Chaz Bojórquez
SALA

Rudy Chacon
Grandpa and His Farm

Yvette Flores
Che

Robert Gutiérrez
Playa Vista

Sonia Romero and Frank Romero
Family Quilt

Carlos "Asylum" Solorzano
Sky High

Linda Vallejo
Electric Oak

49 ATELIER XLIX—HOMOMBRE
LA—2007–2008

Alex Alferov
Passage

Miguel Angel Reyes
Butch/Top

Alex Donis
Spider and Officer Johnson

Rubén Esparza
Y Que

Jef Huereque
Positive + Spirit

Rigo Maldonado
Hard to Swallow

Luciano Martinez
Intertwined

Hector Silva
Saint Drastiko

P.E. Sweeney Perez
Montebello G.K.K.

Joey Terrill
Remembrance (For Teddy and Arnie)

50 ATELIER L—MAESTRAS V—2008

Gloria E. Alvarez
Maestras/Mujeres Totémicas

Judy Baca
Absolutely Chicana

Barbara Carrasco
Tina Modotti

Magda Dejose
Bonita

Ofelia Esparza
How Many More?

Carol Es
Out of Reach

Emilia Garcia
Mujer de Maiz

Aydee Lopez-Martinez
Still Complete

Amelia Malagamba
Mujeres

Poli Marichal
Mujer de Fuego

Linda Vallejo
Electric Landscape

DAY OF THE DEAD 2008

Peter Tovar

All Is Not Forgotten

SPECIAL PROJECTS—2008

Miguel Angel Reyes

Flip

John Carr

We Love Iraq

Rubén Esparza

Si Se Puede

Yolanda González

Lauren con Su Corona de Flores

Gronk

Desaparecidas
Tale of Two Rocks

Wayne Healy

Tight "D"

José Lozano

Club Japonesas

Oscar Magallanes

And the Boss Laughs

J. Michael Walker

San Ysidro de Los Angeles

Willie R. Middlebrook

I've Given Everything!

Noni Olabisi

Death to the Ego/Here Comes the Sun

José Ramirez

Escuela

Shizu Saldamando

Vexing
*Class Notes aka What I Learned in Art
 School*

Gina Stepaniuk

Vibrate

Vincent Valdez

Christmas en LA

DAY OF THE DEAD 2009

Diane Gamboa

Deadly Stylish

SPECIAL PROJECTS—2009

Ricardo Duffy

Three Virgins

Gronk

Human Denial
*Numbered Art the Word's
 Reason*

José Ramirez

Las Tres Reinas

Ricky Ridecos/Rincones

Autonomous

Marianne Sadowski

Joven Soldadera

Richard B. Valdes

What Now My Love?

Ernesto Yerena
Aquí Estoy y No Me Voy
Ruben Salazar/La Voz de la Raza

52 ATELIER LII—2009–2010
Jesus V. Barraza
Las Flores

Sandow Birk
Estados Unidos Mexicanos

John Carr
Stop U.S. Aggression

Melanie Cervantes
Rigoberta Menchu

Contra
Trudell

Karen Florito
Hope

Overton Loyd
Media Assassin Nation

Mear One
Are You Ready to Die for Your Country?

Jaime "Vyal" Reyes
Invest in Revolution?

Favianna Rodriguez
Walk of Life

Jari Rene Alvarez
Amexican Spirito

Ernesto Yerena and Shepard Fairey
Re-Elect Sheriff Joe

DAY OF THE DEAD 2010
Leo Limón
Untitled (D.O.D Restrike 1981, bones cut out)

SPECIAL PROJECTS—2010
William Acedo
Sky Shark

Miguel Angel Reyes
Papillon

Melo Dominguez
F-1070

Felipe Ehrenberg
El Armadillo and La Bella (de la serie Mis Tenaugos)

EnikOne
Niños Heroes

Edward Escamilla
Uprooted

Nery Gabriel Lemus
Two Gulls Migrating and a Bed of Workers

Sandra de la Loza
Mural Remix. Artist Unknown, Untitled, 1970s

José Lozano
The Utamaro Lounge

Miles "El Mac" MacGregor
Cry Now

Stephanie Mercado
The Golden Tree

Shizu Saldamando
Una Cobija

Miyo Stevens-Gandara
Monterey Park, CA

Peter Tovar
Lies

Vincent Valdez
John

Ernesto Yerena
Esperanza para los Ganas
Ganas Soldier

DAY OF THE DEAD 2011
Patssi Valdez
DEDE Starring in the SHG Revival
Print

SPECIAL PROJECTS—2011
Miguel Angel Reyes
Amarrado

Mario Calvano
Pandora's Box

Rafael Cardenas
MLK Monte Carlo

Wayne Healy
La Alondra

Oscar Magallanes
Heuristic

Poli Marichal
Sacrifice

Paul Martinez
La Muerte de Mi

Joseph "Nuke" Montalvo
Cyberzapata 2010

Hanh Nguyen
Alien Growth

Louie Pérez
The Long Goodbye

Eric Reese
Roots Jam Session

Jaime "Vyal" Reyes
Tattooed Concrete

Shizu Saldamando
Homegirls

Jacqueline Sanders
Love Comes Naturally

Maye Torres
Shell Emergence
Toltec Talker

Judithe Hernandez
Eve Awakening

Raul Pizarro
Sharia

José Ramirez
The Boy

Ernesto Yerena
Frank Del Olmo

55 ATELIER LV—COMMUNICATION THREADS AND ENTWINED RECOLLECTIONS—2012–2013

Victoria Delgadillo
Bolsa de Mercado

Dalila Paola Mendez
Balam Huipil Remix

Patricia Valencia
03:15 PM, Tijuana, Mexico, 1983

Yu Cotton-Well
Through the Crossing Lines

Leslie Gutierrez Saiz
Toile de East LA

Mavis Leahy
Rouge d'andrinople

Raquel Rocky Ormsby-Olivares
Tradition

David Orozco
Nautilus

Eva Sandoval
Hilos Ancestrales

Carol Shaw-Sutton
Raga/Saga

DAY OF THE DEAD 2013
Daniel Martin González
Arte es Vida

SPECIAL PROJECTS—2013
Enrique Castrejon
Heart Measured in Inches

Gronk
Maya Texting

Jennifer Gutierrez Morgan
Ojos y Milagros: Finding Space

José Lozano
La Marisoul

Miyo Stevens-Gandara
Phil Spector's Pyrenees Castle, Alhambra

Dewey Tafoya
Xicano/a Time, Space, Dimension Portal

John Tallacksen
Serenata en el Callejón 12th and Alvarado

John Valadez
Chicano Heaven

ATELIER 2014

Fumiko Amano
Ibaza Series 003

Joel Garcia
Untitled

Gronk
Feminine
Depiction
Exposure

Sandy Rodriguez
Fire Storm
Tijuana Fire

Yolanda González
Portrait of Xochitl
Portrait with Aracadas

DAY OF THE DEAD 2014

Luis-Genaro Garcia
Una Cita con la Vida

SPECIAL PROJECTS—2014

Zeque Penya
Autonomia

PRINTMAKING SURVEY OF THE LOS
ANGELES RIVER ATELIER 2015

Alvaro D. Márquez
Ave. 60 Bridge

Alex Fridrich
L.A. River Path

Usen Gandara
*The River of Los Angeles with Its Plants
and Animals*

Poli Marichal
Frogtown

Kimiko Miyoshi
Big Gulp at Glendale Narrows

Miyo Stevens-Gandara
*Natural History: Los Angeles River, 1938
with Elderberry, Mugwort, and
Mulefat*

Christian Ward
*Up the River from Golden Shore to
DTLA*

DAY OF THE DEAD 2015

Sonia Romero
Wings of the Dead

SPECIAL PROJECTS—2015

Angel Villanueva
The Blue Cat

Dalila Paola Mendez
Queerios

CUBA EXCHANGE—2015

LA artists who traveled to Havana:
Delilah Montoya
Margaret Alarcón
Rogelio Gutierrez
Dalila Paola Mendez
Erin Miyo Stevens
Ernesto Yerena (alternate)

Cuban artists who traveled to Los
 Angeles:

Yamylis Brito

Carlos del Toro

Dairén Fernández

Aliosky García

Octavio Irving

ATELIER 2016

Jimmy Saldivar

Animal Farm

Miyo Stevens-Gandara

Chavez Ravine

Juan Carlos de Luna

Los Angeles

DAY OF THE DEAD 2016

Shizu Saldamando

Día de los Muertos 2016, Alice Bag

ATELIER 2017

Wayne Perry

DispLAced

Kimberly Robertson

Slay

Joel Garcia

El Pirka

Votan

We Are Still Here

El Mac

Amor y Arte

Gabriel García Román

Carlos y Fernando

Rosalie Lopez

Her Hands Remind Us

ATELIER 2018

Sandra C. Fernández

The Northern Triangle

Margaret Alarcón

Ojo del Agua

Zeke Peña

The River

Douglas Miles

Apache 59

Humberto Saenz

La Liebre Liberada

Kimberly Robertson

In Aunties We Trust

River Garcia

Breath of the Ocean

Luis Genaro Garcia

Coatlicue's Legacy

Sherin Guirguis

Untitled

DAY OF THE DEAD 2018

Dewey Tafoya

Los tenis de Cuauhtémoc

COMPILER'S NOTE

Discrepancies exist between the SHG database, the original "Atelier History" document, the California Ethnic and Multicultural Archives (CEMA) and its "Guide to the Self Help Graphics Archives, 1960–2003 [bulk 1972–1992]," and the finding aid found in *Self Help Graphics & Art: Art in the Heart of East Los Angeles* in terms of atelier number or date. If the information was not provided in the database, then preference was given to the records at CEMA and/or those stated in the anthology essays. Additionally, for certain works that were both a Special Project and part of an atelier, the abbreviation (S/P) was added after the entries on the atelier list. If it was both a Day of the Dead print and part of an atelier, the atelier's list entry is followed with the abbreviation (DOD).

SELF HELP GRAPHICS & ART TIMELINE

Compiled by Kendra Lyimo

1960
- June Wayne establishes the Tamarind Lithography Workshop in Los Angeles.

1962
- Cesar Chavez and Dolores Huerta cofound the National Farm Workers Association, which eventually becomes the United Farm Workers.

1963
- Reies López Tijerina establishes La Alianza Federal de Mercedes, launching a campaign for land reclamation in New Mexico.

1965
- The Watts riots take place in Los Angeles.

- Carlos Almaraz, Gilbert "Magu" Luján, Beto de la Rocha, and Frank Romero cofound the artist collective Los Four, which later includes Judithe Hernández in 1974.
- The Woman's Building, beginning as the Feminist Studio Workshop, opens under founders Judy Chicago, Arlene Raven, and Sheila Levrant de Bretteville.

1974
- Los Four holds a landmark exhibition at LACMA, both challenging and gaining access to the mainstream art world. (source 1, p. 27)
- Willie Herrón begins talking to Sister Karen Boccalero about using SHG as an alternative space to play and record music, and he shows an *Exhibition of Our Worst Works.* (source 3)
- Michael Amescua and Linda Vallejo start working at SHG by serving as staff members for the Barrio Mobile Art Studio. (source 3)

1975
- SHG launches the Barrio Mobile Art Studio. (source 3)
- Mari Cárdenas Yáñez volunteers at SHG, eventually becoming a paid employee in 1979. (source 2; source 3)
- End of the Vietnam War for the United States.

1976
- Galería Otra Vez opens at SHG.
- Sister Karen and Virginia Torres (René Acosta) submit a request to the National Endowment for the Humanities for a grant to help find research materials and develop curriculum about Día de los Muertos through the Barrio Mobile Art Studio. (source 4)

1977
- Bueno and Ibañez depart Los Angeles and return permanently to Mexico.
- El Teatro Campesino's Calavera Band (La Banda Calavera) performs at SHG's annual Día de los Muertos celebration. (source 5, p. 48)
- Carlos Almaraz and Richard Durado found Centro de Arte Público on Figueroa and 56th Street in Highland Park. (source 1, p. 25)
- David Botello and Wayne Healey found Los Dos Streetscapers. When more artists join, they change its name to East Los Streetscapers. (source 1, p. 26; Mural Conservancy of Los Angeles)

1978

- The cast of the play *Zoot Suit* performs at SHG's annual Día de los Muertos celebration. (source 5, p. 48)
- Robert Gil de Montes, Gronk, and Harry Gamboa Jr. found LACE (Los Angeles Contemporary Exhibitions). (source 1, p. 26)
- The Barrio Mobile Art Studio program at SHG reaches nine thousand youth in East LA. (source 3)
- El Teatro Campesino performs *El Fin del Mundo* for SHG's Día de los Muertos program at Roosevelt High School. (source 2, p. 12)

1979

- SHG moves to a building on 3802 Broadway Avenue (renamed Cesar E. Chavez Avenue in 1994). The space was previously used by the Catholic Youth Organization. (source 2, p. 10)
- El Teatro Campesino's Calavera Band (La Banda Calavera) performs at SHG's annual Día de los Muertos celebration. (source 5, p. 48)
- Leo Limón begins working at SHG as the staff printer. (source 3)
- Artists found the Museum of Contemporary Art in Los Angeles. (source 3)

1980

- On March 22, The Vex, a short-run music venue and nightclub, opens at SHG for all ages. Gronk and Jerry Dreva host its opening night, featuring sets by Los Illegals, the Brat, Plugz, and the Fender Buddies. (source 2, pp. 13–14; source 3)

1981

- Galería Otra Vez is officially founded as part of SHG. (source 3)

1982

- The Barrio Mobile Art Studio van breaks down, becoming cost-prohibitive for the organization.
- SHG invites Gronk to produce a series of prints as part of the Mexican American Printers Program. Gronk creates the first series of prints known as the Special Projects that commemorates the tenth anniversary of SHG's Día de los Muertos revival. The sale of these prints will be instrumental in launching the Atelier Program. (source 2, p. 15; source 3)
- SHG hosts the first paper fashion show, highlighting the work of Diane Gamboa, Consuelo Flores, and Marisela Norte. (source 4, p. 25)

1983
- SHG launches the Experimental Silkscreen Atelier program (Professional Printmaking Program). Stephen Grace, who was invited by artist Peter Sparrow to join SHG, serves as the first master printer. (source 1, p. 31; source 3)
- Sister Karen Boccalero creates both of her only known prints in SHG's collection: *Without* and *In Our Remembrance/In Our Resurrection.* (source 3)
- SHG's gallery is temporarily renamed New Directions but eventually reverts to Galería Otra Vez. (source 3)

1984
- SHG holds an exhibition for *Artists Call Against U.S. Intervention in Central America* in Galería Otra Vez.

1985
- SHG terminates the Barrio Mobile Art Studio.

1986
- SHG begins an archiving project with the California Ethnic and Multicultural Archives at the University of California, Santa Barbara, under the leadership of Salvador Güereña. (source 2, p. 23; source 3)

1987
- SHG holds its first exhibition featuring a Central American artist, Juan Edgar Aparicio, curated by Shifra M. Goldman.
- Eduardo Oropeza installs a ceramic mural on the exterior of SHG. (source 3)
- Oscar Duardo becomes master printer at SHG.

1988
- Arturo Urista becomes the artist-in-residence at SHG and helps to manage Galería Otra Vez. (source 3)

1989
- The Laguna Art Museum's curator of collections, Bolton Colburn, visits SHG and develops the idea to purchase all publications of the print atelier to that date. (source 1, p. 5)

1990
- Tomas Benitez begins working at SHG. (source 3)
- The Hammer Museum opens to the public.

1991

- The Laguna Art Museum organizes an exhibition titled *"Self-Help"
 Artists: Painting and Printmaking in East L.A.* featuring prints produced
 at SHG and paintings by ten Los Angeles artists. (source 1, p. 6)
- José "Joe" Alpuche joins SHG and begins working as a master printer.
 (source 3)
- The Artes de Mexico Festival is held across Los Angeles. LACMA
 shows an exhibition called *Mexico—Splendors of 30 Centuries* and SHG
 hosts a complementary exhibition, *Arts of Mexico: Its North American
 Variant.* (source 3)

1992

- SHG becomes a collaborating institution for "Finding Family Stories"
 with the Japanese American National Museum.
- The Laguna Art Museum purchases and acquires 170 prints by 90
 artists from SHG. (source 1, p. 5)
- SHG forms a cooperative agreement with the United States
 Information Agency (USIA), which brings about SHG's first traveling
 exhibition, *Chicano Expressions: Serigraphs from the Collection of Self
 Help Graphics.* It goes to seven countries in sub-Saharan Africa.
- Homeboy Industries opens in Boyle Heights, including a bakery,
 commercial print shop, restaurant, counseling, and tattoo removal
 service in its facilities. (source 3)
- LA uprising occurs following the acquittal of the police officers who
 were involved in the savage beating of Rodney King. The uprising
 results in more than $1 billion worth of property damage, fifty deaths,
 four thousand injured, and twelve thousand arrests.
- In October, Sister Karen and Tomas Benitez decide to remove the
 artwork *Vade Retro* by Manuel Ocampo from the group exhibition
 titled *Monster? Monster!,* citing offensive racial stereotypes. (source 3)

1993

- *Chicano Expressions: Serigraphs from the Collection of Self Help Graphics*
 international tour begins in Bujumbura, Burundi (the exhibition never
 materializes due to civil war); travels to Galerie Max Boullé,
 Mauritius; Zambia National Visual Arts Council Art Center, Lusaka,
 Zambia; and the National Museum of Art in Maputo, Mozambique.

1994

- Christina Ochoa begins serving as gallery director and curator for
 SHG (until 2005).

- *Chicano Expressions* is presented at the Pretoria Art Museum, South Africa; at the Durban Art Gallery in Durban, South Africa; and at the Nommo Art Gallery in Kampala, Uganda.
- The second UK/LA Festival is held in Los Angeles in September–November.
- SHG collaborates with Glasgow Print Studio in October.
- The 1994 UK/LA Exchange closes with an exhibition and open house at SHG.

1995
- Antonio Ibañez Gonzalez (1949–95) dies in Mazatlán, Mexico, at the age of forty-six.
- SHG launches S.O.Y. Artista, a free five-week summer youth arts program, which becomes SHG's longest-running youth summer arts program. (SHG website)
- The Laguna Art Museum opens its exhibition *Across the Street: Self Help Graphics and Chicano Art in Los Angeles,* which travels to the Hammer Museum in Los Angeles (October 10, 1995–January 7, 1996), the Art Museum of South Texas in Corpus Christi (March 1–May 15, 1996), the Anchorage Museum of History and Art in Anchorage (October 13–December 8, 1996), and El Paso Museum of Art (July–October 1997). (source 1, pp. 6–7; source 3)
- *Chicano Expressions: Serigraphs from the Collection of Self Help Graphics* is featured as an inaugural event of the art fair ARCO 95 and presented at Casa de América from February 2 to 26. The exhibition travels to Barcelona, Berlin, Frankfurt, Aix-Les-Bains, and La Rochelle.

1996
- Sister Karen finalizes the donation of over forty prints from SHG to the Riverside Art Museum in Riverside, California. The museum goes on to highlight these works in an exhibition titled *Aztlán and Beyond: Works from Self Help Graphics.* (source 2, p. 29)
- *Chicano Expressions* finishes its tour in France with a presentation at Cité du Livre in Aix-en-Provence. Much later in the year, *Chicano Expressions* begins its tour in Mexico, opening on December 13 at the Centro Cultural de Tijuana and followed by a short presentation in Mexicali.
- On November 1, the first Día de los Muertos celebration takes place in Glasgow, Scotland. In their gallery, the Glasgow Print Studio hosts a featured exhibition of thirty-four SHG monoprints and serigraphs celebrating Día de los Muertos from November 1 to 23.

1997
- Sister Karen Boccalero (May 13, 1933–June 24, 1997) dies at age sixty-four.
- SHG opens a satellite location on Olvera Street named Galería Sister Karen Boccalero after its founder. Christina Ochoa curates the satellite gallery, which remains open until 2000. (source 3)
- SHG's satellite gallery exhibition is invited to Italy, where it shows until 1999–2000.
- SHG puts on its first Annual Print Fair and Exhibition.
- *Chicano Expressions* continues its tour in Mexico, traveling to Museo Metropolitano de Monterrey, Museo de las Artes at the University of Guadalajara, and Museo del Instituto Nacional de Bellas Artes in Ciudad Juárez. Finally, in November, the last USIA-sponsored exhibition of *Chicano Expressions* takes place at Universidad Autónoma Metropolitana/Azcapotzalco in Mexico City.
- Tomas Benitez begins serving as executive director of SHG (until 2005).

1999
- Yreina D. Cervántez serves as the curator for the Maestras Atelier—an all women's screenprint portfolio and show—which makes her the first guest curator for SHG's Atelier Program. (source 3)
- Second iteration of "Finding Family Stories" with the Japanese American National Museum brings SHG, the California African American Museum, and the Chinese American Museum together to collaborate and focus on Japanese Americans, Chicanx, and African Americans in Los Angeles.
- The USIA and Arts America are abolished and folded into the Department of State. (source 2, pp. 21–22)
- The California Community Foundation provides a $20,000 grant to SHG to support the salary of an assistant director. (source 2, p. 24)

2000
- UCLA's Chicano Studies Research Center partners with SHG. (source 3)
- Reina Prado begins working at SHG and remains there until 2005. (source 3)
- The California Community Foundation funds SHG with a $30,000 grant to hire an archivist. (source 2, p. 24)
- In December, SHG rewrites artist contracts and the new version removes SHG as the joint copyright holder of the artists' works.

2001

- Evonne Gallardo begins work as the director of development at SHG (until 2003). (source 3)
- The California Community Foundation supplies SHG with a $300,000 grant to develop and implement a capital campaign as well as to hire new staff members. (source 2, p. 24)
- On August 18, Carlos Bueno Poblett (1941–2001) dies of natural causes in Mazatlán, Mexico, at the age of sixty.
- On September 1, SHG launches a $5 million capital campaign, which is shortly upended by the events of September 11, creating a shift in the funding climate.
- On September 19, fourteen of Alex Donis's prints are removed from SHG's gallery due to unapproving reactions from older viewers.

2002

- Until 2004, the Annenberg Foundation awards $125,000 to SHG to help with financial difficulties. (source 3)
- SHG and UCLA's Chicano Studies Research Center begin a community partnership with a one-year grant through the "UCLA in LA" initiative. (source 2, p. 89)

2003

- On November 7, the United Nations Educational, Scientific and Cultural Organization (UNESCO) declares Día de los Muertos a masterpiece of the Oral and Intangible Heritage of Humanity. (source 4, p. 35)

2004

- William Acedo begins leading the papier-mâché workshops at SHG. (source 4, p. 40)
- Gustavo Leclerc is hired as the artistic director at SHG. (source 2, p. 25)
- UCLA's Chicano Studies Research Center (CSRC) hires Colin Gunckel as part of their university-community partnership program to work on site at SHG doing archival work. (source 2, p. 38)
- In February, the CSRC and SHG jointly convene a Latino Arts Summit, inviting representatives from fifteen LA Latino arts organizations and scholars to discuss the need for preservation and access. With a follow-up meeting in June, the CSRC gains support from the Getty Grant Program to create a survey of Latino art historical materials in the LA area. (source 2, p. 92)

2005
- SHG opens the *Black Velvet Kruise* exhibition at Galería Otra Vez. (source 3)
- SHG, in partnership with the CSRC, publishes the first edition of *Self Help Graphics & Art: Art in the Heart of East Los Angeles,* a guide to the organization's archives at UCLA and CEMA that can also be used as a classroom text. (source 2, p. 94)
- On June 7, SHG closes its facilities due to a lack of liability insurance and a financial crisis that causes layoffs, while the facilities experience structural issues due to weather damage. Director Tomas Benitez and the board of directors all resign, with SHG experiencing mounting bills, its first-ever audit, and $150,000 debt. (source 2, p. 31; source 3)
- Community members and artists come together to help the organization survive. UCLA's Chicano Studies Research Center partners with local arts advocates for two town halls moderated by Chon A. Noriega. With the support of the California Community Foundation, consultant Max Benavidez designs a strategic plan to help revitalize SHG. (source 2, p. 31)
- In September, SHG reopens with Gabriel Tenorio as executive director, Armando Durón is named the president of the board, and Gustavo Leclerc becomes SHG's artistic director. The organization focuses on eliminating debt, streamlining operations, and emphasizing forward thinking and relevance. (source 2, p. 31; source 3)

2006
- The Museo José Luis Cuevas in Mexico City hosts an exhibition titled *La Estampa de Self Help Graphics* in October. The exhibition later travels to the Burling Gallery at Grinnell College, Iowa in February 2008. (source 2, p. 34)

2007
- Miguel Angel Reyes curates *Homombre LA,* the first gay-themed atelier. (source 3)
- Armando Durón is appointed as interim executive director (until 2008).
- On June 23, SHG holds an exhibition curated by Christina Ochoa and Alex Alferov that commemorates the tenth anniversary of the death of Sister Karen Boccalero. (source 3)
- In December, the Latino Museum of History, Art, and Culture in downtown LA holds an exhibition called *Virgen Prints of Self Help Graphics,* running until January 2008. (source 2, p. 34)

2008

- LACMA hosts a show featuring many SHG resident artists. (source 3)
- On July 3, the Archdiocese of Los Angeles notifies SHG that its building at 3802 Cesar E. Chavez Avenue, leased to Self Help for a dollar per year, has been sold to the Piedmont Investment Company. The organization is forced to relocate and begins searching for a new location. (source 2, p. 34; source 3)
- On July 19, Armando Durón resigns as SHG's president of the board. (source 2, pp. 31–32)
- In late 2008 to early 2009, Stephen Saiz is named SHG's president of the board. (source 3)

2009

- SHG hosts "Hard in Da Paint" on Friday nights, offering a space for individuals to explore and express themselves through spoken word, free-style rap, and break dancing. (source 3)
- Diane Gamboa is chosen as artist and curator for *Deadly Stylish*, the Día de los Muertos exhibition. (source 2, p. 35)
- Gronk produces four print editions and curates a mini-atelier at SHG. (source 2, p. 35)
- On June 1, Evonne Gallardo is promoted from development director to executive director and serves through June 2014. (source 3)
- On November 15, the Gold Line Eastside Extension opens, which brings light-rail public transportation back to East Los Angeles and Boyle Heights, thus connecting these areas to other parts of Los Angeles and Pasadena. (source 3)

2010

- For the first time, SHG holds its Día de los Muertos celebration in partnership with the East Los Angeles Civic Center in Belvedere Community Regional Park. The art exhibition is still held at SHG with Diane Gamboa, Mario Ybarra Jr., Karla Diaz, and José Ramirez serving as lead artists. This partnership extends into 2011. (source 2, p. 36)
- In December, SHG collaborates with the Chinese American Museum for an exhibition titled *Dreams Deferred: Artists Respond to Immigration Reform*. (source 3)

2011

- Douglas Miles, founder of Apache Skateboard, curates a special project titled *Puro Indio* at SHG, sharing the influence of the contemporary Native art movement. (source 2, p. 35)

- Rita Gonzalez, the associate curator (now head curator as of 2019) of contemporary art at LACMA, and Evonne Gallardo conceive the project titled *The Unpopular InBetween,* which brings together four artists whose works are influenced by Asco. Cindy Santos Bravo, Eamon Ore-Giron, Felicia Montes, and Alexandro Segade come together to pay homage to Asco through the creation of limited edition serigraphs, coinciding with LACMA's exhibition *Asco: Elite of the Obscure, A Retrospective, 1972–1987.* (source 2, pp. 35–36)
- The CSRC holds the exhibition *Mapping Another L.A.: The Chicano Art Movement* at the Fowler Museum at UCLA, which features works made at SHG. (source 2, p. 94)
- In April, SHG moves to a leased building at 1300 East First Street in Boyle Heights under the leadership of executive director Evonne Gallardo, master printer José Alpuche, and program manager Joel Garcia. (source 3)
- In May, the former residence of SHG on Cesar E. Chavez Avenue is placed on the California Register of Historical Resources. (source 2, p. 31)
- In October, SHG collaborates with Cal State University Long Beach's University Art Museum for the Getty Foundation's first Pacific Standard Time, a collaborative effort between sixty cultural institutions across Los Angeles. (Getty website)

2013
- The SHG's Día de los Muertos celebration now includes *Noche de Ofrendas,* where organizations, partners, artists, and community members are invited to Grand Park in downtown LA to build community altars.

2014
- The Barrio Mobile Art Studio is resurrected and brought back into operation under the tutelage of Dewey Tafoya. (source 4, p. 40)

2015
- Under the supervision of Betty Avila and with the organization's financial growth, SHG begins the process to purchase the building in Boyle Heights.

2016
- SHG experiences an eighteen-month closure of the First Street location due to water damage. SHG addresses accusations that it contributes to gentrification in Boyle Heights.

2017

- SHG begins to require its Open Studio artists to pay a nominal fee or complete five volunteer hours, as well as donate 20 percent of their artistic production for the art organization's gallery inventory.
- The University of Minnesota hosts the symposium Utopian World-Making: Art, Social Justice, and Communities of Color, with an accompanying art exhibition titled *Remembrance* at the Quarter Gallery, Regis Center. The symposium acts as a reunion for artists Rubén Esparza, Rigo Maldonado, Luciano Martinez, Miguel Angel Reyes, Joey Terrill, and Lalo Ugalde, most of whom participated in SHG's *Homombre LA* atelier. (University of Minnesota website)
- SHG creates a program named Jorn-Art-Leros, providing low-wage workers of color an opportunity to explore designs, branding, imagery, and text through printmaking and other media while also engaging with the issues that they faced. (SHG 2017 Annual Report)
- In February, the Biennial Printmaking Summit premieres at SHG.
- In September, SHG collaborates with the Getty Foundation for its second iteration of Pacific Standard Time, which explores the dialogue between Latin American and Latino art in Los Angeles. SHG receives $36,000 from the Getty Foundation to help with implementation and publication support for the exhibition *Día de los Muertos: A Cultural Legacy, Past, Present & Future*. (Getty website)

2018

- Dalila Paola Mendez curates *Queerida*, SHG's first all-queer Latina atelier.
- Betty Avila begins her role as executive director of SHG. She also joins the board of Art for LA. (SHG 2018 Annual Report)
- SHG begins its Youth Ambassador Program, which trains participating youth to be knowledgeable carriers of Self Help's exhibitions, thus allowing them to give tours to the rest of the community. (SHG 2018 Annual Report)
- SHG moves forward with its Young Curator Program, which provides youth a mentorship opportunity to work with a lead exhibition curator or historian. (SHG 2018 Annual Report)
- SHG finalizes the purchase of the building at 1300 East First Street in Boyle Heights, launching a capital campaign to complete the acquisition of the building and raise money for renovations. (SHG 2018 Annual Report)

- Cal State University Los Angeles collaborates with SHG for an exhibition titled *Entre Tinta y Lucha: 45 Years of Self Help Graphics & Art,* which runs through 2019, traveling also to Cal State University Bakersfield and Cannon Art Gallery in Carlsbad, California. (SHG 2018 Annual Report)
- During the summer, SHG partners with the Getty Marrow Multicultural Undergraduate Internship to provide two undergraduate internships in the fields of communication and archiving. Additionally, two other internships materialize through a partnership with the University of Notre Dame. (SHG 2018 Annual Report)

2019
- The solidarity-based cross-ethnoracial exhibition *Black, Brown, and Beige,* curated by Nery Gabriel Lemus and Jimmy O'Balles, opens at SHG.
- SHG initiates an after-school program for high school youth in the area, called Creative Labs, offering workshops in virtual reality, digital media, animation, printmaking, and laser cutting. (SHG website)
- SHG launches the first-ever Youth Committee, with the intention of highlighting youth voices in regard to SHG's programming and civic engagement. (SHG website)
- SHG holds the second Biennial Printmaking Summit during April 18–20. (SHG website)
- On May 3, for the celebration of its forty-sixth year of operation, SHG revives the Paper Fashion Gala that first made its appearance for the Día de los Muertos celebration in 1982. Jovana Lara and Danny Romero of ABC7 Vista LA host the event, which becomes a biennial going forward. (SHG website)

2020
- SHG partners with the "Make It Count" US Census campaign through a series of public art workshops that encourage hard-to-count communities to take part in the census. (SHG 2020 Annual Report)
- In March, the World Health Organization declares COVID-19 to be a global pandemic after it is first identified in Wuhan, China, in December 2019.
- In June, SHG offers live-printing events in the wake of Black Lives Matter protests and demonstrations.

- SHG's forty-seventh annual Día de los Muertos celebration on November 1 is held virtually through Self Help's *YouTube* channel due to the COVID-19 pandemic. (SHG website)
- Under the leadership of Betty Avila, SHG's annual budget grows by 30 percent, an unprecedented increase for any arts organization.

2021

- SHG receives $110,000 to fund exhibition research support in January for its third collaboration with the Getty's Pacific Standard Time initiative, set to open in 2024, which explores the relationship between art and science. In its exhibition *Sinks: Places We Call Home*, SHG partners with artists Beatriz Jaramillo and Maru Garcia and scientists from the Natural History Museum of Los Angeles County to highlight local environmental disparities and demonstrate land remediation processes. (Getty website)
- During March 10–12, SHG hosts its third Biennial Printmaking Summit. (SHG website)
- In April, Dewey Tafoya is chosen as SHG's next master printer and assistant director of the Professional Printmaking Program. (SHG website)
- Philanthropist MacKenzie Scott gifts $1 million to SHG in June as part of an effort to support arts and cultural institutions that serve overlooked and underfunded communities. (SHG website)
- In June, with the support of California State Senator María Elena Durazo and California Assemblymember Miguel Santiago, the state budget allocates $4 million for SHG building renovations. (SHG website)
- SHG becomes a Google Arts & Culture partner organization with its exhibitions, stories, and vast archive featured on its own dedicated page, while also being presented alongside more than fifty-two national art institutions within the Latino Art Now website. (SHG website)

2022

- SHG pays off the mortgage and officially owns the facility at 1300 East First Street.

COMPILER'S NOTE

Discrepancies exist among the sources listed below and the SHG website. Whenever possible, archival documentation was used to fact-check data. The essays in this anthology also provided a great deal of contextual information for this timeline.

SOURCES

1. Bolton Colburn, ed. *Across the Street: Self-Help Graphics and Chicano Art in Los Angeles.* With essay by M. Nieto. Laguna Beach, CA: Laguna Art Museum, 1995.

2. Kristen Guzmán. "Art in the Heart of East Los Angeles." In *Self Help Graphics & Art: Art in the Heart of East Los Angeles,* 2nd ed. Edited by Colin Gunckel. Los Angeles: UCLA Chicano Studies Research Center Press, 2014.

3. Jeremy Rosenberg, Tomas Benitez, and Reina A. Prado Saldivar. "Timeline." LA History Archive. The Studio for Southern California History, 2010. www.lahistoryarchive .org/resources/Boccalero/timeline.html.

4. Mary Thomas, ed. *Día de los Muertos: A Cultural Legacy, Past, Present & Future,* curated by Linda Vallejo and Betty Brown. Los Angeles: Self Help Graphics & Art, 2017.

5. Sybil Venegas. "The Day of the Dead in Aztlán: Chicano Variations on the Theme of Life, Death and Self-Preservation." MA thesis, University of California, Los Angeles, 1993.

FURTHER READING

Anderson, Isabel. "Self-Help Graphics: Merging Art with the Chicano Community." *Screenprinting,* October 1992, 69–71, 172–73, 209.

Benavidez, Max. *Gronk.* Los Angeles: UCLA Chicano Studies Research Center Press, 2007.

Cárdenas, Gilberto. "Art and Migration: A Collector's View." In *Caras Vemos, Corazones No Sabemos = Faces Seen, Hearts Unknown: The Human Landscape of Mexican Migration,* edited by Amelia Malagamba-Ansótegui, 103–14. Notre Dame, IN: Snite Museum, University of Notre Dame, 2006.

Chavoya, C. Ondine, and David Evans Frantz, eds. *Axis Mundo: Queer Networks in Chicano L.A.* Los Angeles: ONE National Gay & Lesbian Archives at the USC Libraries; Munich, Germany: DelMonico Books/Prestel, 2017.

Colburn, Bolton, ed. *Across the Street: Self-Help Graphics and Chicano Art in Los Angeles.* With essay by M. Nieto. Laguna, CA: Laguna Art Museum, 1995.

Davalos, Karen Mary. "The Art of Convergence: Troubling the Discourse and the Archive." In *Entre Tinta y Lucha: 45 Years of Self Help Graphics & Art,* edited by Michelle L. López and Victor Viesca, 5–19. Los Angeles: Fine Arts Gallery of California State University, 2018.

———. "Centro de Arte Público/Public Art Center." *Aztlán: A Journal of Chicano Studies* 36, no. 2 (Fall 2011): 171–78.

———. *Chicana/o Remix: Art and Errata since the Sixties.* New York: NYU Press, 2017.

———. *Exhibiting Mestizaje: Mexican (American) Museums in the Diaspora.* Albuquerque: University of New Mexico Press, 2001.

Donis, Alex. "How to Make a Paint Bomb: Alex Donis Recalls *My Cathedral* and *WAR.*" *QED: A Journal in GLBTQ Worldmaking* 2, no. 3 (2015): 70–71.

Gamboa, Harry, Jr. "In the City of Angels, Chameleons, and Phantoms: Asco, a Case Study of Chicano Art in Urban Tones (or Asco Was a Four-Member Word)." In *Chicano Art: Resistance and Affirmation, 1965–1985,* edited by Richard Griswold del Castillo, Teresa McKenna, and Yvonne Yarbro-Bejarano, 121–30. Los Angeles: Wight Art Gallery, University of California, Los Angeles, 1991.

———. "Self Help Graphics: Tomas Benitez Talks to Harry Gamboa, Jr." In *The Sons and Daughters of Los: Culture and Community in L.A.,* edited by David E. James, 195–210. Philadelphia: Temple University Press, 2003.

Gaspar de Alba, Alicia, and Alma López, eds. *Our Lady of Controversy.* Austin: University of Texas Press, 2011.

Goldman, Shifra M. "A Public Voice: Fifteen Years of Chicano Posters." *Art Journal* 44, no. 1 (Spring 1984): 50–57.

———. *Tradition and Transformation: Chicana/o Art from the 1970s through the 1990s,* edited by Charlene Villaseñor Black. Los Angeles: UCLA Chicano Studies Research Center Press, 2015.

Goldman, Shifra M., and Tomás Ybarra-Frausto, eds. *Arte Chicano: A Comprehensive Annotated Bibliography of Chicano Art, 1965–1981.* Berkeley: Chicano Studies Library Publications Unit, University of California, 1985.

———. "The Political and Social Contexts of Chicano Art." In *Chicano Art: Resistance and Affirmation, 1965–1985,* edited by Richard Griswold del Castillo, Teresa McKenna, and Yvonne Yarbro-Bejarano, 83–95. Los Angeles: Wight Art Gallery, University of California, 1991.

Gonzalez, Martha. *Chican@ Artivistas: Music, Community, and Transborder Tactics in East Los Angeles.* Austin: University of Texas Press, 2020.

Gunckel, Colin. "Art and Community in East L.A.: Self Help Graphics & Art from the Archive Room." *Aztlán: A Journal of Chicano Studies* 36, no. 2 (Fall 2011): 157–70.

———, ed. *Self Help Graphics & Art: Art in the Heart of East Los Angeles,* 2nd ed. Los Angeles: UCLA Chicano Studies Research Center Press, 2014.

Guzmán, Kristen. "Art in the Heart of East L.A.: A History of Self Help Graphics and Art, Inc., 1972–2004." PhD dissertation, University of California, Los Angeles, 2005.

Hernández, Robb. *Archiving an Epidemic: Art, AIDS and the Queer Chicanx Avant-Garde.* New York: NYU Press, 2019.

———. *VIVA Records, 1970–2000: Lesbian and Gay Latino Artists of Los Angeles.* Los Angeles: UCLA Chicano Studies Research Center Press, 2013.

Jackson, Carlos Francisco. *Chicana and Chicano Art: ProtestArte.* Tucson: University of Arizona Press, 2009.

Letellier, Pascal. *Le Demon des Anges: 16 artistes chicanos autour de Los Angeles,* exhibition catalog. Nantes, France: Centre de recherche pour le développement culturel, 1989.

López, Michelle L., and Victor Hugo Viesca, eds. *Entre Tinta y Lucha: 45 Years of Self Help Graphics & Art.* Los Angeles: Fine Arts Gallery of California State University, 2018.

Marchi, Regina M. *Day of the Dead in the USA: The Migration and Transformation of a Cultural Phenomenon,* 2nd ed. Newark, NJ: Rutgers University Press, 2022.

McCaughan, Edward J. *Art and Social Movements: Cultural Politics in Mexico and Aztlán.* Durham, NC: Duke University Press, 2012.

Medina, Lara, and G.R. Cadena. "Días de los Muertos: Public Ritual, Community Renewal, and Popular Religion in Los Angeles." In *Horizons of the Sacred,* edited by T.M. Matovina and G. Riebe-Estrella, 69–94. Ithaca, NY: Cornell University Press, 2002.

Mesa-Bains, Amalia. "'Domesticana': The Sensibility of Chicana Rasquache." *Aztlán: A Journal of Chicano Studies* 24, no. 2 (1999): 155–67.

———, ed. *Chicano Expressions: Serigraphs from the Collection of Self Help Graphics/Expresiones chicanas: serigrafías de la colección de Self Help Graphics.* Los Angeles: Self Help Graphics, 1993.

Noriega, Chon A., ed. *Just Another Poster? Chicano Graphic Arts in California.* Santa Barbara: University Art Museum, University of California, 2001.

Noriega, Chon A., Terezita Romo, and Pilar Tompkins Rivas, eds. *L.A. Xicano.* Los Angeles: UCLA Chicano Studies Research Center Press, 2011.

Pérez, Laura E. *Chicana Art: The Politics of Spiritual and Aesthetic Altarities.* Durham, NC: Duke University Press, 2007.

———. *Eros Ideologies: Writings on Art, Spirituality, and the Decolonial.* Durham, NC: Duke University Press, 2019.

———. "Fashioning Decolonial Optics: Days of the Dead Walking Altars and Calavera Fashion Shows in Latina/o Los Angeles." In *MeXicana Fashions: Politics, Self-Adornment, and Identity Construction,* edited by Aída Hurtado and Norma E. Cantú, 191–215. Austin: University of Texas Press, 2020.

Prado Saldivar, Reina A. "Self Help Graphics: Case Study of a Working Space for Arts and Community." *Aztlán: A Journal of Chicano Studies* 25, no. 1 (2000): 167–81.

Reinoza, Tatiana. "Printed Proof: The Cultural Politics of Ricardo and Harriett Romo's Print Collection." In *A Library for the Americas: The Nettie Lee Benson Latin American Collection,* edited by Julianne Gilland and José Montelongo, 145–55. Austin: University of Texas Press, 2018.

———. *Reclaiming the Americas: Latinx Art and the Politics of Territory.* Austin: University of Texas Press, 2023.

Romo, Tere. "¡Presente! Chicano Posters and Latin American Politics." In *Latin American Posters: Public Aesthetics and Mass Politics,* edited by Russ Davidson, 51–63. Santa Fe: Museum of New Mexico Press, 2006.

Saldamando, Shizu. "On Art and Connection." *Asian Diasporic Visual Cultures and the Americas* 4 (2018): 321–27.

Schneider, Greg. "A Conversation with Sister Karen Boccalero, Founder of Self-Help Graphics." *Artweek* 23, no. 21 (August 1992): 16–17.

Thomas, Mary, ed. *Día de los Muertos: A Cultural Legacy, Past, Present & Future.* Los Angeles: Self Help Graphics & Art, 2017.

Tompkins, Pilar, and Colin Gunckel, eds. *Vexing: Female Voices of East LA Punk.* Claremont, CA: Claremont Museum of Art, 2008.

Vargas, George. *Contemporary Chican@ Art: Color and Culture for a New America.* Austin: University of Texas Press, 2010.

Venegas, Sybil. "The Day of the Dead in Aztlán: Chicano Variations on the Theme of Life, Death and Self-Preservation." In *La Calavera Pocha,* Self Help Graphics & Art 40th Anniversary Día de los Muertos Celebration, November 2, 2013, 7.

———. "The Day of the Dead in Aztlán: Chicano Variations on the Theme of Life, Death and Self-Preservation." In *Chicanos en Mictlán: Día de los Muertos in California,* curated by Tere [Terezita] Romo, 42–54. San Francisco: The Mexican Museum, 2000.

———. "The Day of the Dead in Aztlán: Chicano Variations on the Theme of Life, Death and Self-Preservation." MA thesis, University of California, Los Angeles, 1993.

Viesca, Victor Hugo. "The Battle of Los Angeles: The Cultural Politics of Chicana/o Music in the Greater Eastside." *American Quarterly* 3, no. 56 (2004): 719–39.

Williams, Lyle W., ed. *Estampas de la Raza: Contemporary Prints from the Romo Collection.* San Antonio, TX: McNay Art Museum, 2012.

Willick, Damon. "Handfuls of Creative People: Printmaking and the Foundations of Los Angeles Art in the 1960s." In *Proof: The Rise of Printmaking in Southern California,* 180–213. Los Angeles: Getty Publications, in association with the Norton Simon Museum, 2011.

Yarbro-Bejarano, Yvonne. "Por todos nuestros anhelos: el género y la crianza en la serigrafía chicana (II Taller Maestras de Self Help Graphics 2001)." *Revista Iberoamericana* 71, no. 212 (July–September 2005): 909–28.

Ziff, Trisha, ed. *Distant Relations: A Dialogue among Chicano, Irish & Mexican Artists.* Santa Monica, CA: Smart Art Press, 1995.

CONTRIBUTORS

KENCY CORNEJO is an associate professor at the University of New Mexico, where she teaches contemporary Latin American and Latinx art histories. Her teaching, research, and publications focus on contemporary art of Central America and its US-based diaspora, on art and activism in Latina/o America, and on decolonizing methodologies in art. Her work has been supported by the Fulbright and Ford foundations, an Andy Warhol Foundation Arts Writers Grant, and a National Endowment for the Humanities Faculty Award Grant. Kency was born in Los Angeles to Salvadoran immigrant parents and raised in Compton, California.

KAREN MARY DAVALOS, professor of Chicano and Latino studies at the University of Minnesota, has written extensively about Chicana/o/x art, including the prizewinning book *Yolanda M. López* (distributed by UMN Press, 2008). With Constance Cortez, she leads "Mexican American Art Since 1848," an open-source search tool that links art collections and related documents from libraries, archives, and museums. She has served on the board of directors of Self Help Graphics & Art since 2012.

ARLENE DÁVILA is a professor of anthropology and American studies at New York University. She is the author of six books focusing on Latinx cultural politics, spanning the media, urban politics, museums, and contemporary art markets. Her latest book, *Latinx Art: Artists, Markets, and Politics* (Duke University Press, 2020), was selected as one of the best art books of 2020 by the *New York Times* and *ARTnews*. She is also the founding director of The

Latinx Project, an interdisciplinary space focusing on Latinx art and culture and hosting artists and curatorial projects at NYU.

JV DECEMVIRALE is the Weisman Postdoctoral Instructor in Visual Culture and the Presidential Postdoctoral Fellow in the Division of Humanities and Social Sciences at the California Institute of Technology. A native Angeleno of Italian and Peruvian descent, he is currently working on a book project, *Keeping Fires in the Hinterlands: A Decolonial History of Colonial Aesthetic Rule in Los Angeles,* which traces the work of art within Spanish and Anglo colonial projects of epistemic dominance. Decemvirale's writings on the history of arts activism and community art spaces of color can be found online at Smithsonian American Art Museum blog, *Artsy,* and Smarthistory.

ROBB HERNÁNDEZ is an associate professor of English at Fordham University. He is the author of *Archiving an Epidemic: Art, AIDS, and the Queer Chicanx Avant-Garde* (NYU Press, 2019). His articles have appeared in *American Art, ASAP/Journal, Aztlán, Radical History Review,* and *TSQ,* among others. In 2017, he cocurated *Mundos Alternos: Art and Science Fiction in the Americas* in conjunction with the Getty Foundation's Pacific Standard Time: LA/LA initiative. He is a senior fellow in Latinx art at the Smithsonian American Art Museum and a recipient of an Arts Writers Grant from the Andy Warhol Foundation.

OLGA U. HERRERA is an art historian, curator, and the author of *American Interventions and Modern Art in South America* (University Press of Florida, 2017), winner of the 2018 SECAC Award for Excellence in Scholarly Research and Publication, and *Toward the Preservation of a Heritage: Latin American and Latino Art in the Midwestern United States* (ILS, University of Notre Dame, 2008). She is editor of the books *Scherezade García: From This Side of the Atlantic* and *iliana emilia García: The Reason/The Object/The Word* (both published by Art Museum of the Americas, 2020). She holds a PhD in Latin American art and theories of globalization from George Mason University.

ADRIANA KATZEW is a professor of art education at the Massachusetts College of Art and Design. Her research focuses on the intersection of Chicanas/os, Latinas/os, visual art, education, social justice, and activism. Katzew obtained her doctorate and master's degrees from the Harvard Graduate School of Education and a law degree from the University of Pennsylvania. Her art practice encompasses photography, mixed media, and installation. Currently, Katzew teaches art education courses that focus on issues of diversity and social justice, community-based art education, and studio/critique for art education majors.

KENDRA LYIMO studies art history with minors in Africana studies and Italian at the University of Notre Dame (UND). Her primary research interest is East African art. In 2021, she participated in the Cross Cultural Leadership Program at the Institute for Latino Studies at UND, and it supported her summer internship at Self Help Graphics & Art. Kendra served as a research assistant for the Brandywine Workshop and Archives' exhibition *All My Ancestors: The Spiritual in Afro-Latinx Art.* The 2022 Gero Travel Grant supported her trip to Kenya and Tanzania to conduct research on East African art and build a foundation for her undergraduate thesis and curatorial aspirations.

TATIANA REINOZA is an assistant professor of art history at the University of Notre Dame. A specialist in the Latinx graphic arts movement, she has published her writing in articles, catalog essays, and edited anthologies. Her book *Reclaiming the Americas: Latinx Art and the Politics of Territory* (2023) was published by the University of Texas Press. Her book *Reclaiming the Americas: Latinx Art and the Politics of Territory* (2023) was published by the University of Texas Press.

MARY THOMAS is an independent scholar and curator whose research examines improvisatory expressions in Black and Latinx art. Her publications include "Within/Against: Circuits and Networks of African American Art in California," in *The Routledge Companion to African American Art History*, and "*Bricozaje*: Between Contested Terrains and Aesthetic Borderlands," *Archives of American Art Journal* 61, no. 1 (Spring 2022). She earned her PhD in visual studies from UC Santa Cruz. Mary currently serves as Director of Programs for the U.S. Latinx Art Forum (USLAF).

CLAUDIA E. ZAPATA (they/them) earned their PhD in art history from Southern Methodist University. They received their BA and MA in art history from the University of Texas at Austin, specializing in Maya art from the Classic period (250–900 CE). Zapata has curated several exhibitions, including *A Viva Voz: Carmen Lomas Garza* (2009), *Sam Coronado: A Retrospective* (2011), and *Fantastic & Grotesque: José Clemente Orozco in Print* (2014). They have published articles in *Panhandle-Plains Historical Review, JOLLAS, El Mundo Zurdo, Hemisphere,* and *Aztlán*. Zapata was the curatorial assistant for Latinx art at the Smithsonian American Art Museum and is currently a Chancellor's Postdoctoral Fellow at UCLA.

INDEX

Page numbers in *italics* refer to illustrative matter.

Founded in 1893,
UNIVERSITY OF CALIFORNIA PRESS
publishes bold, progressive books and journals
on topics in the arts, humanities, social sciences,
and natural sciences—with a focus on social
justice issues—that inspire thought and action
among readers worldwide.

The UC PRESS FOUNDATION
raises funds to uphold the press's vital role
as an independent, nonprofit publisher, and
receives philanthropic support from a wide
range of individuals and institutions—and from
committed readers like you. To learn more, visit
ucpress.edu/supportus.